PAUL
NASH
1889–1946
Artist
lived here

BLACK DOG
THE DREAMS OF PAUL NASH

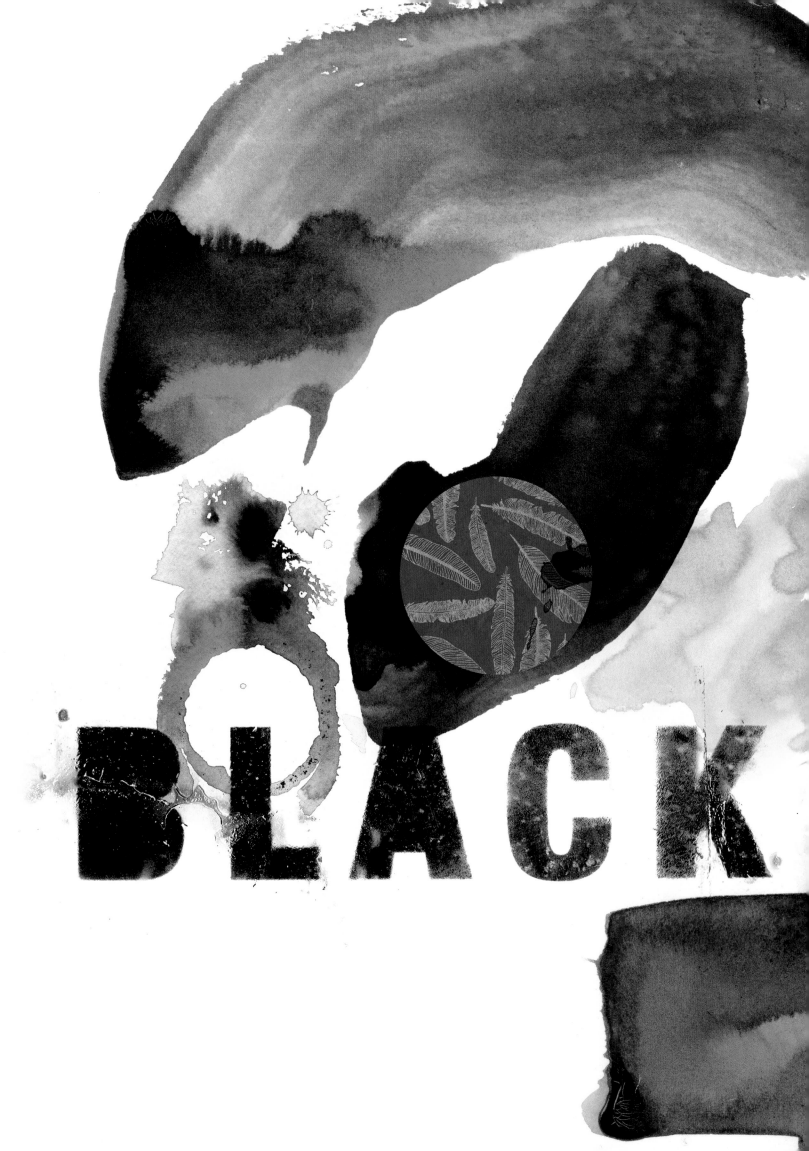

DOG

THE DREAMS OF PAUL NASH

Dark Horse Books

Black Dog: The Dreams of Paul Nash, by Dave McKean, was co-commissioned in 2016 by the Lakes International Comic Art Festival, On a Marché sur la Bulle, and 14-18 NOW: WW1 Centenary Art Commissions, supported by the National Lottery through the Heritage Lottery Fund and Arts Council England, and by the Department for Culture, Media & Sport. The commission was also supported by Kendal College, Kendal Business Improvement District, South Lakeland District Council, Cumbria County Council, and the Brewery Arts Centre.

Publisher: Mike Richardson
Editor: Daniel Chabon
Assistant Editor: Cardner Clark
Digital Production: Cary Grazzini

Published by Dark Horse Books
A division of Dark Horse Comics, Inc.
10956 SE Main Street
Milwaukie, OR 97222

DarkHorse.com
DaveMcKean.com

Library of Congress Cataloging-in-Publication Data
Names: McKean, Dave, author, illustrator.
Title: Black Dog : the dreams of Paul Nash / Dave McKean.
Description: First edition. | Milwaukie, OR : Dark Horse Books, 2016.
Identifiers: LCCN 2016016755 | ISBN 9781506701080 (paperback)
Subjects: LCSH: Nash, Paul, 1889-1946--Comic books, strips, etc. | World War, 1914-1918--Comic books, strips, etc. | Graphic novels. | BISAC: COMICS & GRAPHIC NOVELS / Fantasy.
Classification: LCC PN6737.M396 B57 2016 | DDC 741.5/942--dc23
LC record available at https://lccn.loc.gov/2016016755

First edition: October 2016
ISBN 978-1-50670-108-0

10 9 8 7 6 5 4 3 2
Printed in the United States of America

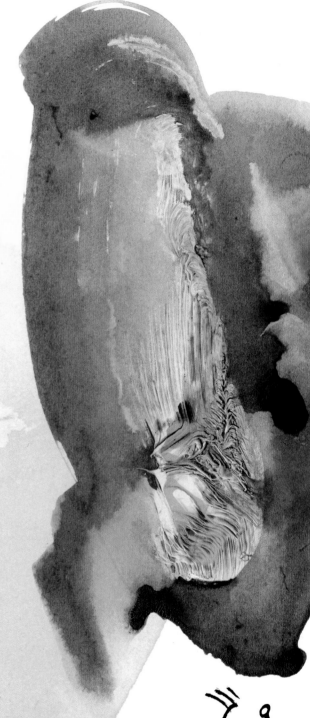

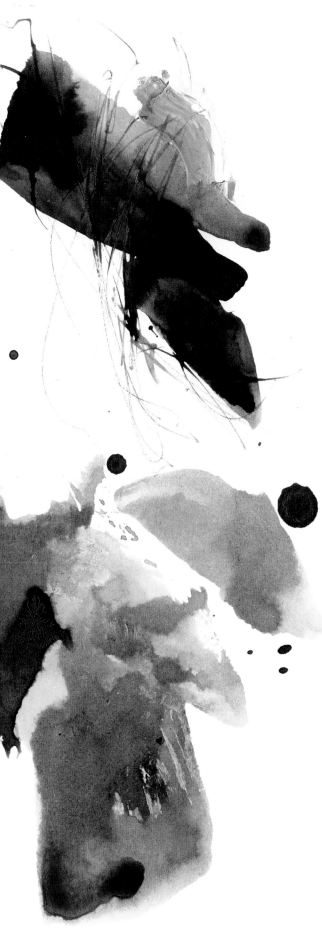

Foreword

In September 1914, six weeks after the start of the First World War, a twenty-five-year-old from Buckinghamshire named Paul Nash joined the British army. Just over two years later, he was sent to join the troops on the Western Front. His experiences there scarred his psyche and fired his imagination.

Paul Nash was one of the most influential and important British artists of his era. The paintings he created after his time on the frontline, first as a soldier and then as an official war artist, are some of the most potent documents of the First World War. These paintings have now inspired Dave McKean, a ceaselessly thoughtful and creative artist, to create *Black Dog: The Dreams of Paul Nash.*

Artists' reflections on war can illuminate events that might seem abstract to those of us living at some distance from the horrors of the battlefield. The best art carries a unique and profound power, shaping our understanding of the historical episodes that inspired it. This is true of Paul Nash's paintings, which retain their resonance and relevance a hundred years after they were created, and equally true of this vital new work by Dave McKean.

Black Dog: The Dreams of Paul Nash is part of 14-18 NOW, a five-year programme of new cultural works created especially to mark the centenary of the First World War. For their support, I would like to thank the Heritage Lottery Fund, Arts Council England, and the Department for Culture, Media & Sport, the funders of 14-18 NOW; and the Lakes International Comic Art Festival and On a Marché sur la Bulle, our co-commissioning partners for *Black Dog.* Most of all, I would like to thank Dave McKean for creating for us all a work of such richness, insight, and imagination.

Jenny Waldman
Director, 14-18 NOW

This commission is the stuff of which dreams are made. When we proposed a new comic art commission to 14-18 NOW, the UK's arts programme for the First World War centenary, our first choice was Dave McKean, although we thought it might be a long shot. Our aim was simple: to identify a comic artist who was internationally recognised and acclaimed by audiences and peers alike, who had an artistic vision which transcended artistic disciplines and boundaries, and whose work could appeal to existing and new audiences alike. Crucially for us we sought an artist who had an irresistible idea for a piece of work which would illuminate, in a new way, the experiences and impact of the First World War. As you will see Dave had much more than just an idea, as he had long been fascinated by the art and imagination of Paul Nash and relished the opportunity the commission afforded.

Paul Nash has been described as a Romantic artist who created a landscape of feeling in his work, who provided a bridge between the individual and the natural world, who was both a painter and a poet and more. In our view Dave has brought an additional dimension to our understanding and appreciation of Nash and his experiences of World War I and, using his image-making genius in both visuals and narrative, has created an original piece of work that speaks powerfully to today's audiences.

We must thank 14-18 NOW for making this extraordinary piece of work possible and all our partners and team for their energy and commitment. Of course, the biggest thanks must go to Dave McKean for immersing himself for many months in another's psyche to create this astonishingly perceptive work of art.

Julie Tait, *Director, and* **Aileen McEvoy**, *Associate Director*
Lakes International Comic Art Festival

1

1904 - WOOD LANE HOUSE, IVER HEATH, BUCKINGHAMSHIRE

This was my first dream.
At least, the first dream I remember.

Of all the stories that echo in our past -
little candles, clinging to life against the damp and the
cold and the draught -
dreams are the most elusive.
Hiding in the valleys and the folds of our minds, reclusive.

Hunkered in the shadows of our past and present tenses -
in the trenches.

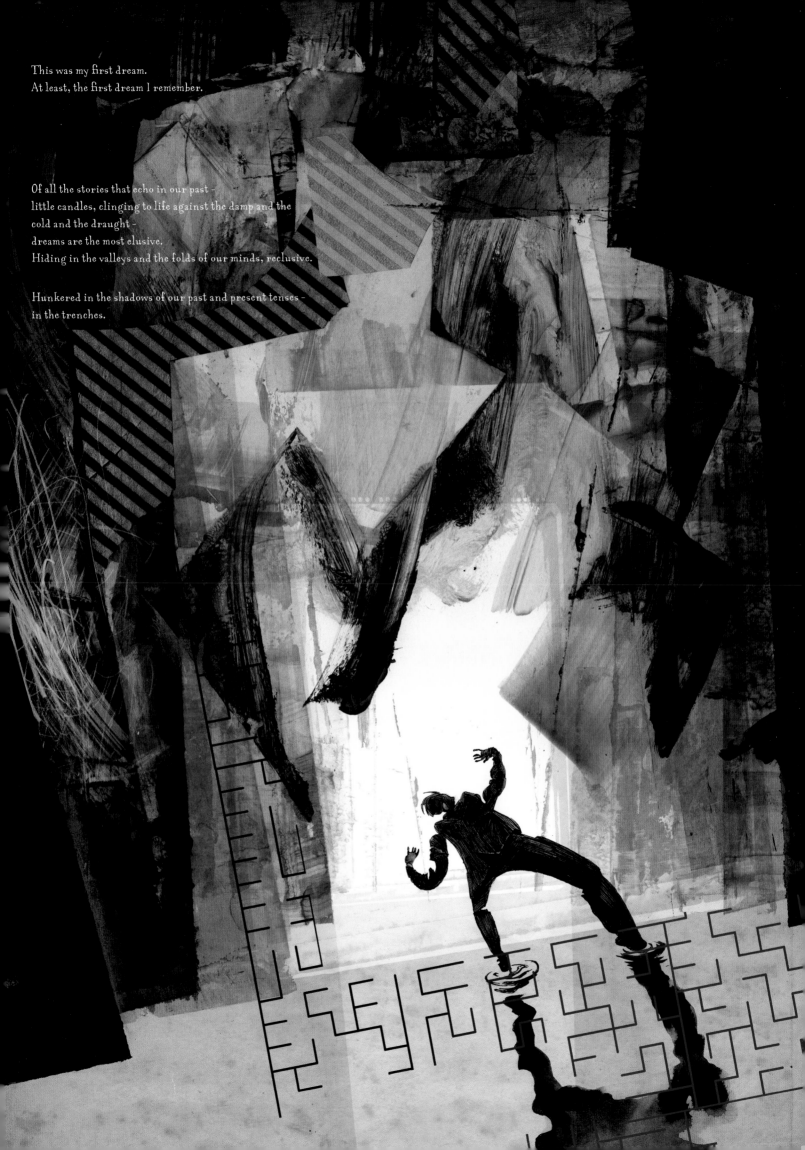

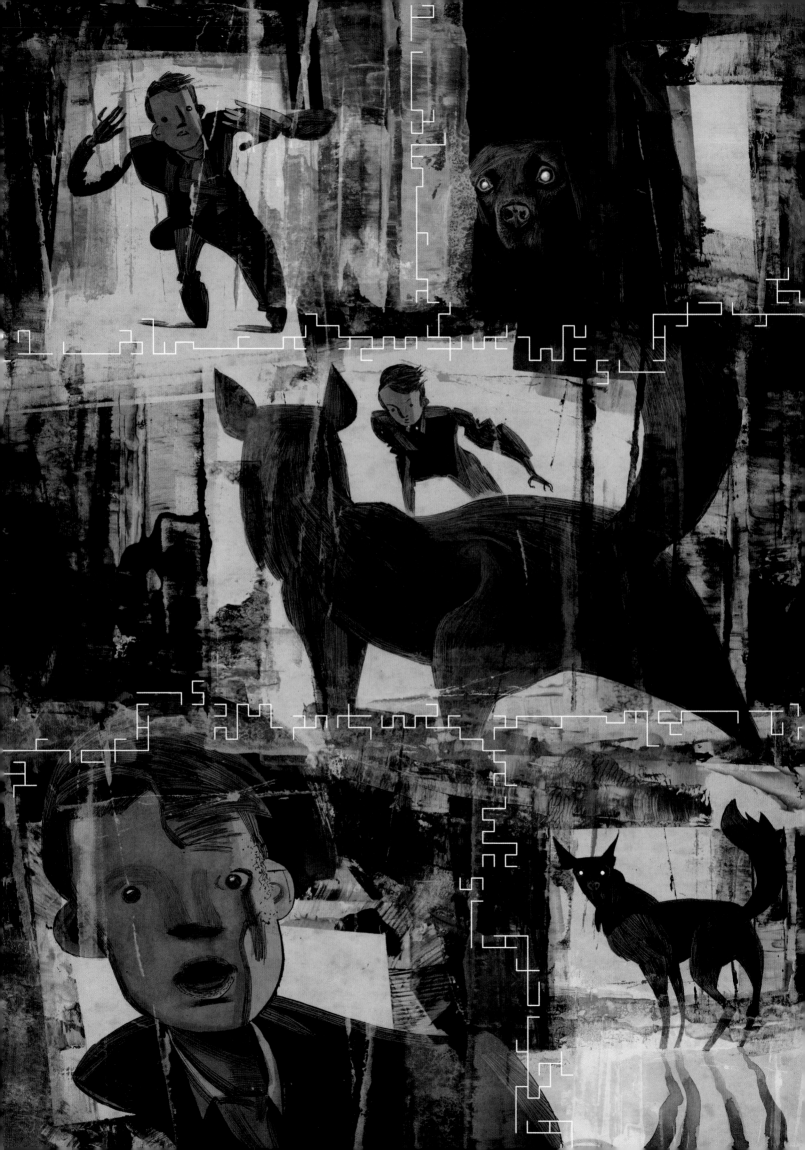

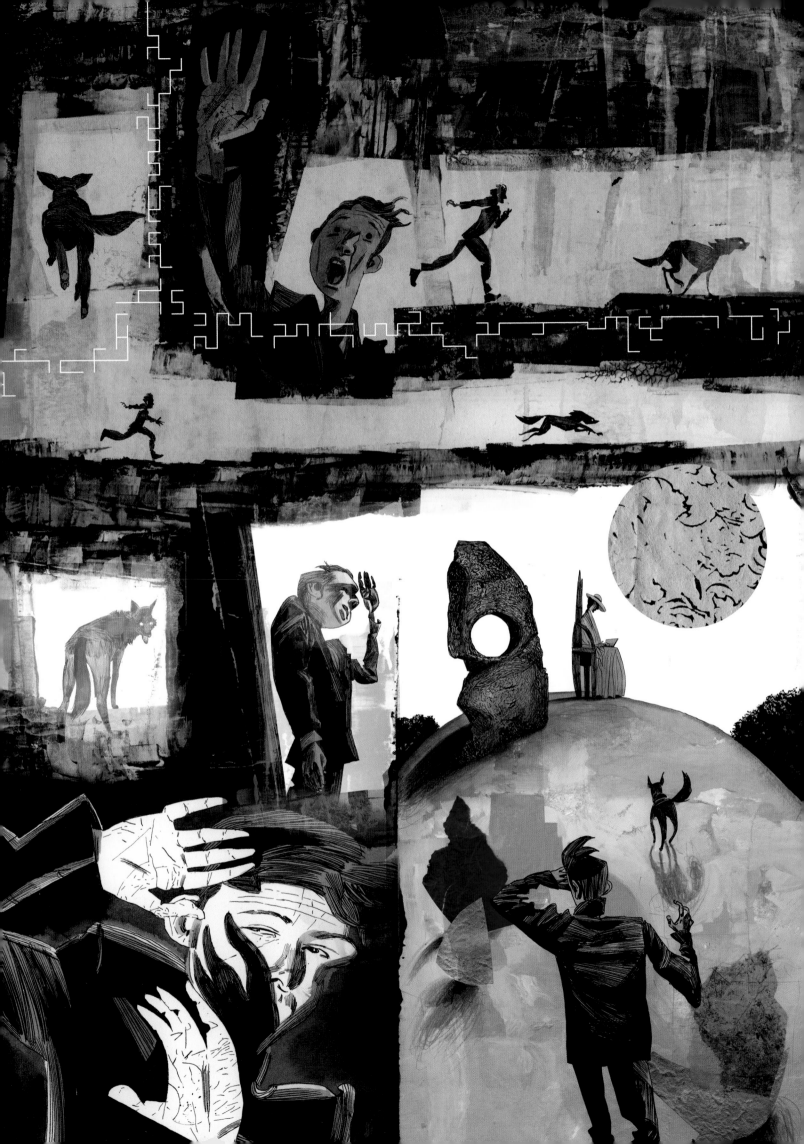

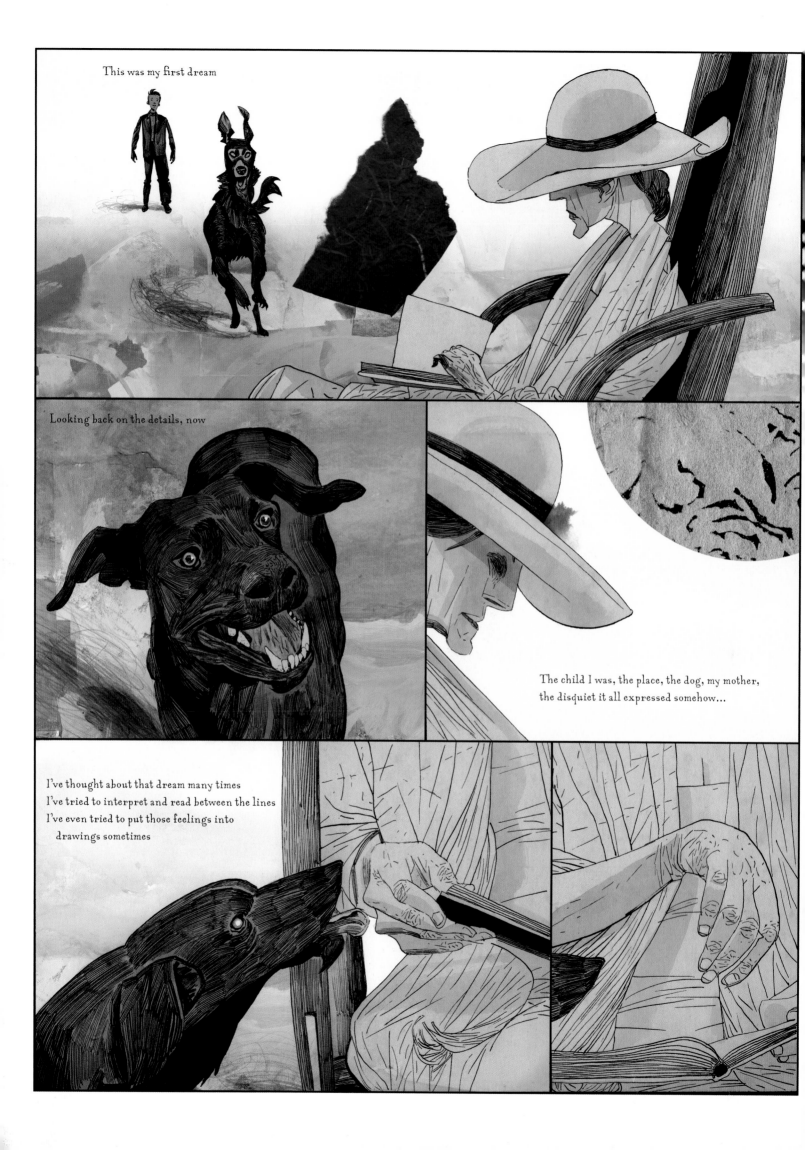

This was my first dream

Looking back on the details, now

The child I was, the place, the dog, my mother, the disquiet it all expressed somehow...

I've thought about that dream many times
I've tried to interpret and read between the lines
I've even tried to put those feelings into
 drawings sometimes

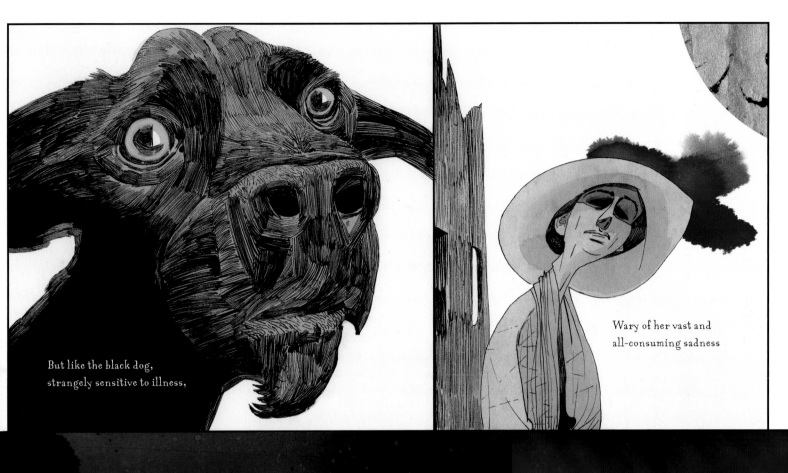

But like the black dog,
strangely sensitive to illness,

Wary of her vast and
all-consuming sadness

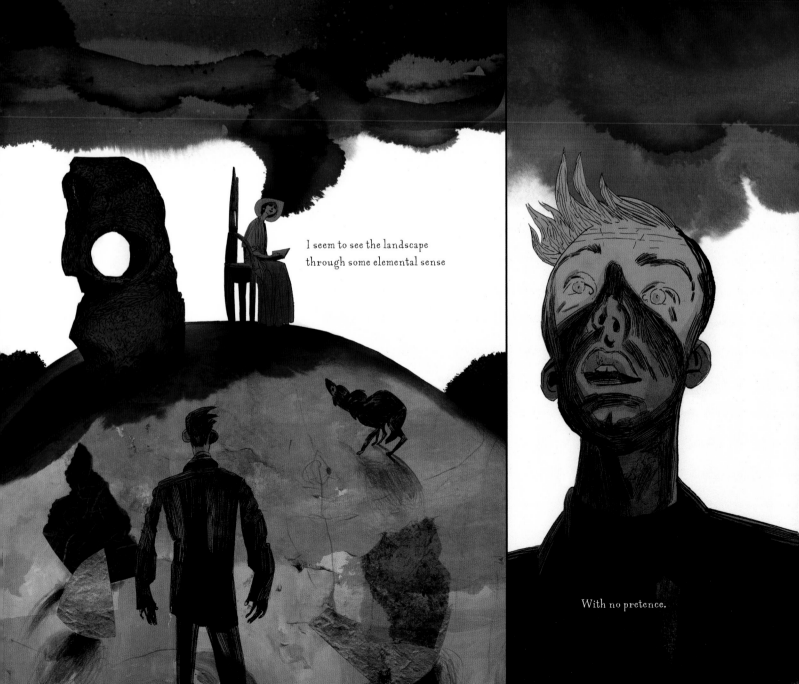

I seem to see the landscape
through some elemental sense

With no pretence.

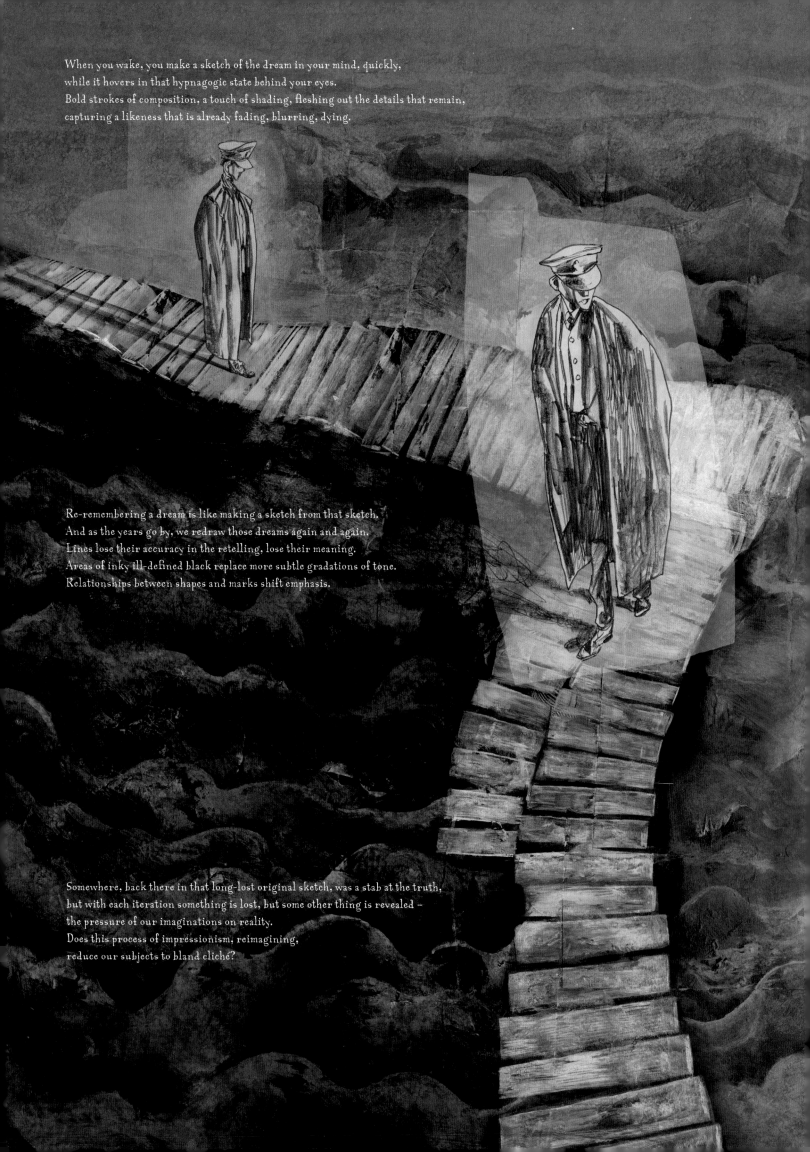

When you wake, you make a sketch of the dream in your mind, quickly,
while it hovers in that hypnagogic state behind your eyes.
Bold strokes of composition, a touch of shading, fleshing out the details that remain,
capturing a likeness that is already fading, blurring, dying.

Re-remembering a dream is like making a sketch from that sketch.
And as the years go by, we redraw those dreams again and again.
Lines lose their accuracy in the retelling, lose their meaning.
Areas of inky ill-defined black replace more subtle gradations of tone.
Relationships between shapes and marks shift emphasis.

Somewhere, back there in that long-lost original sketch, was a stab at the truth,
but with each iteration something is lost, but some other thing is revealed –
the pressure of our imaginations on reality.
Does this process of impressionism, reimagining,
reduce our subjects to bland cliché?

BLACK DOG

THE DREAMS OF PAUL NASH

Or are we panning for gold,
sieving out the unimportant details.
Focusing, narrowing the sharpness
of our gaze, finding those glints of
elemental truth within the noise?

That is the artist's balancing act.
It is so easy to fall off this narrow
pathway into the mud either side.

2

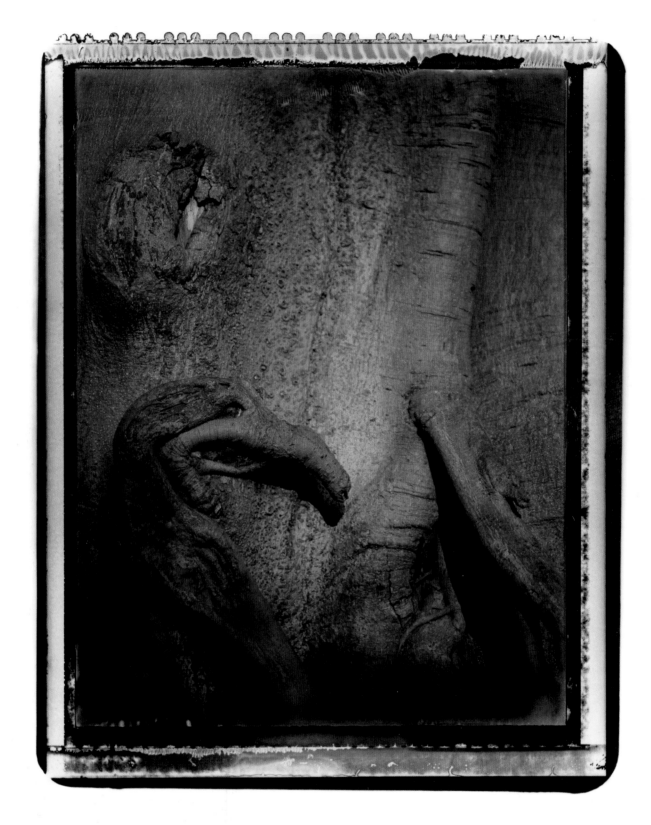

1905 - HAWK'S WOOD, IVER HEATH, BUCKINGHAMSHIRE
1913 - HIGHGATE CEMETERY, LONDON
WITH MARGARET THEODOSIA ODEH

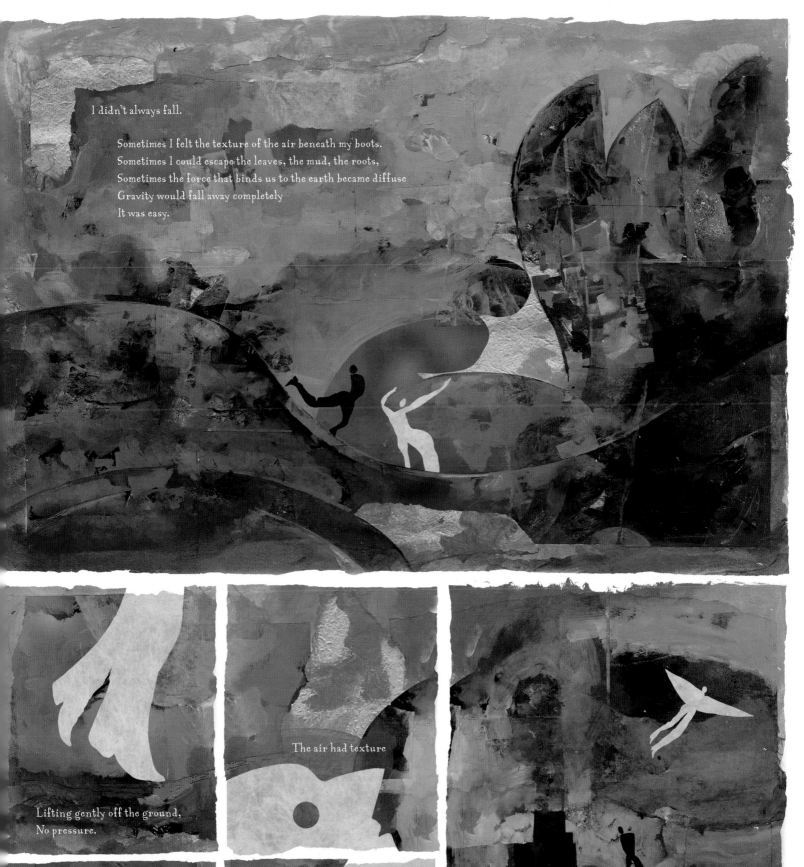

I didn't always fall.

Sometimes I felt the texture of the air beneath my boots.
Sometimes I could escape the leaves, the mud, the roots,
Sometimes the force that binds us to the earth became diffuse
Gravity would fall away completely
It was easy.

Lifting gently off the ground,
No pressure.

The air had texture

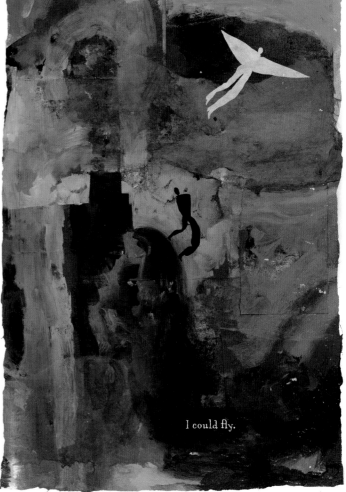

Like a diver pushing off the
bottom of the ocean.
Like a vague and hazy memory in
slow motion

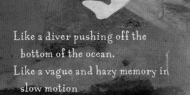

I could push against the
dark substantial sky

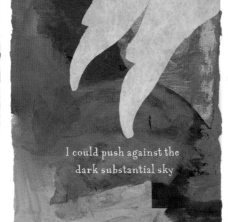

I could fly.

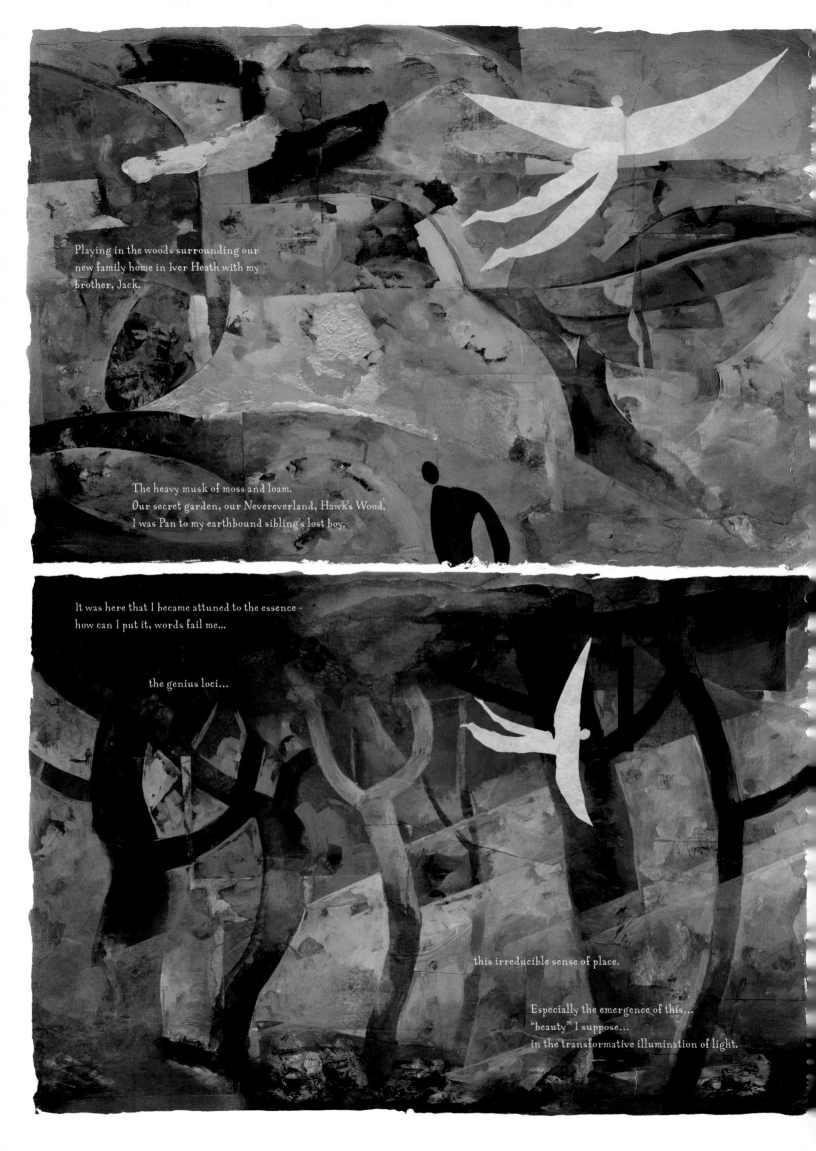

Playing in the woods surrounding our
new family home in Iver Heath with my
brother, Jack.

The heavy musk of moss and loam.
Our secret garden, our Nevereverland, Hawk's Wood.
I was Pan to my earthbound sibling's lost boy.

It was here that I became attuned to the essence –
how can I put it, words fail me...

the genius loci...

this irreducible sense of place.

Especially the emergence of this...
"beauty" I suppose...
in the transformative illumination of light.

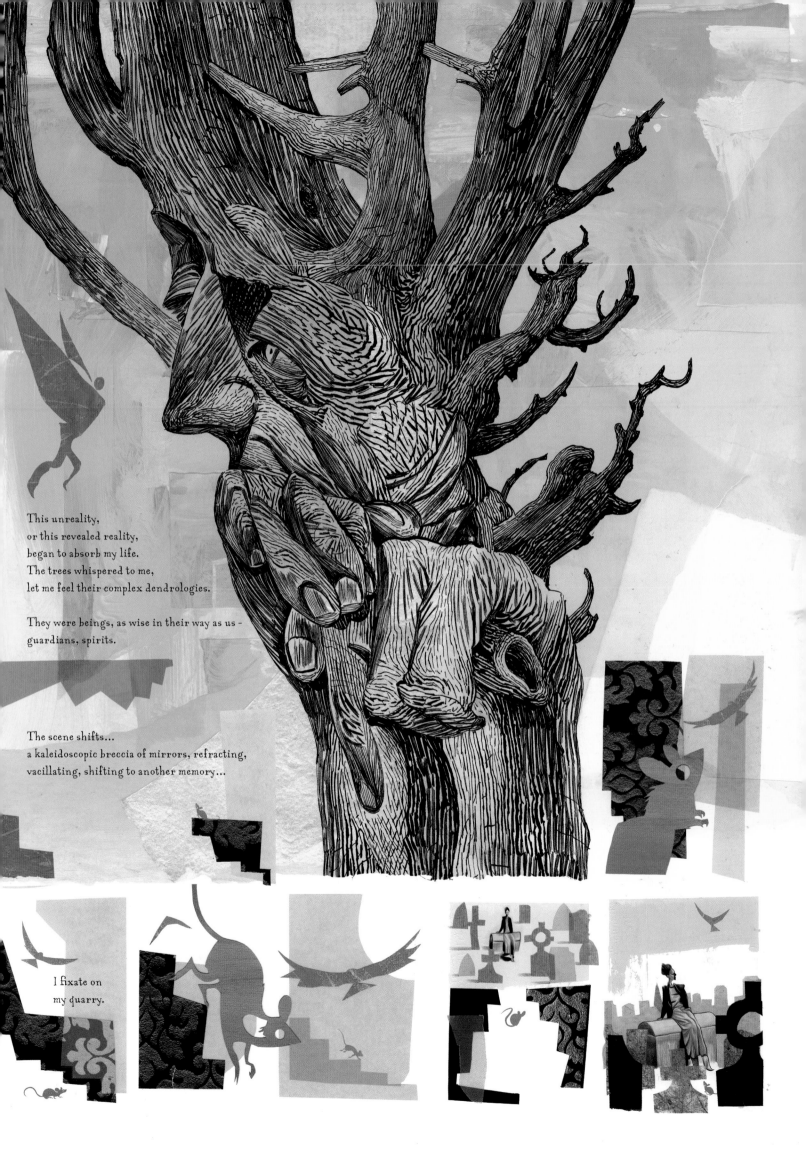

This unreality,
or this revealed reality,
began to absorb my life.
The trees whispered to me,
let me feel their complex dendrologies.

They were beings, as wise in their way as us –
guardians, spirits.

The scene shifts...
a kaleidoscopic breccia of mirrors, refracting,
vacillating, shifting to another memory...

I fixate on
my quarry.

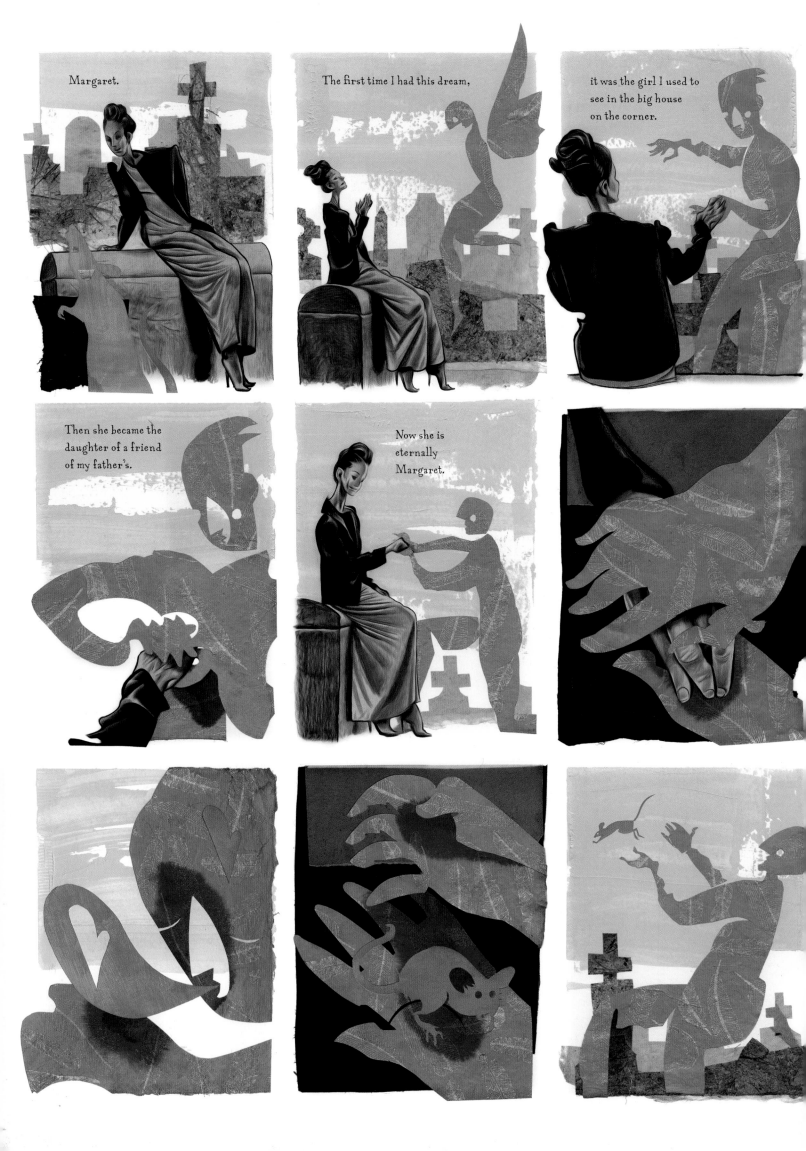

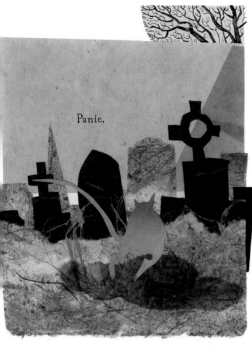

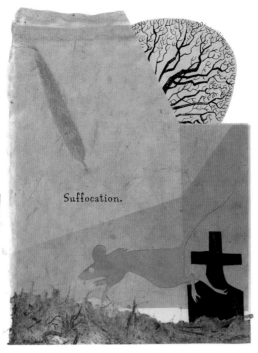

Panic.

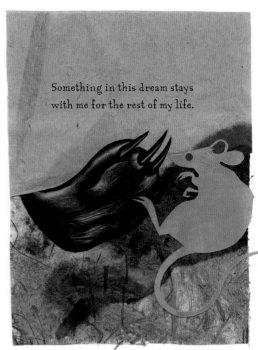

Suffocation.

Something in this dream stays
with me for the rest of my life.

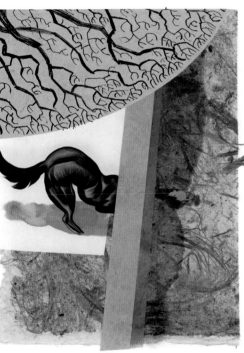

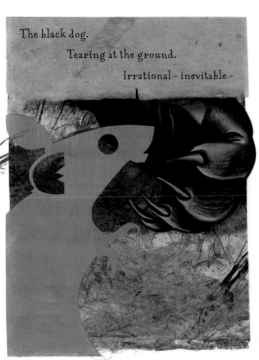

The black dog.

Tearing at the ground.

Irrational - inevitable -

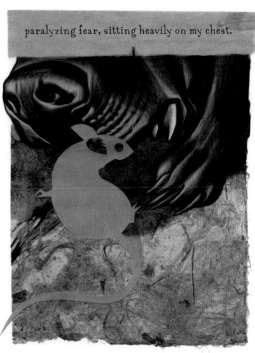

paralyzing fear, sitting heavily on my chest.

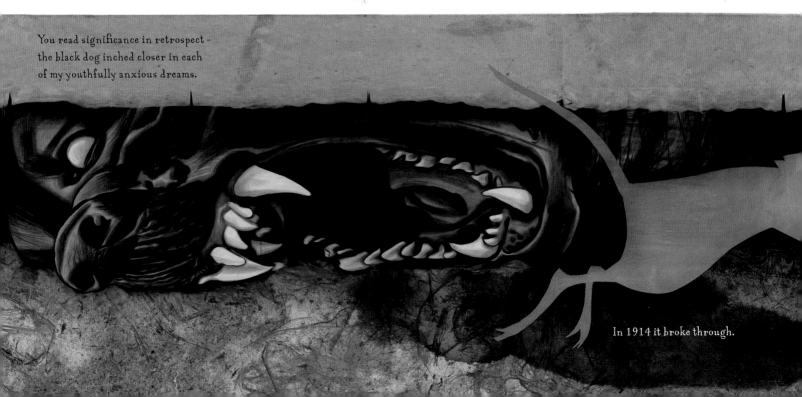

You read significance in retrospect -
the black dog inched closer in each
of my youthfully anxious dreams.

In 1914 it broke through.

3

1914 - Gordon Bottomley's House in Silverdale, the Lake District
1914 - Café Royal, London
with Gordon Craig, Christopher Nevinson, Mark Gertler,
Edward Wadsworth, Dora Carrington, and Roger Fry

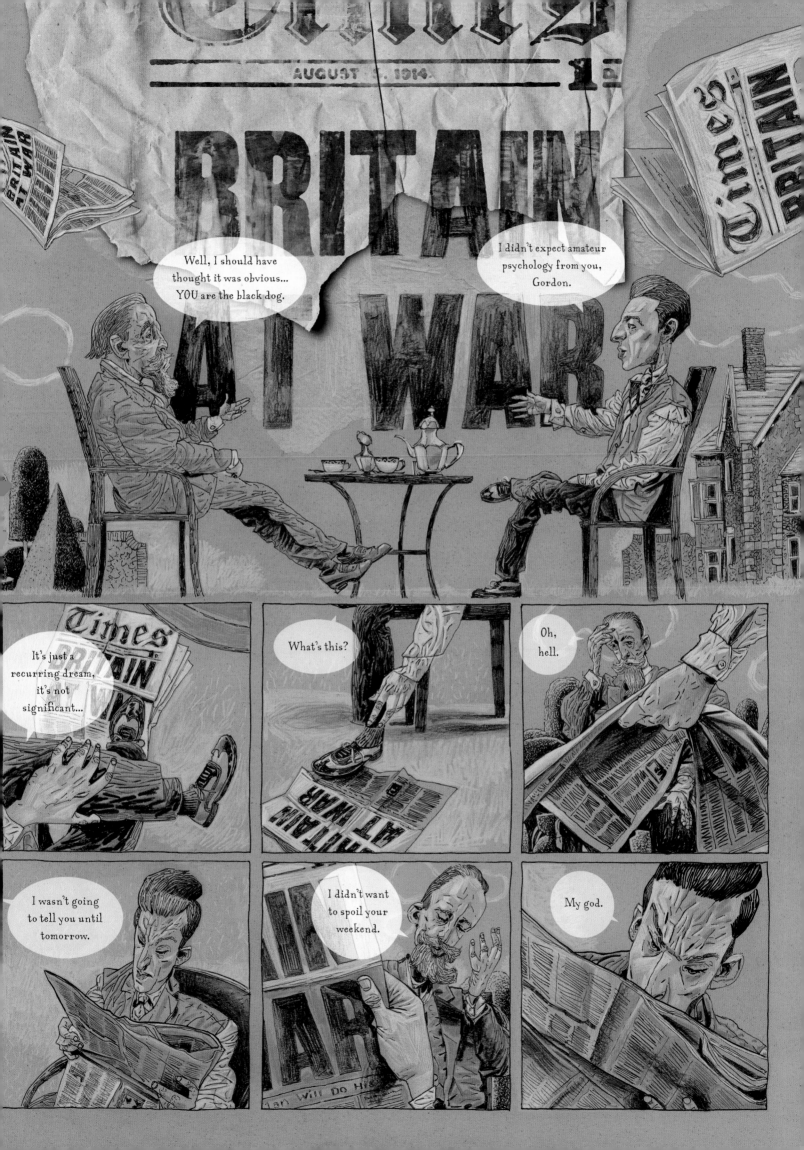

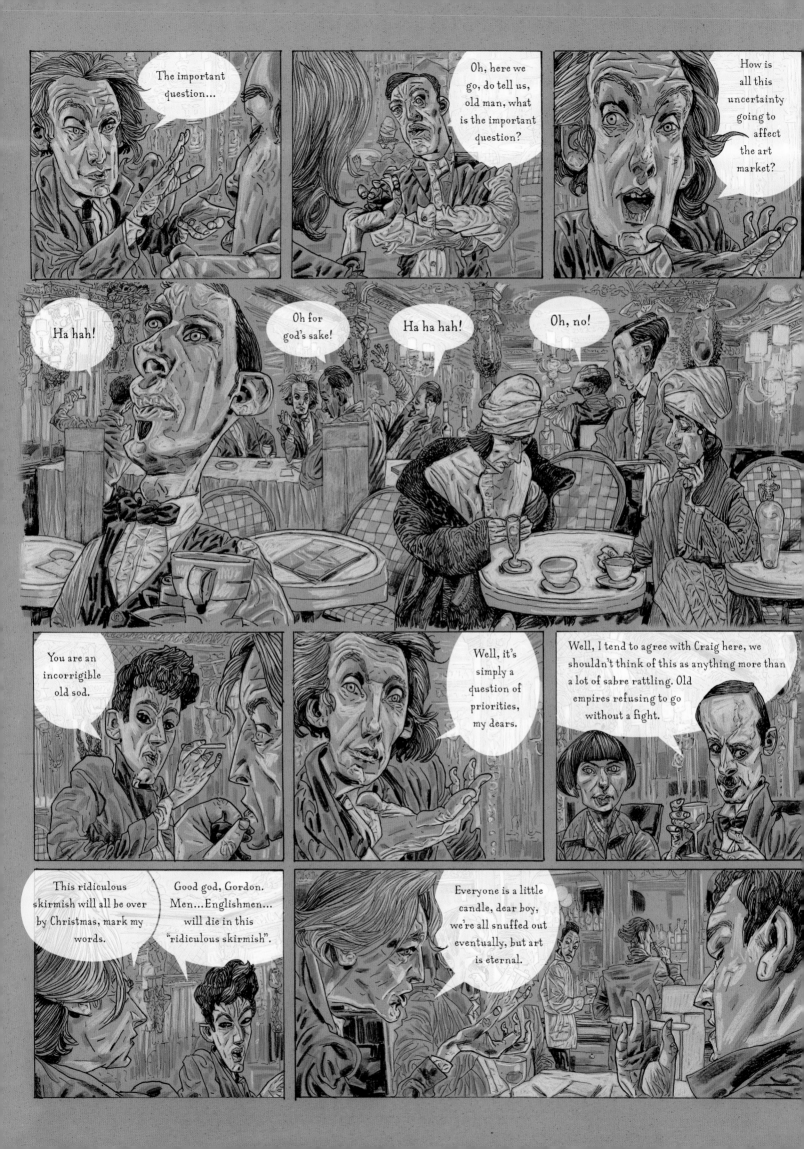

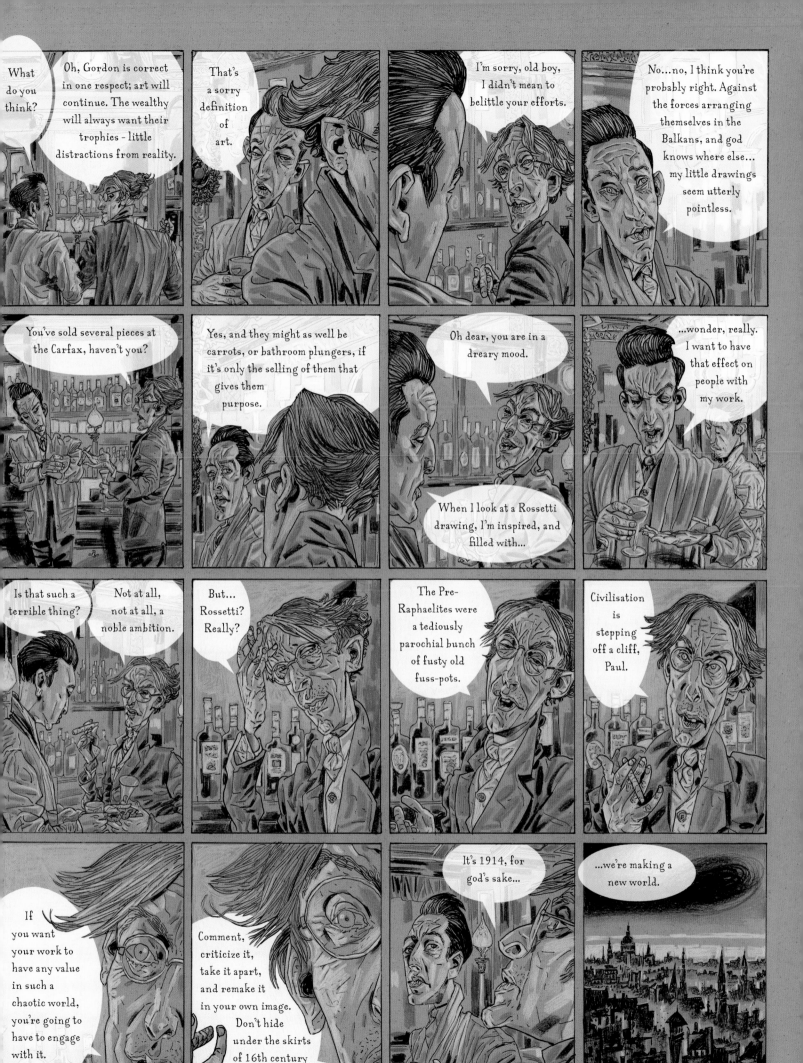

1914 - St. Martin-in-the-Fields Church, London

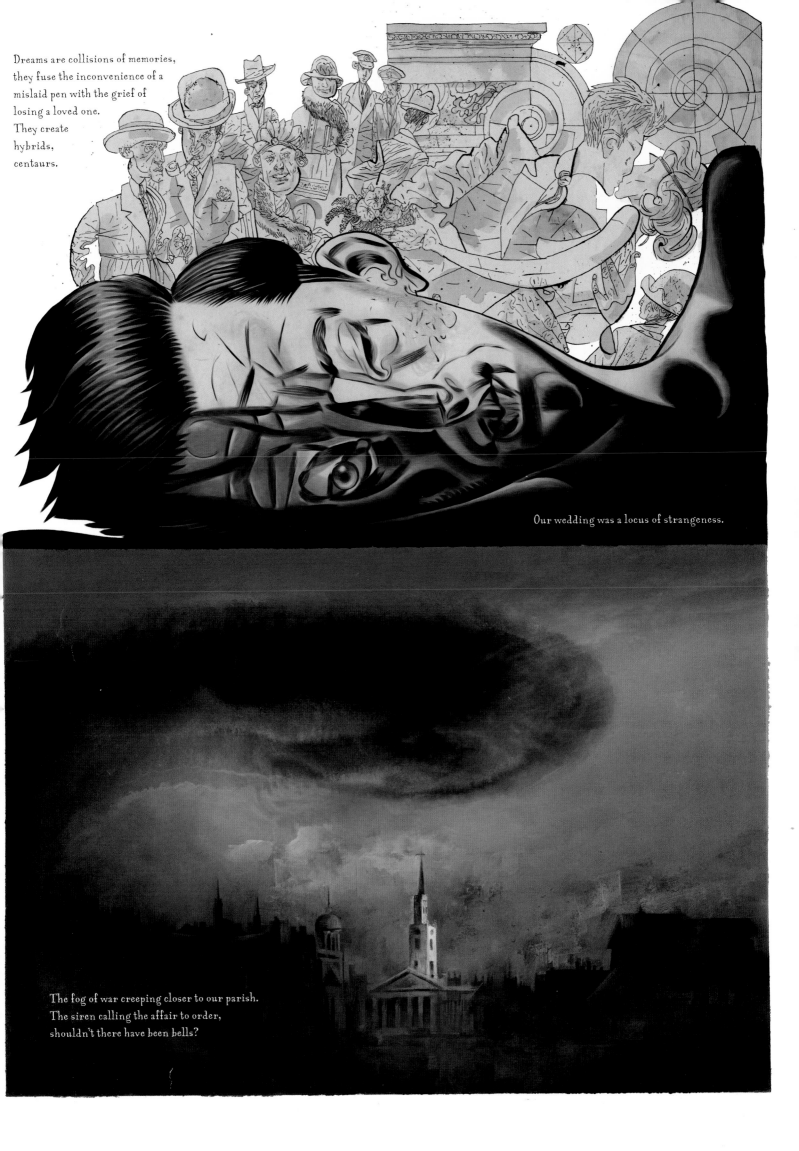

Dreams are collisions of memories,
they fuse the inconvenience of a
mislaid pen with the grief of
losing a loved one.
They create
hybrids,
centaurs.

Our wedding was a locus of strangeness.

The fog of war creeping closer to our parish.
The siren calling the affair to order,
shouldn't there have been bells?

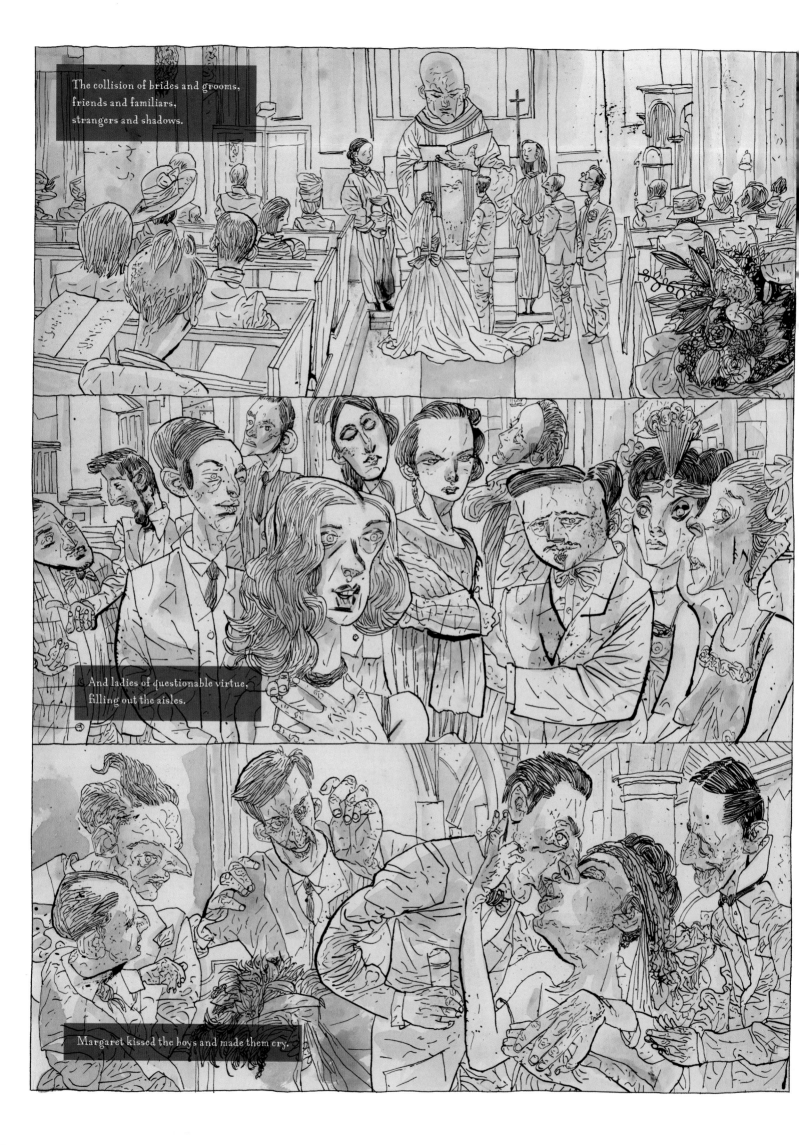

The collision of brides and grooms, friends and familiars, strangers and shadows.

And ladies of questionable virtue, filling out the aisles.

Margaret kissed the boys and made them cry.

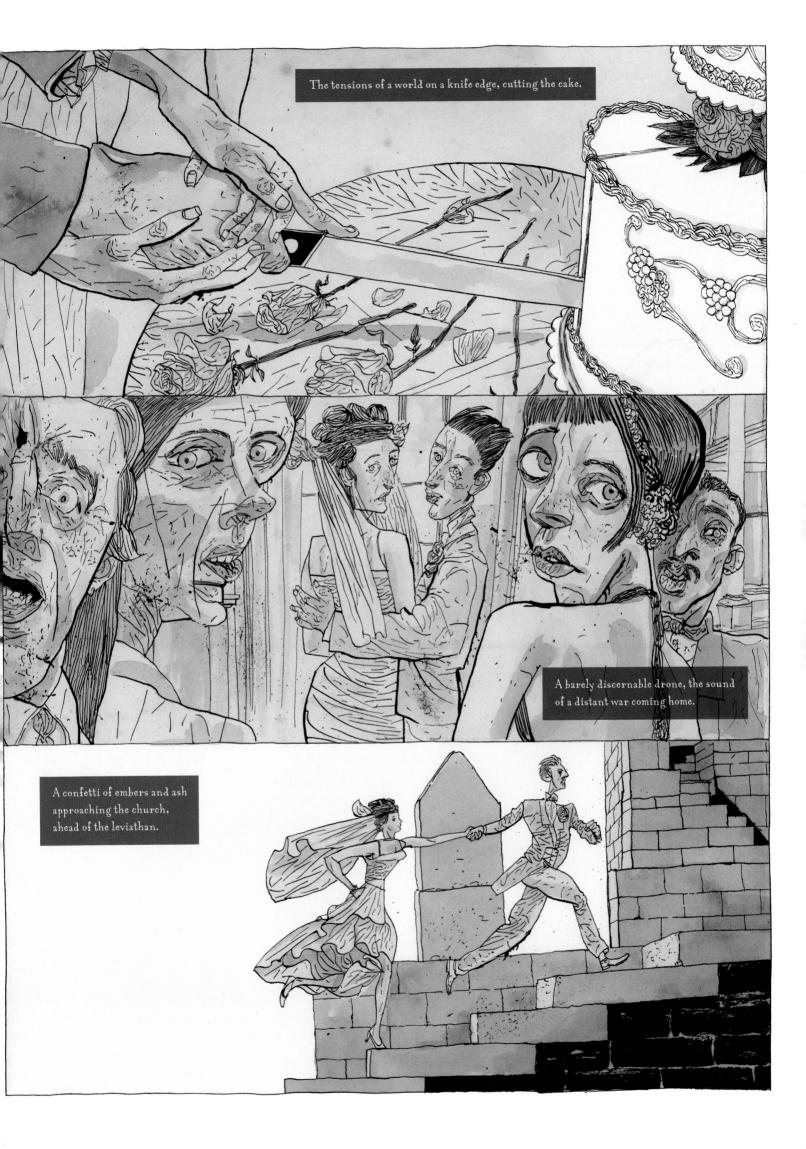

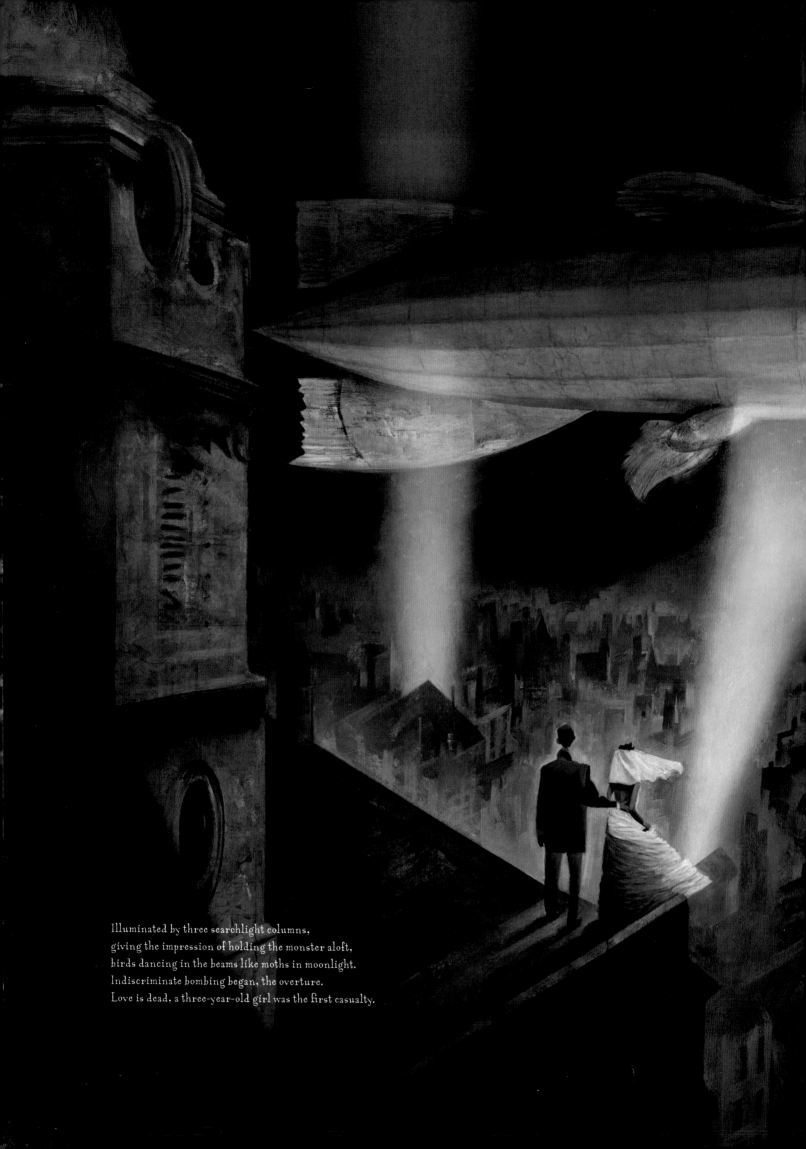

Illuminated by three searchlight columns,
giving the impression of holding the monster aloft,
birds dancing in the beams like moths in moonlight.
Indiscriminate bombing began, the overture.
Love is dead, a three-year-old girl was the first casualty.

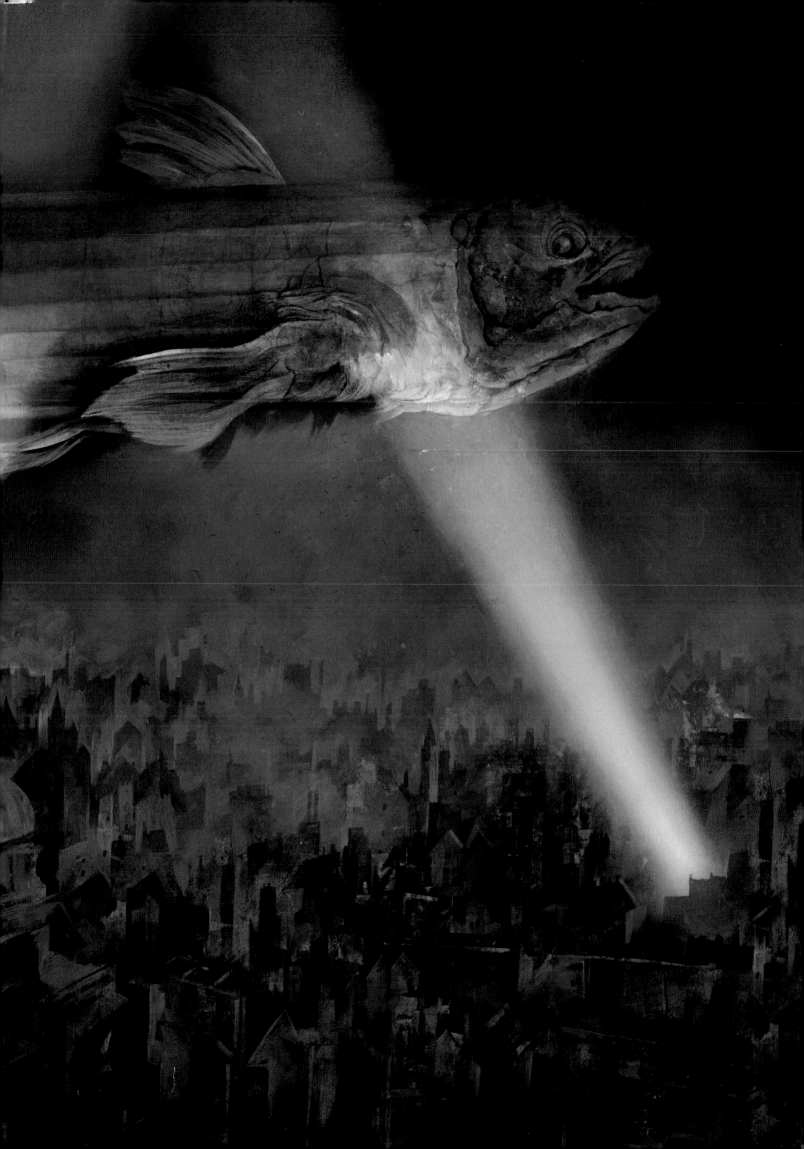

5

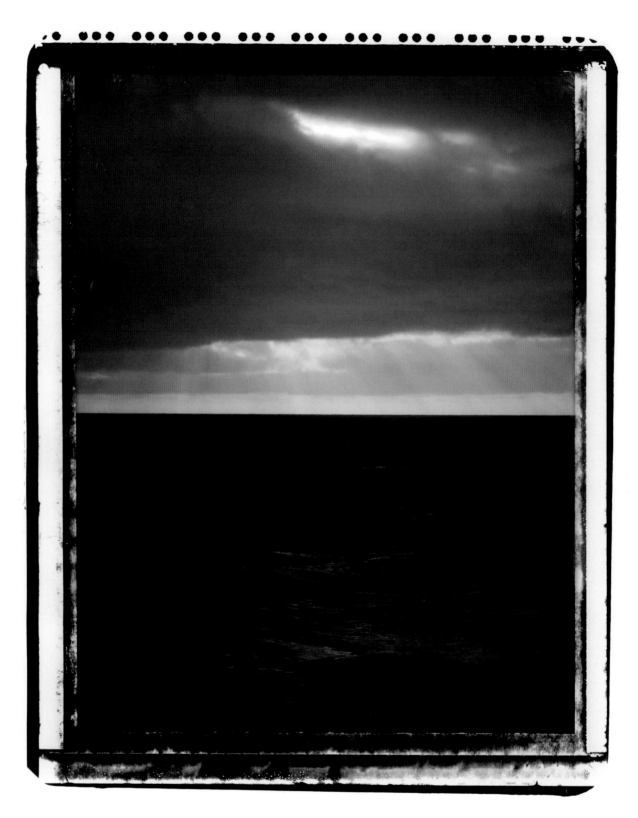

1905 - Iver Heath, Buckinghamshire

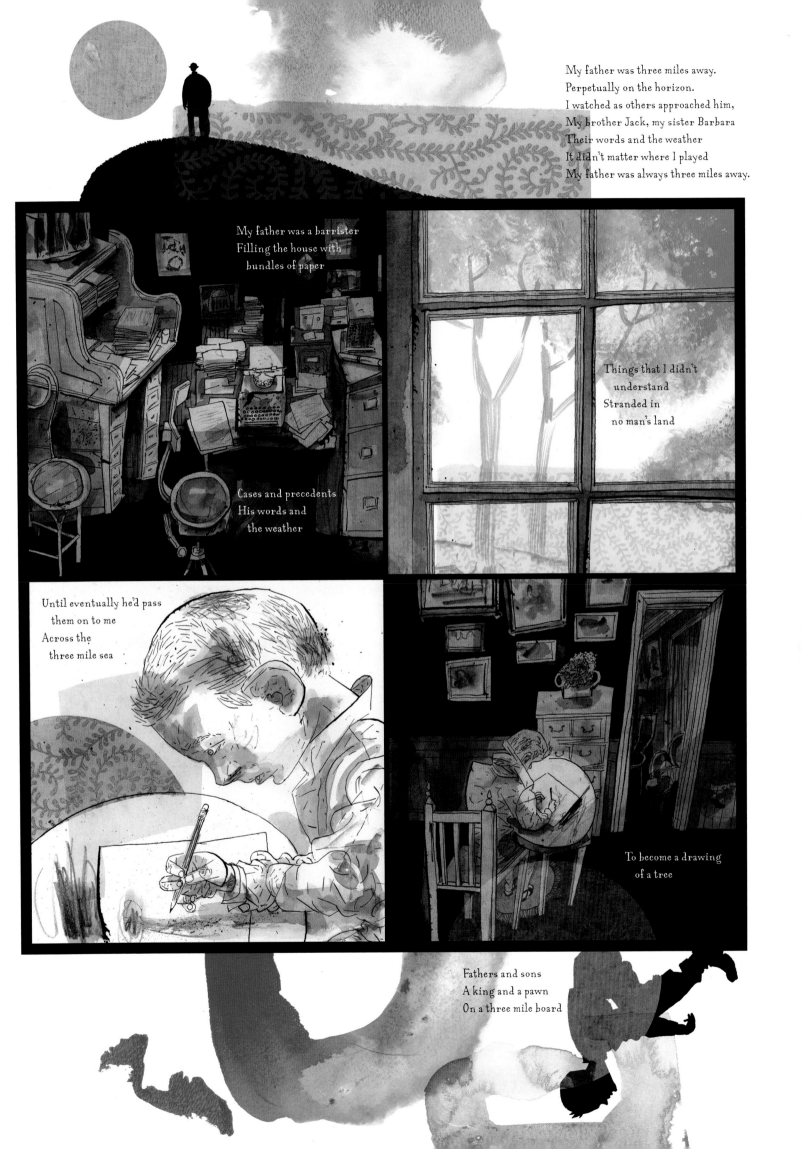

My father was three miles away.
Perpetually on the horizon.
I watched as others approached him,
My brother Jack, my sister Barbara
Their words and the weather
It didn't matter where I played
My father was always three miles away.

My father was a barrister
Filling the house with
bundles of paper

Cases and precedents
His words and
the weather

Things that I didn't
understand
Stranded in
no man's land

Until eventually he'd pass
them on to me
Across the
three mile sea

To become a drawing
of a tree

Fathers and sons
A king and a pawn
On a three mile board

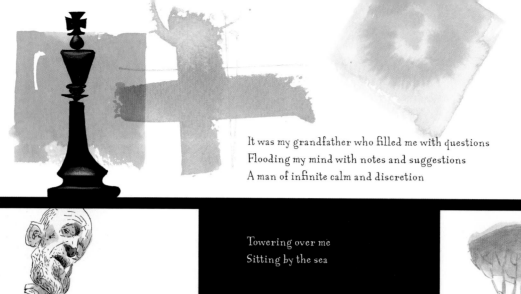

It was my grandfather who filled me with questions
Flooding my mind with notes and suggestions
A man of infinite calm and discretion

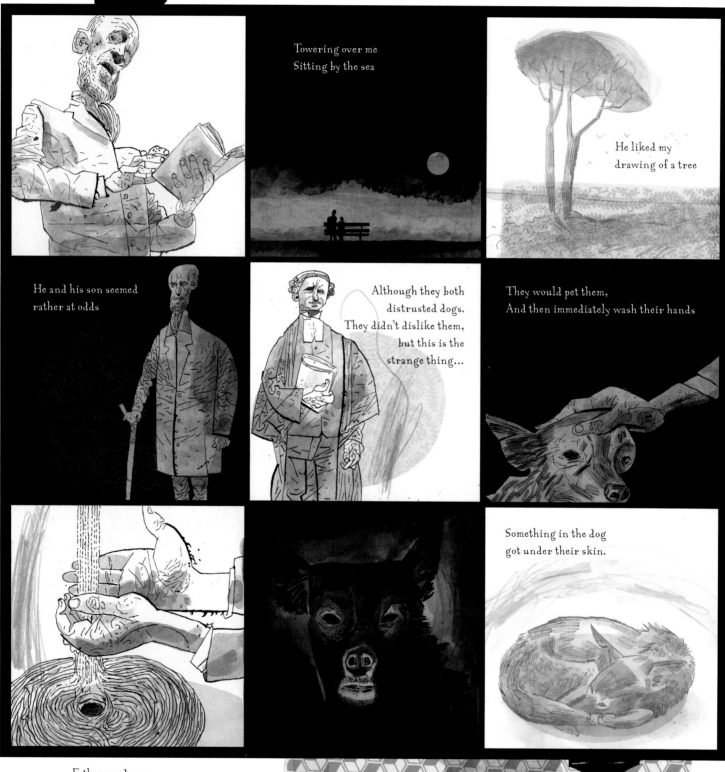

Towering over me
Sitting by the sea

He liked my
drawing of a tree

He and his son seemed
rather at odds

Although they both
distrusted dogs.
They didn't dislike them,
but this is the
strange thing...

They would pet them,
And then immediately wash their hands

Something in the dog
got under their skin.

Fathers and sons
A king and a pawn
On a three mile board
Manoeuvring around each other,
The king checking his position
As the pawn moves towards promotion
Hoping not to be seen
And neither of them comment on the
absence of the queen.

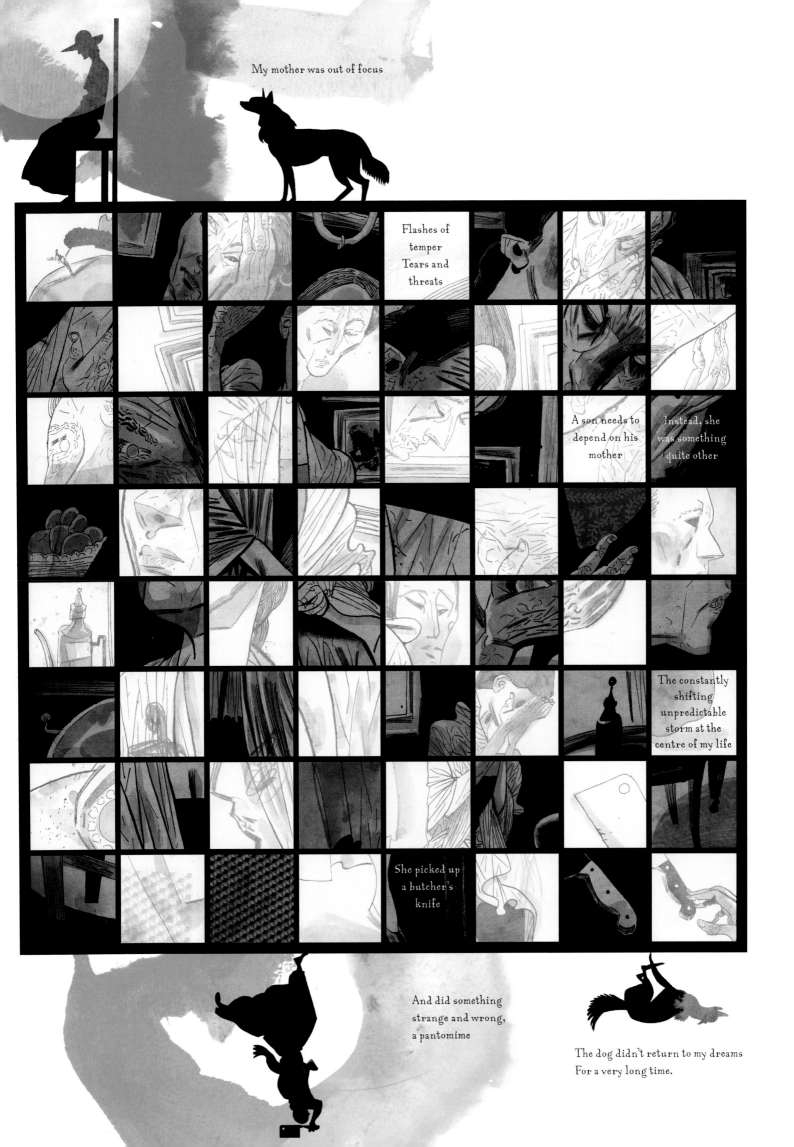

6

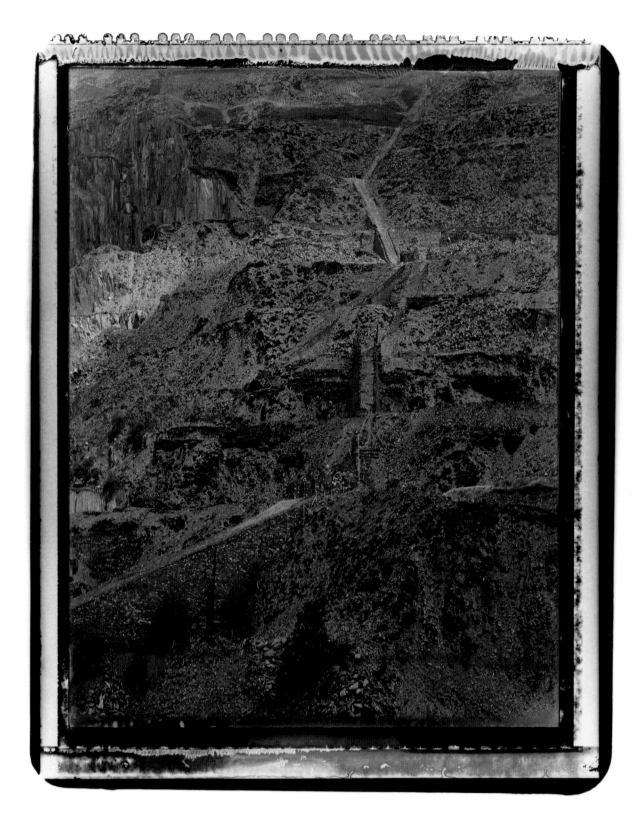

1917 - MILITARY HOSPITAL, GOSPORT

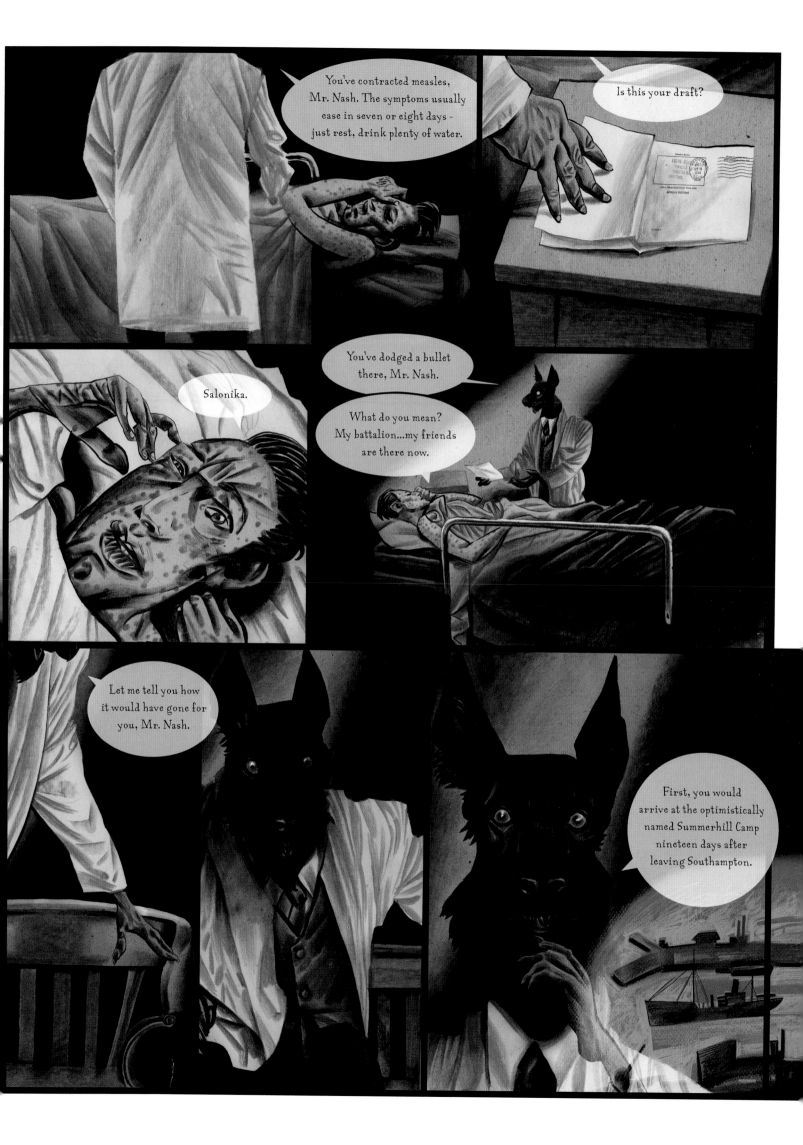

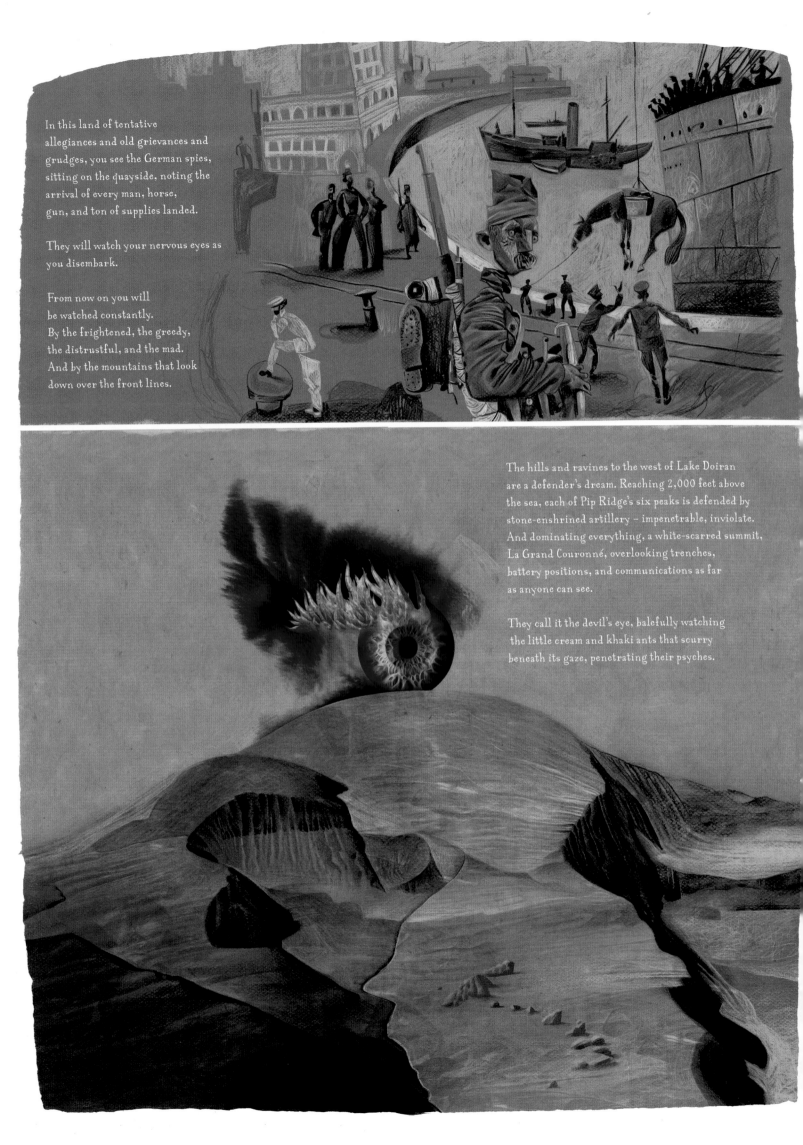

In this land of tentative
allegiances and old grievances and
grudges, you see the German spies,
sitting on the quayside, noting the
arrival of every man, horse,
gun, and ton of supplies landed.

They will watch your nervous eyes as
you disembark.

From now on you will
be watched constantly.
By the frightened, the greedy,
the distrustful, and the mad.
And by the mountains that look
down over the front lines.

The hills and ravines to the west of Lake Doiran
are a defender's dream. Reaching 2,000 feet above
the sea, each of Pip Ridge's six peaks is defended by
stone-enshrined artillery – impenetrable, inviolate.
And dominating everything, a white-scarred summit,
La Grand Couronné, overlooking trenches,
battery positions, and communications as far
as anyone can see.

They call it the devil's eye, balefully watching
the little cream and khaki ants that scurry
beneath its gaze, penetrating their psyches.

The camp is known as the Birdcage,
an almost forgotten Cinderella of a camp, out
of sight of the Western Front and out of mind,
surrounded by scrawny raptors and mad dogs,
packs of them – the officers play golf back to
back to keep them at bay.

From there you will transfer to the trenches,
stone-and-wire encampments. In the heat of
the day, the temperature can reach 114 degrees.
There are no sun helmets, they were deemed
unnecessary. With the sun comes the
mosquitos, and with insufficient nets and
quinine, maybe you will fall to malaria
before you've even fired a shot.

Malaria brings with it a wave of chronic
depression, in many ways the hardest
thing for a man to face in this place.
Some stare through it,
others shoot themselves.

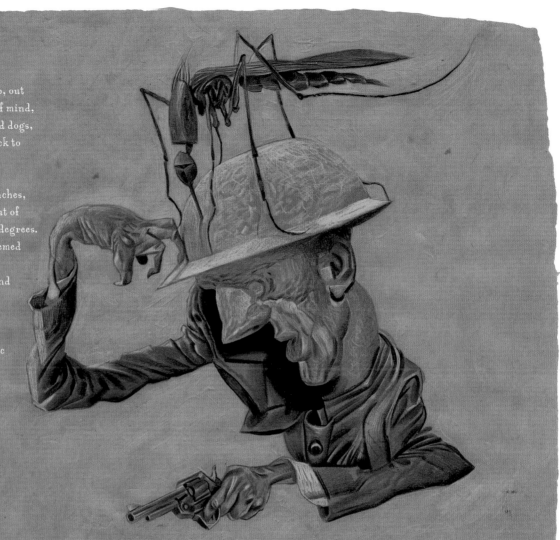

As the seasons turn, the temperature plummets
to -35 degrees. You may get frostbite, you may
get lost in the blinding sleet.

Before daybreak, the guns will abruptly cease,
and there will be an awful pause in which all
men on both sides are utterly alone with their
thoughts, bracing up to face the ordeal,
with fear or desperation, with cool courage
or with barely controlled nervous energy.

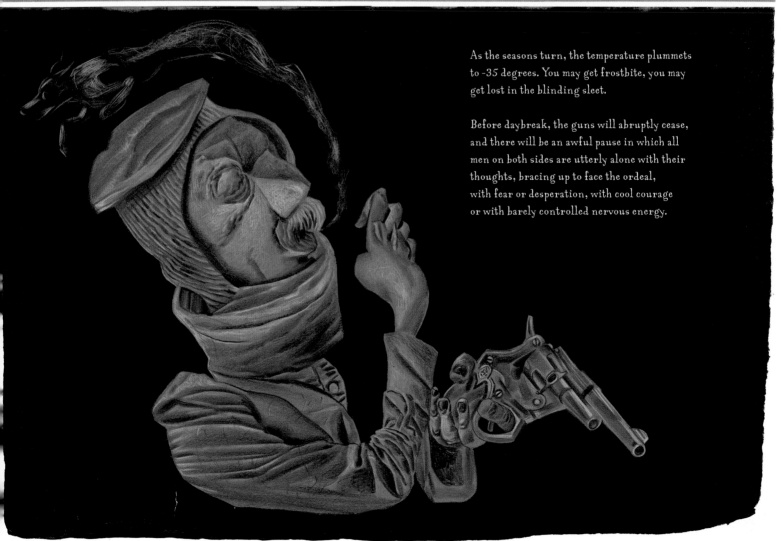

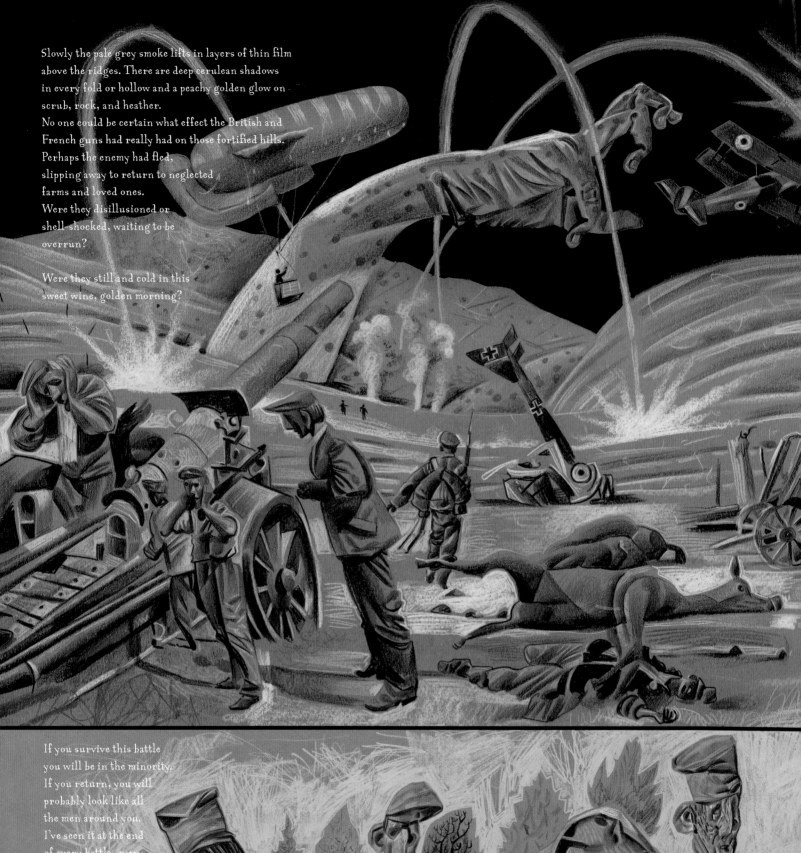

Slowly the pale grey smoke lifts in layers of thin film
above the ridges. There are deep cerulean shadows
in every fold or hollow and a peachy golden glow on
scrub, rock, and heather.
No one could be certain what effect the British and
French guns had really had on those fortified hills.
Perhaps the enemy had fled,
slipping away to return to neglected
farms and loved ones.
Were they disillusioned or
shell-shocked, waiting to be
overrun?

Were they still and cold in this
sweet wine, golden morning?

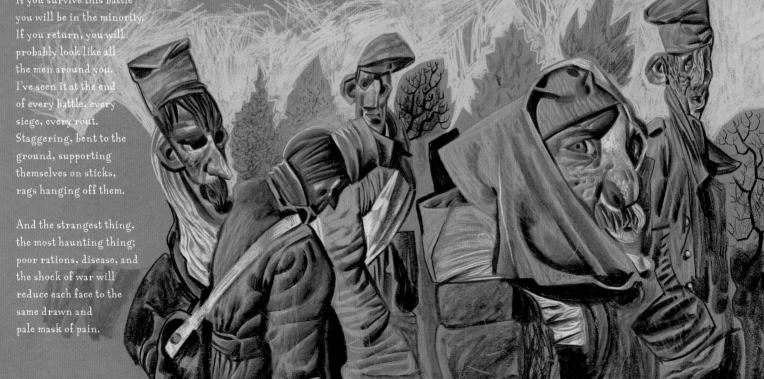

If you survive this battle
you will be in the minority.
If you return, you will
probably look like all
the men around you.
I've seen it at the end
of every battle, every
siege, every rout.
Staggering, bent to the
ground, supporting
themselves on sticks,
rags hanging off them.

And the strangest thing,
the most haunting thing;
poor rations, disease, and
the shock of war will
reduce each face to the
same drawn and
pale mask of pain.

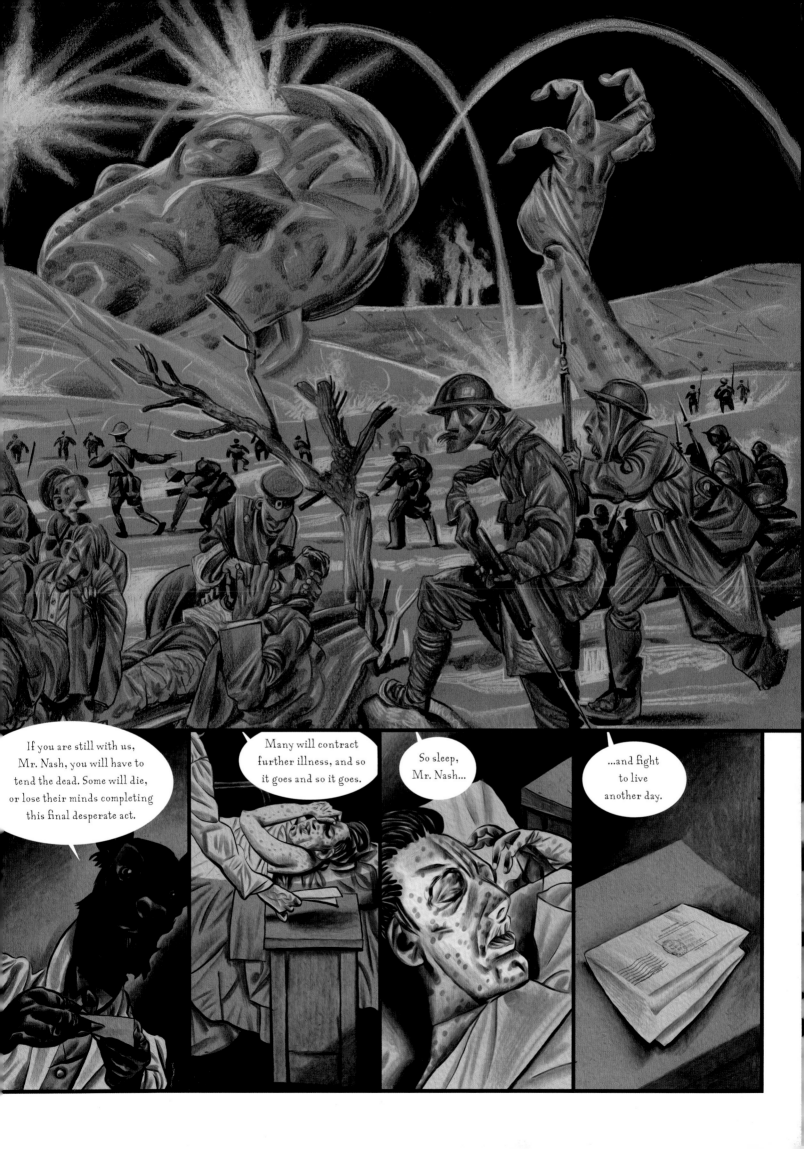

7

1906 - THE PLANES PREPARATORY SCHOOL,
GREENWICH, LONDON

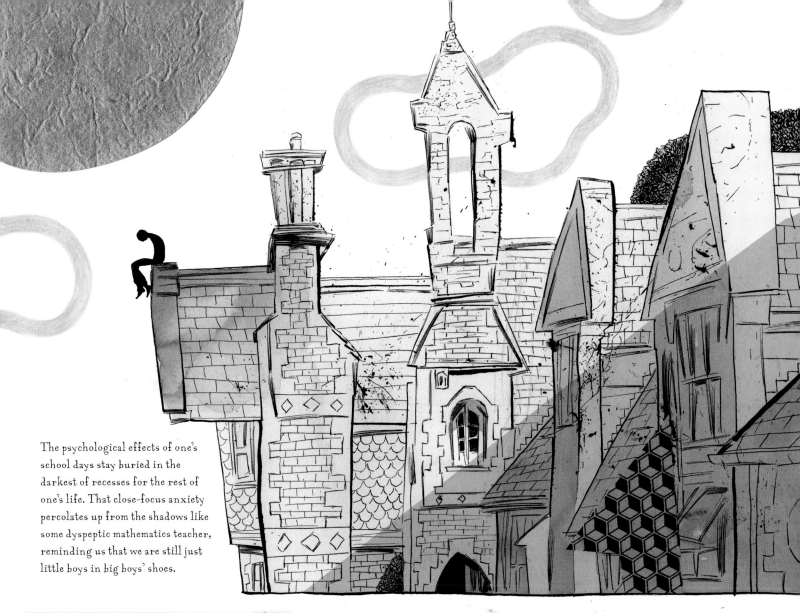

The psychological effects of one's school days stay buried in the darkest of recesses for the rest of one's life. That close-focus anxiety percolates up from the shadows like some dyspeptic mathematics teacher, reminding us that we are still just little boys in big boys' shoes.

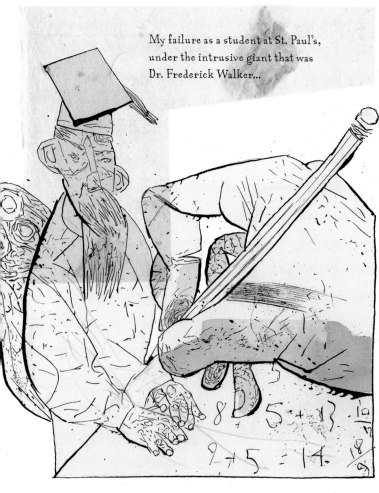

My failure as a student at St. Paul's, under the intrusive giant that was Dr. Frederick Walker...

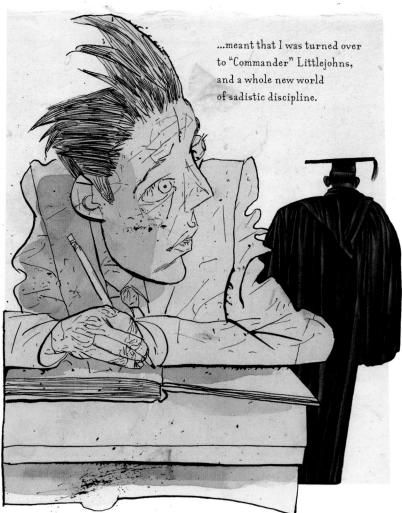

...meant that I was turned over to "Commander" Littlejohns, and a whole new world of sadistic discipline.

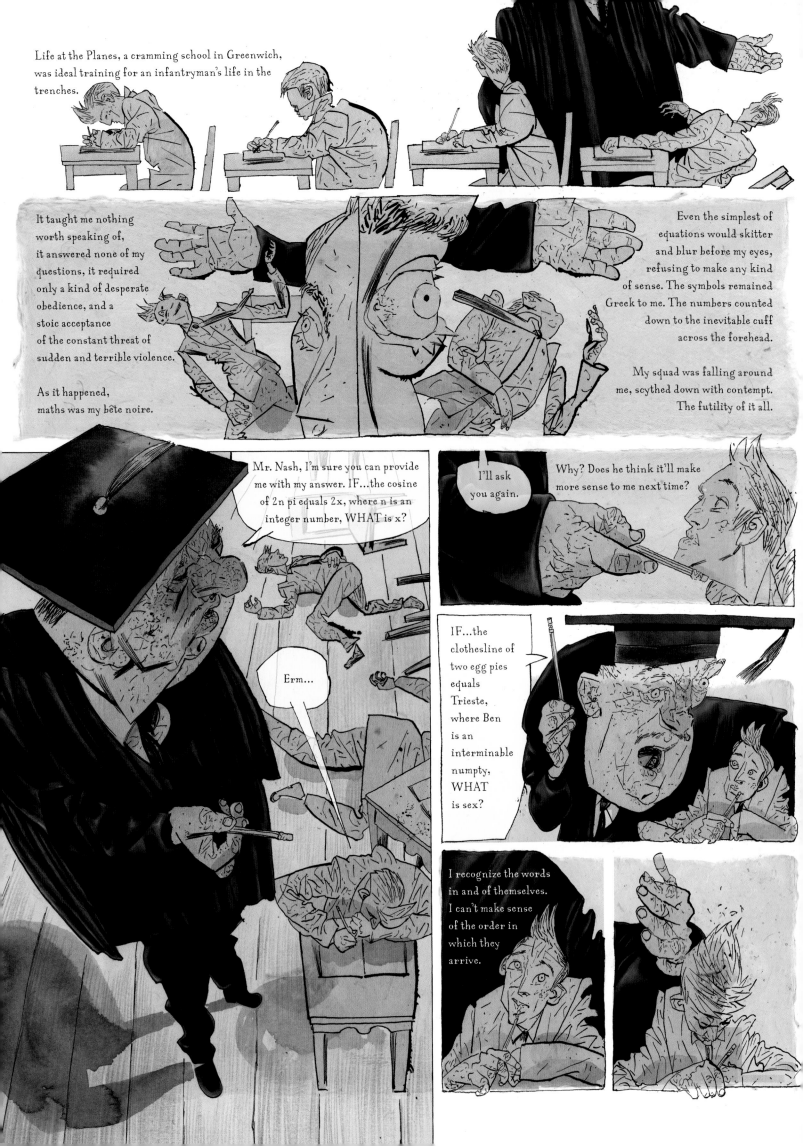

Life at the Planes, a cramming school in Greenwich, was ideal training for an infantryman's life in the trenches.

It taught me nothing worth speaking of, it answered none of my questions, it required only a kind of desperate obedience, and a stoic acceptance of the constant threat of sudden and terrible violence.

As it happened, maths was my bête noire.

Even the simplest of equations would skitter and blur before my eyes, refusing to make any kind of sense. The symbols remained Greek to me. The numbers counted down to the inevitable cuff across the forehead.

My squad was falling around me, scythed down with contempt. The futility of it all.

Mr. Nash, I'm sure you can provide me with my answer. IF...the cosine of 2n pi equals 2x, where n is an integer number, WHAT is x?

Erm...

I'll ask you again.

Why? Does he think it'll make more sense to me next time?

IF...the clothesline of two egg pies equals Trieste, where Ben is an interminable numpty, WHAT is sex?

I recognize the words in and of themselves. I can't make sense of the order in which they arrive.

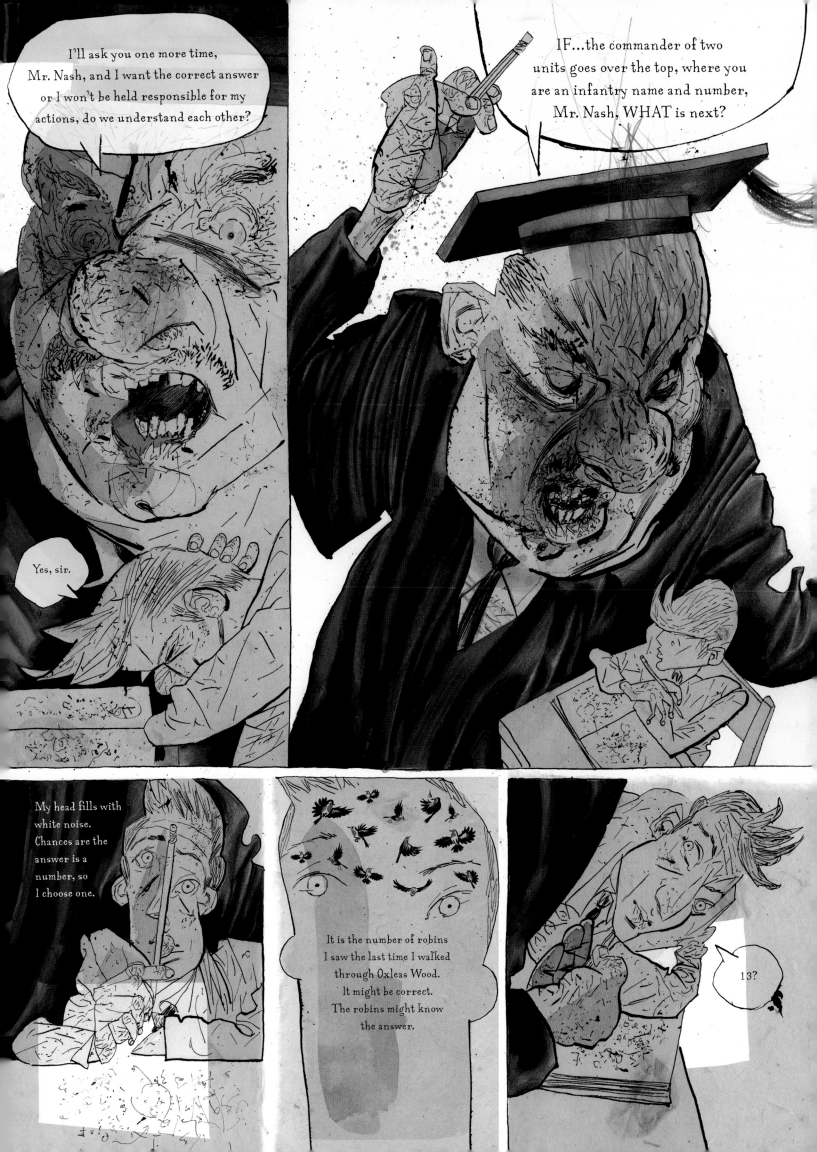

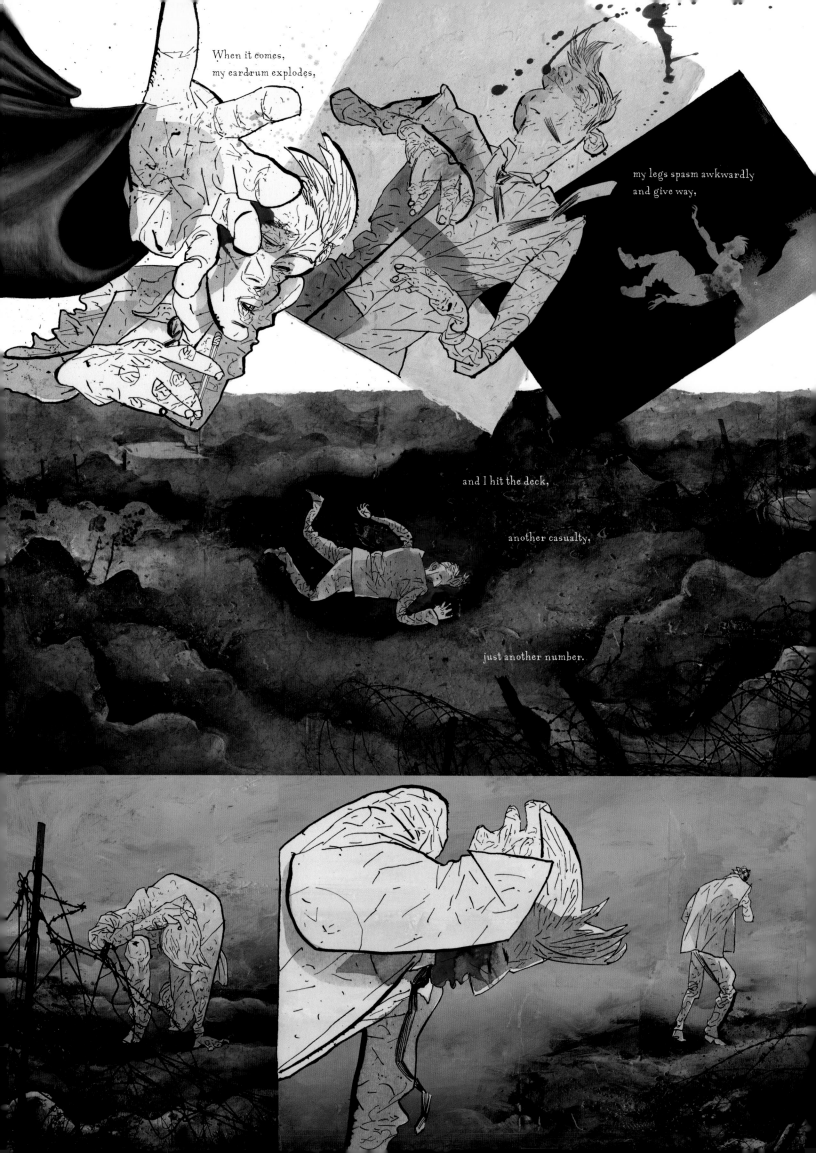

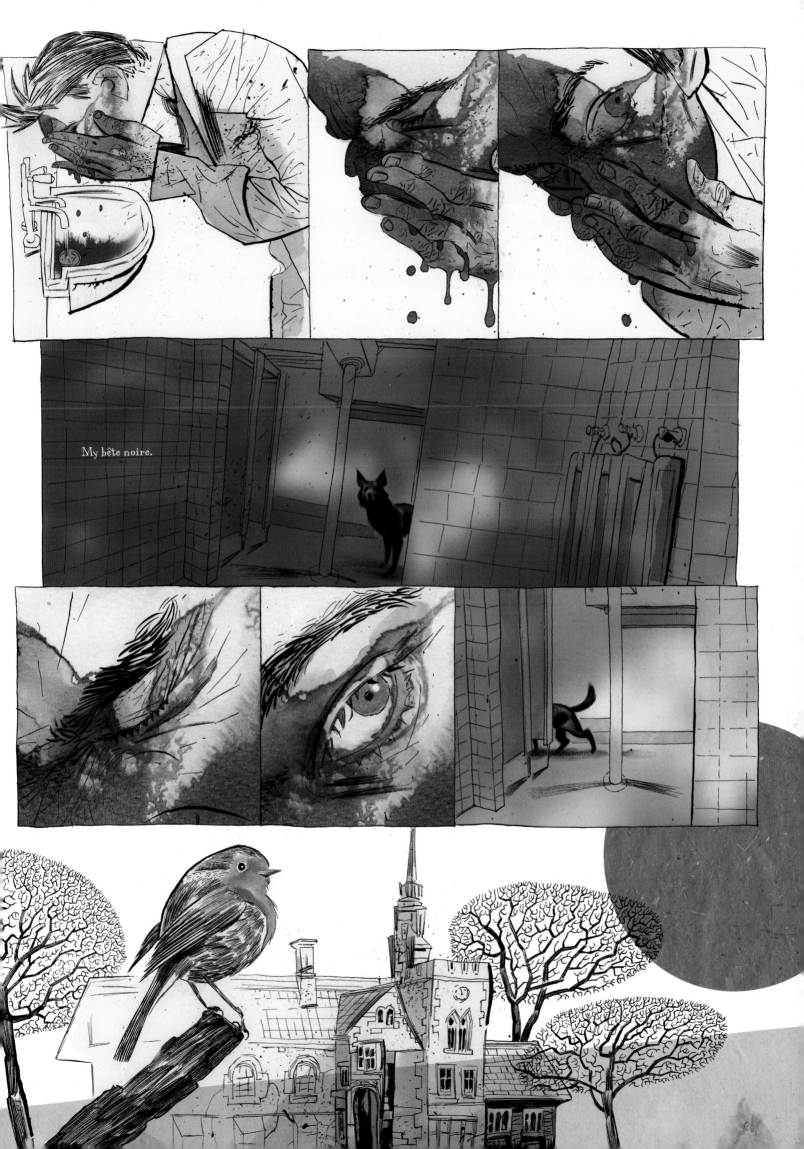

My bête noire.

8

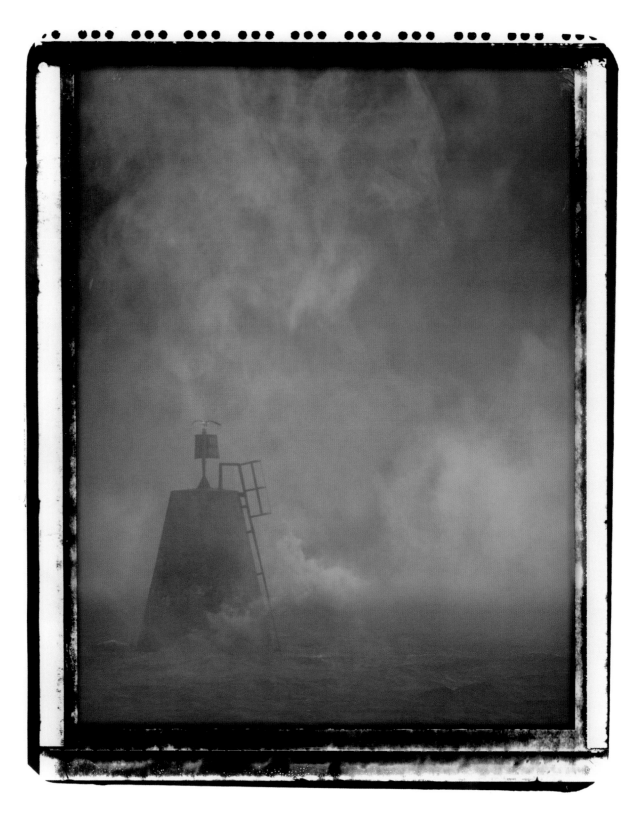

1917 – SOUTHAMPTON DOCKS, THE ENGLISH CHANNEL

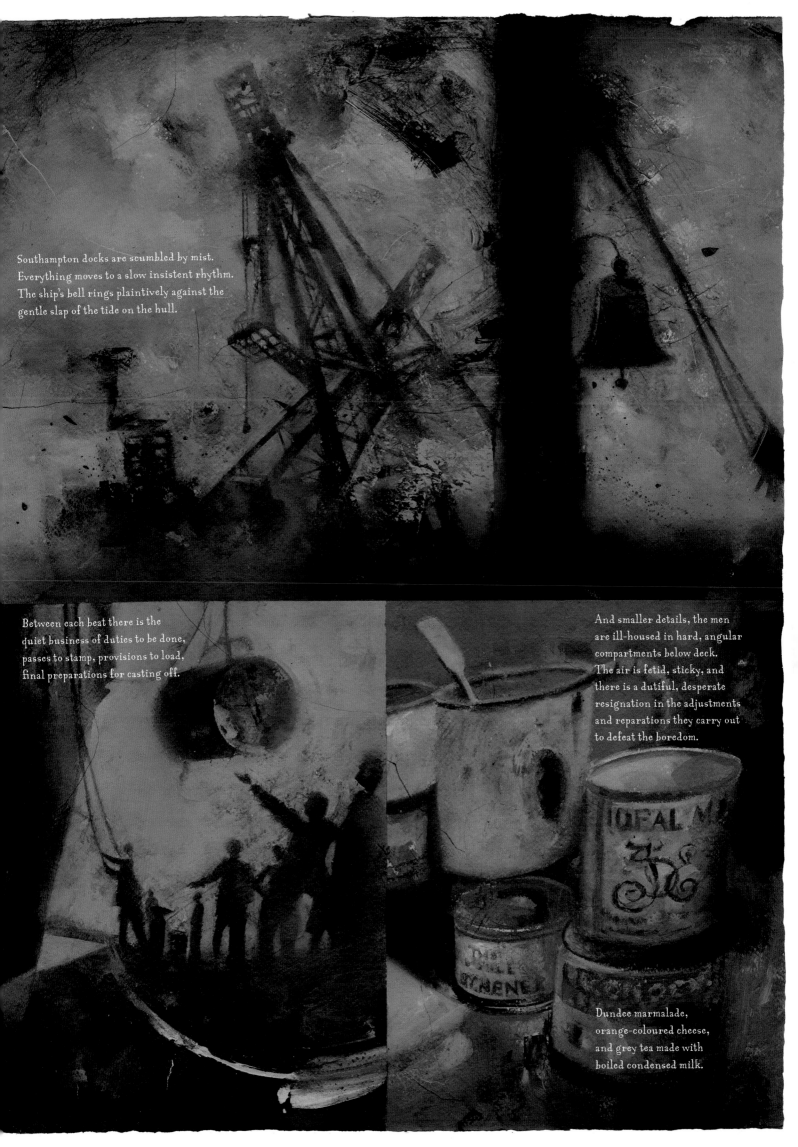

Southampton docks are scumbled by mist. Everything moves to a slow insistent rhythm. The ship's bell rings plaintively against the gentle slap of the tide on the hull.

Between each beat there is the quiet business of duties to be done, passes to stamp, provisions to load, final preparations for casting off.

And smaller details, the men are ill-housed in hard, angular compartments below deck. The air is fetid, sticky, and there is a dutiful, desperate resignation in the adjustments and reparations they carry out to defeat the boredom.

Dundee marmalade, orange-coloured cheese, and grey tea made with boiled condensed milk.

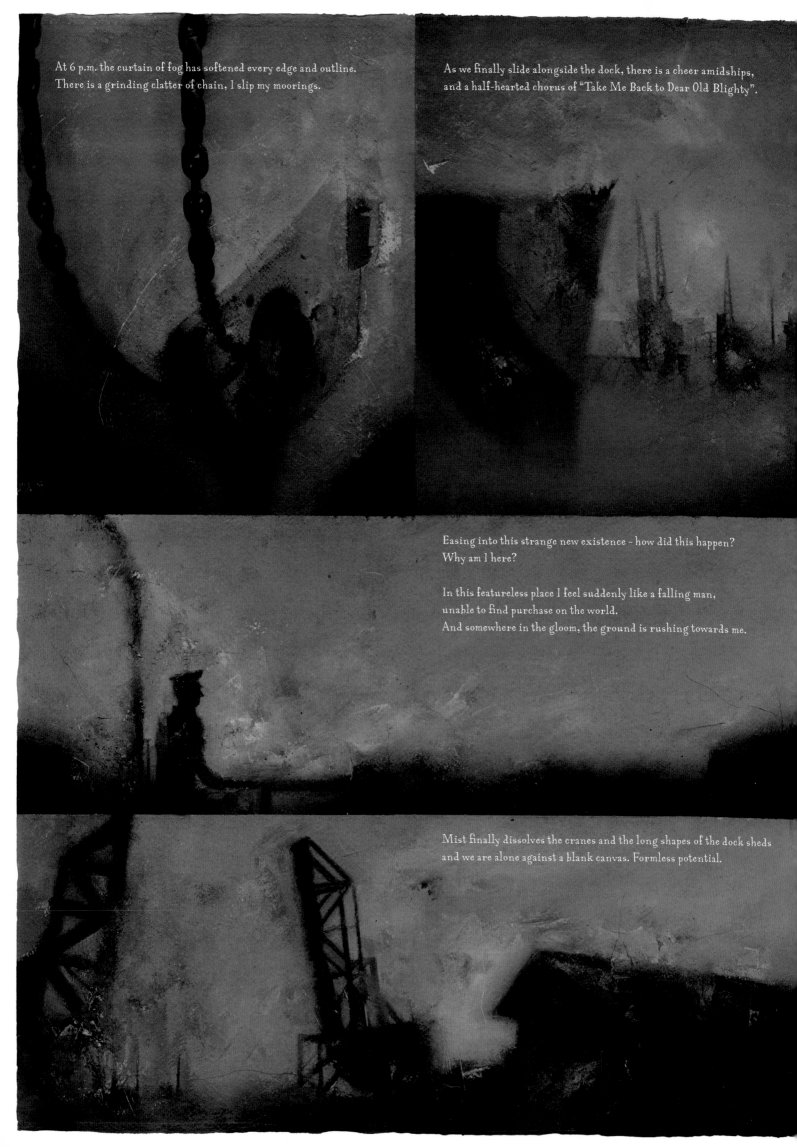

At 6 p.m. the curtain of fog has softened every edge and outline.
There is a grinding clatter of chain, I slip my moorings.

As we finally slide alongside the dock, there is a cheer amidships,
and a half-hearted chorus of "Take Me Back to Dear Old Blighty".

Easing into this strange new existence - how did this happen?
Why am I here?

In this featureless place I feel suddenly like a falling man,
unable to find purchase on the world.
And somewhere in the gloom, the ground is rushing towards me.

Mist finally dissolves the cranes and the long shapes of the dock sheds
and we are alone against a blank canvas. Formless potential.

The ship, blacker than anything, pushes on.
The sea - yellow black, inscrutable.

I take my turn of duty on deck,
a curious game of blind man's bluff –

"Sentry!
Orderly officer!"

"What are
your duties?"

"Keep this 'ere
passage clear."

"Has anyone
found the bread
and butter?"

"No, sir!"

"Tinned jam and
bully beef, then?"

"Sir!"

"And why
are we here,
Corporal?"

"Very good,
carry on."

"We're here because
we're here, sir!"

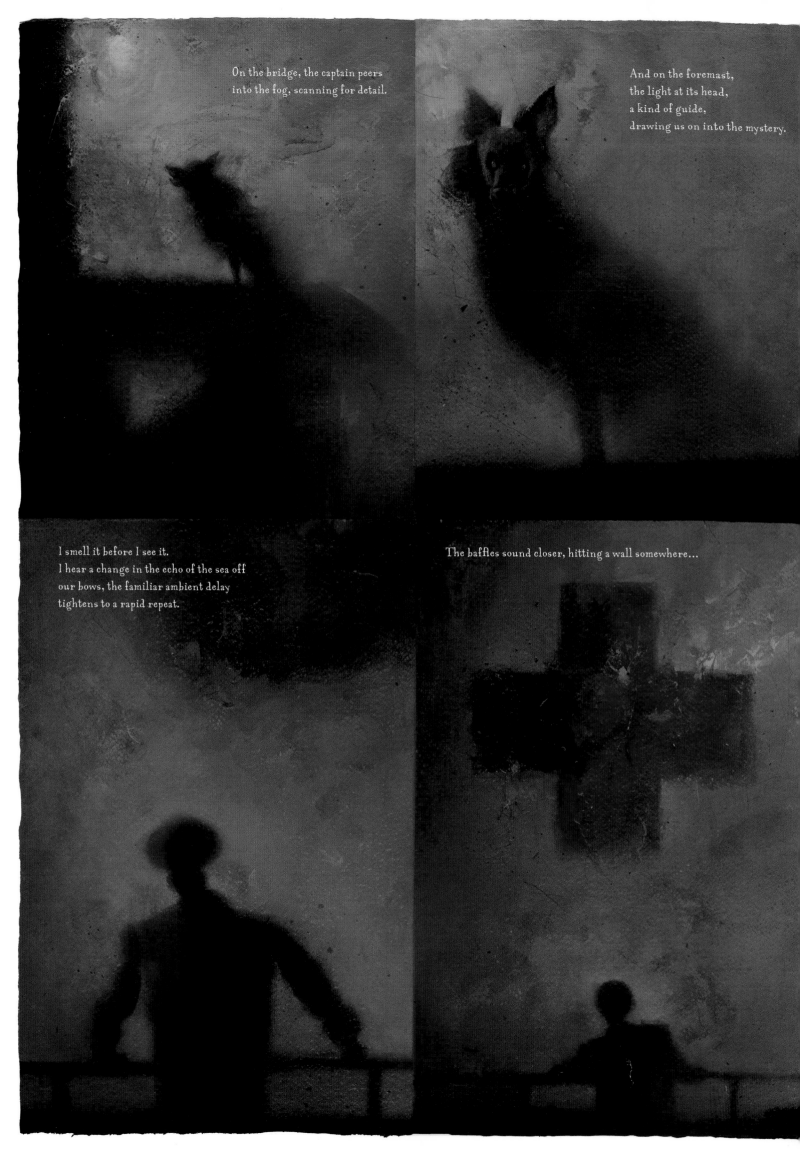

On the bridge, the captain peers
into the fog, scanning for detail.

And on the foremast,
the light at its head,
a kind of guide,
drawing us on into the mystery.

I smell it before I see it.
I hear a change in the echo of the sea off
our bows, the familiar ambient delay
tightens to a rapid repeat.

The baffles sound closer, hitting a wall somewhere…

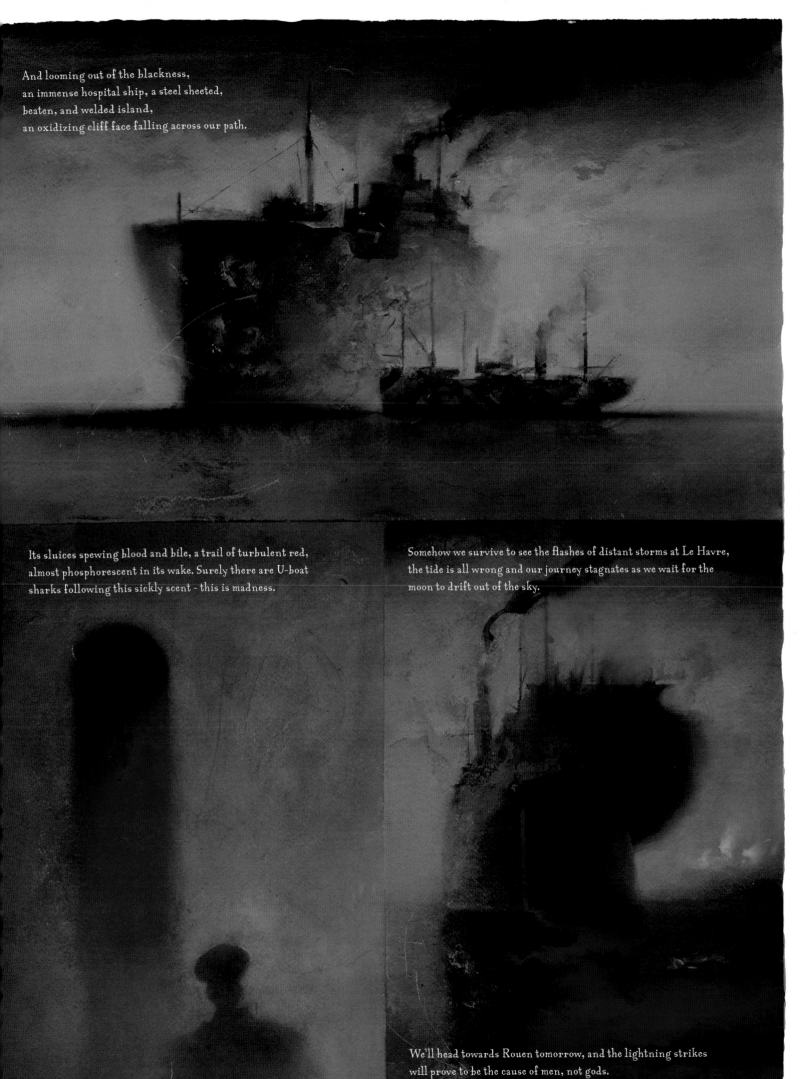

And looming out of the blackness,
an immense hospital ship, a steel sheeted,
beaten, and welded island,
an oxidizing cliff face falling across our path.

Its sluices spewing blood and bile, a trail of turbulent red,
almost phosphorescent in its wake. Surely there are U-boat
sharks following this sickly scent - this is madness.

Somehow we survive to see the flashes of distant storms at Le Havre,
the tide is all wrong and our journey stagnates as we wait for the
moon to drift out of the sky.

We'll head towards Rouen tomorrow, and the lightning strikes
will prove to be the cause of men, not gods.

9

1917 - Ypres Salient

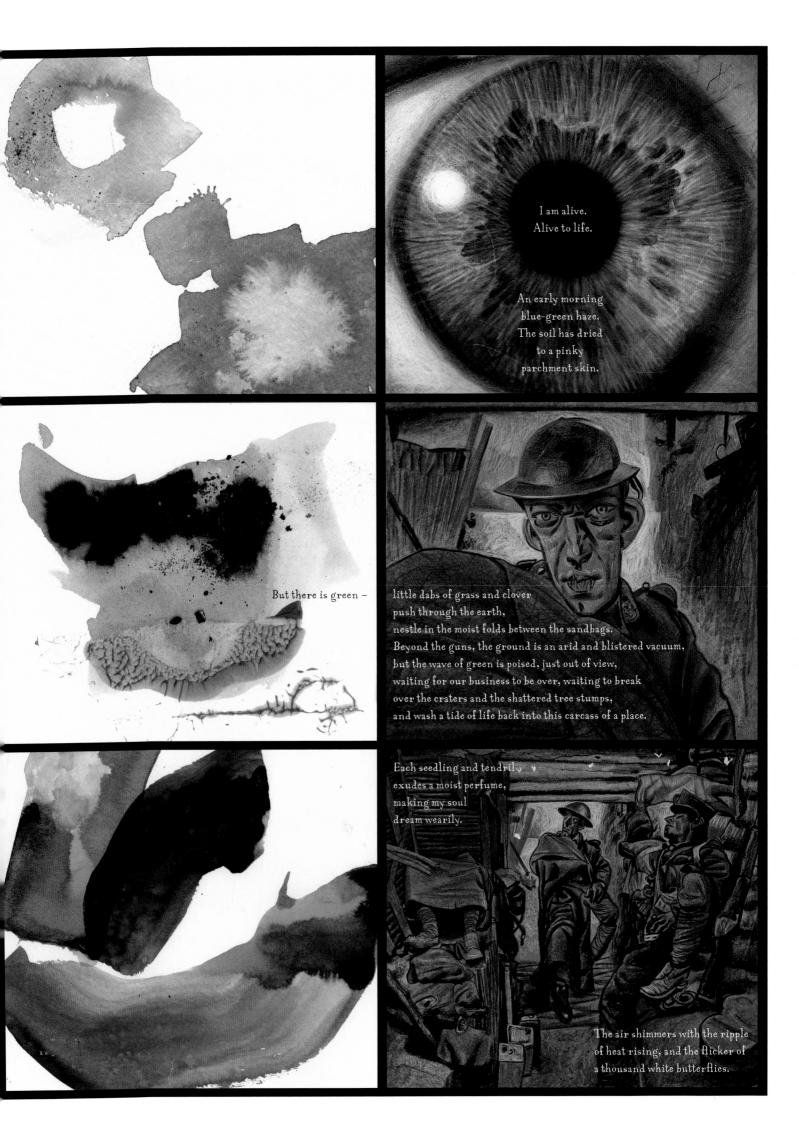

I am alive.
Alive to life.

An early morning
blue-green haze.
The soil has dried
to a pinky
parchment skin.

But there is green –

little dabs of grass and clover
push through the earth,
nestle in the moist folds between the sandbags.
Beyond the guns, the ground is an arid and blistered vacuum,
but the wave of green is poised, just out of view,
waiting for our business to be over, waiting to break
over the craters and the shattered tree stumps,
and wash a tide of life back into this carcass of a place.

Each seedling and tendril
exudes a moist perfume,
making my soul
dream wearily.

The air shimmers with the ripple
of heat rising, and the flicker of
a thousand white butterflies.

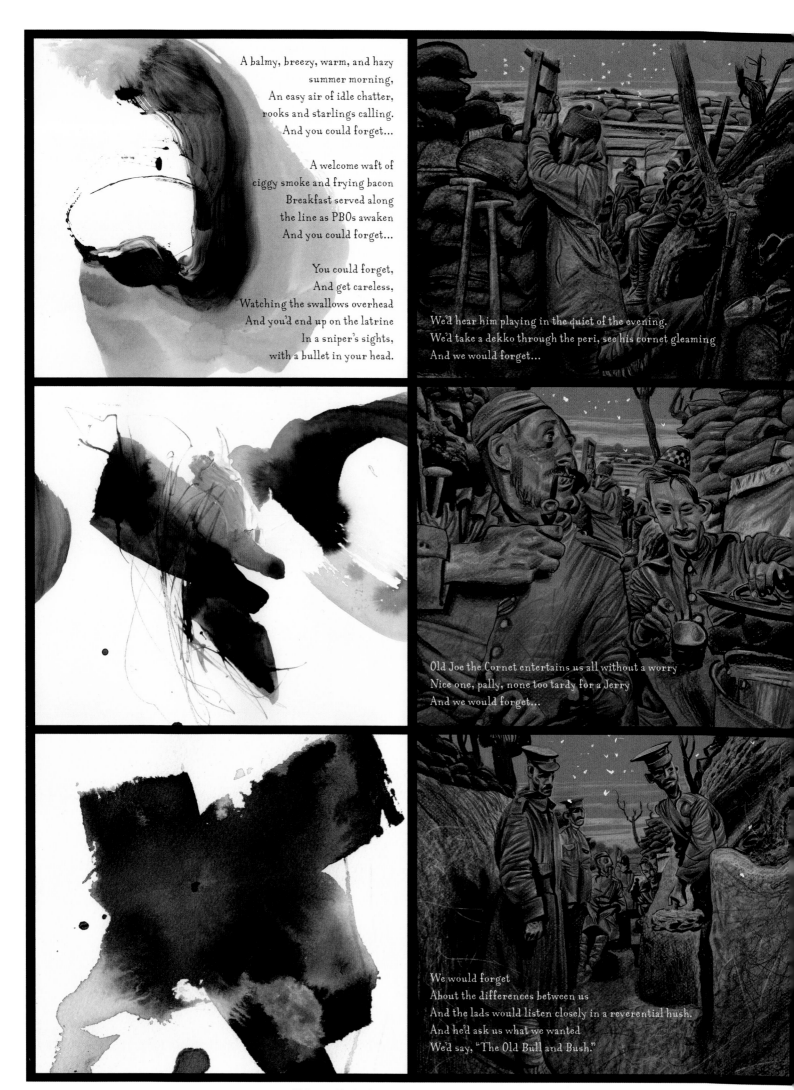

A balmy, breezy, warm, and hazy
summer morning,
An easy air of idle chatter,
rooks and starlings calling.
And you could forget...

A welcome waft of
ciggy smoke and frying bacon
Breakfast served along
the line as PBOs awaken
And you could forget...

You could forget,
And get careless,
Watching the swallows overhead
And you'd end up on the latrine
In a sniper's sights,
with a bullet in your head.

We'd hear him playing in the quiet of the evening.
We'd take a dekko through the peri, see his cornet gleaming
And we would forget...

Old Joe the Cornet entertains us all without a worry
Nice one, pally, none too tardy for a Jerry
And we would forget...

We would forget
About the differences between us
And the lads would listen closely in a reverential hush.
And he'd ask us what we wanted
We'd say, "The Old Bull and Bush."

PBO - poor bloody observer

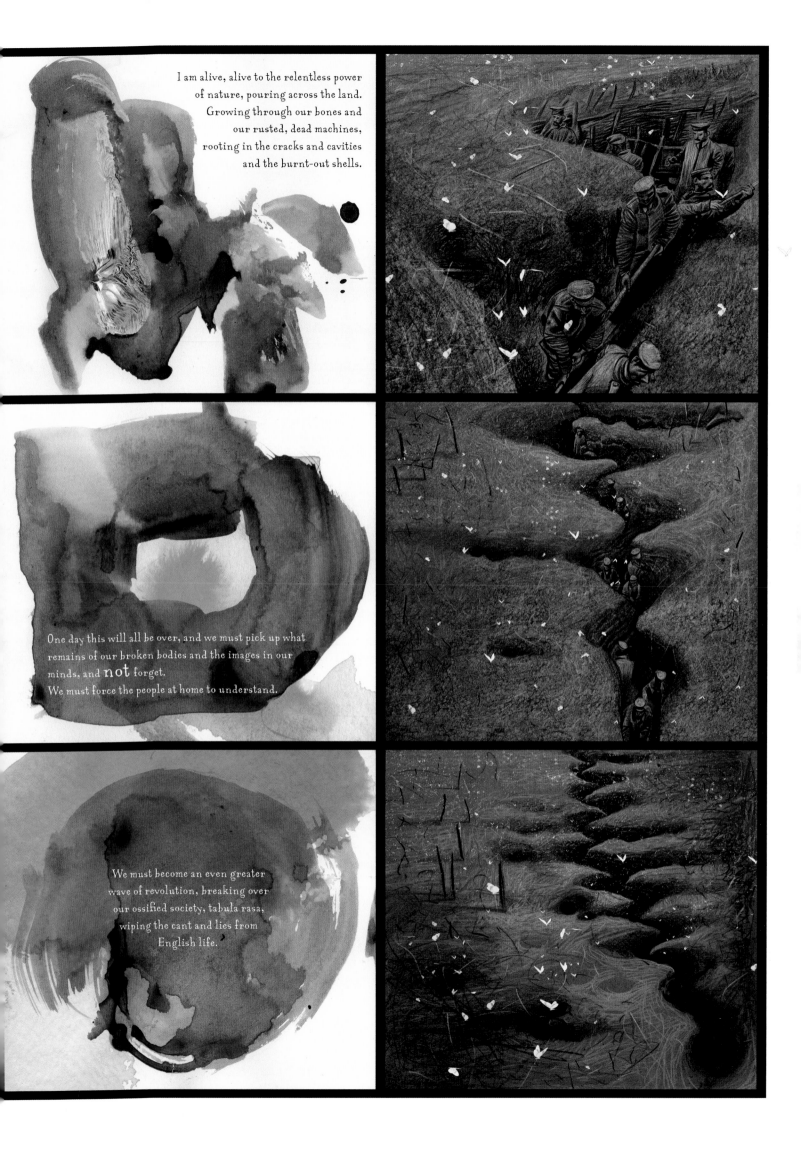

I am alive, alive to the relentless power
of nature, pouring across the land.
Growing through our bones and
our rusted, dead machines,
rooting in the cracks and cavities
and the burnt-out shells.

One day this will all be over, and we must pick up what
remains of our broken bodies and the images in our
minds, and not forget.
We must force the people at home to understand.

We must become an even greater
wave of revolution, breaking over
our ossified society, tabula rasa,
wiping the cant and lies from
English life.

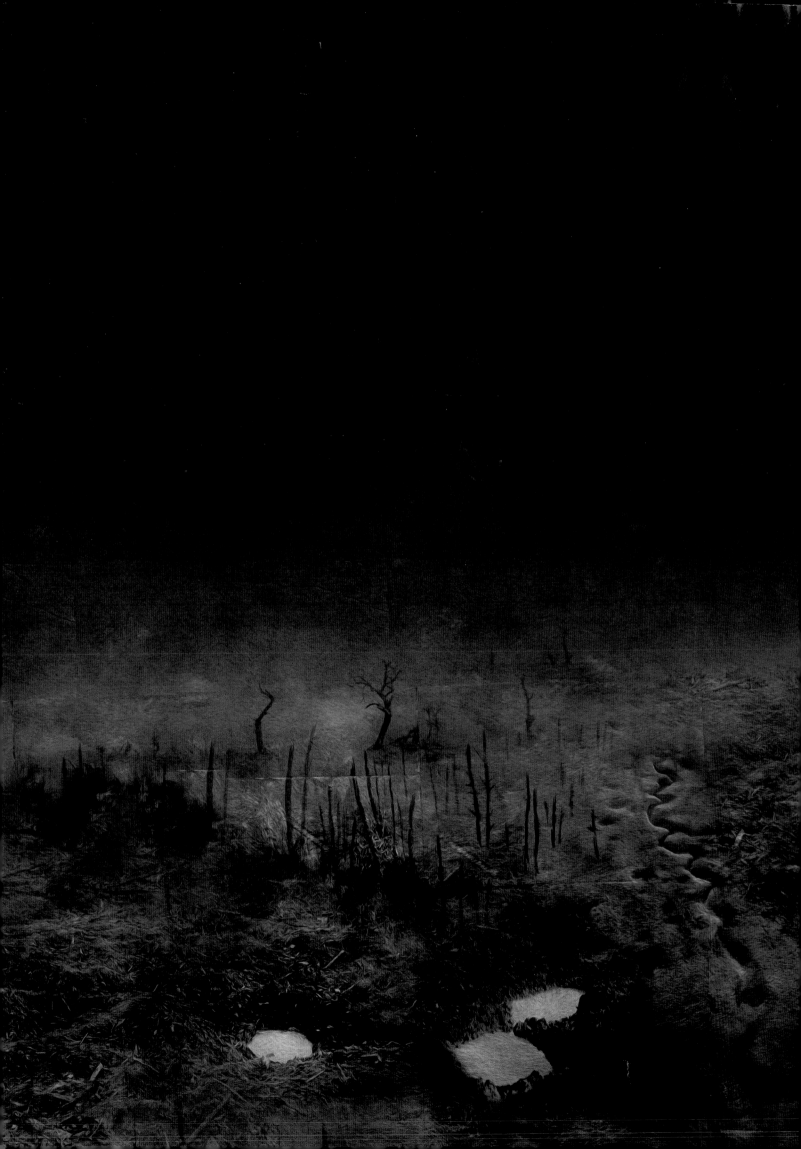

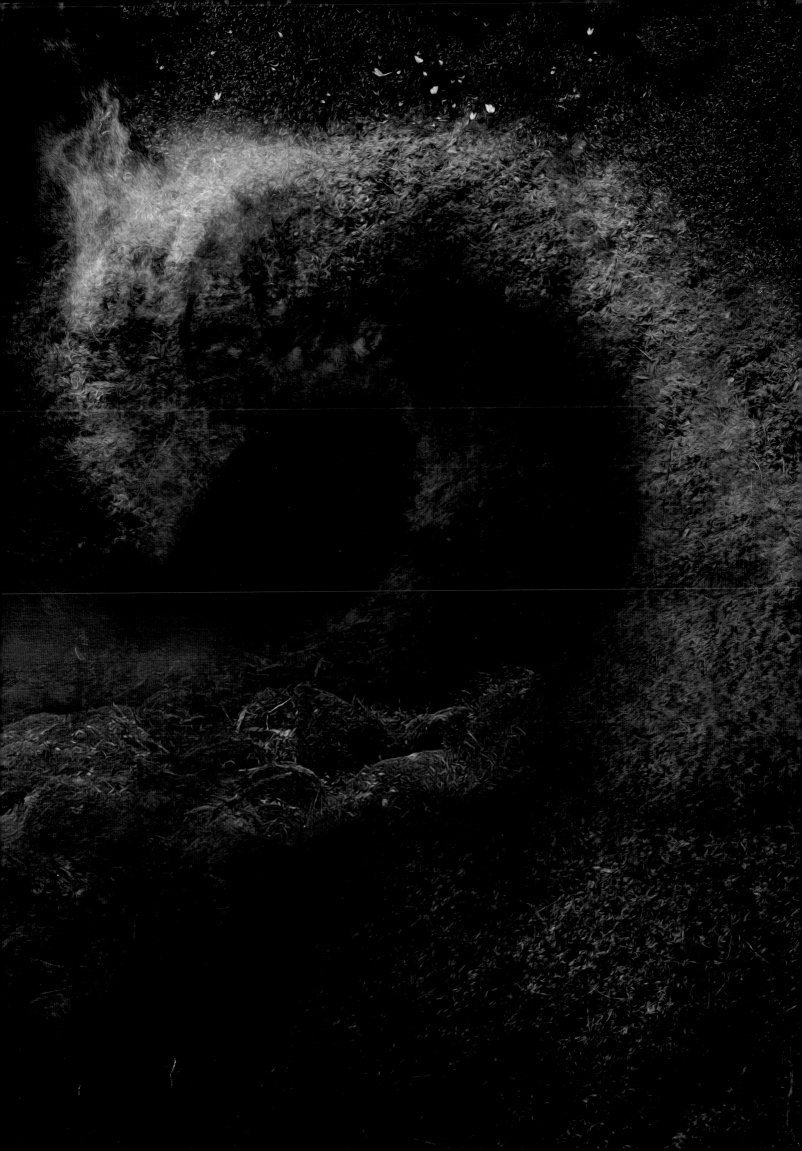

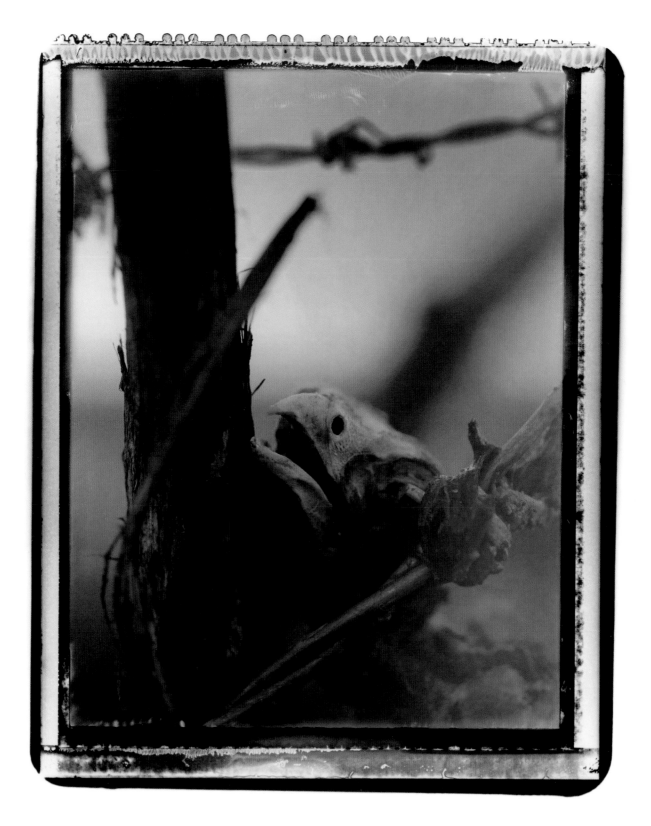

1917 - Ypres Salient
1906 - St. Paul's School, London

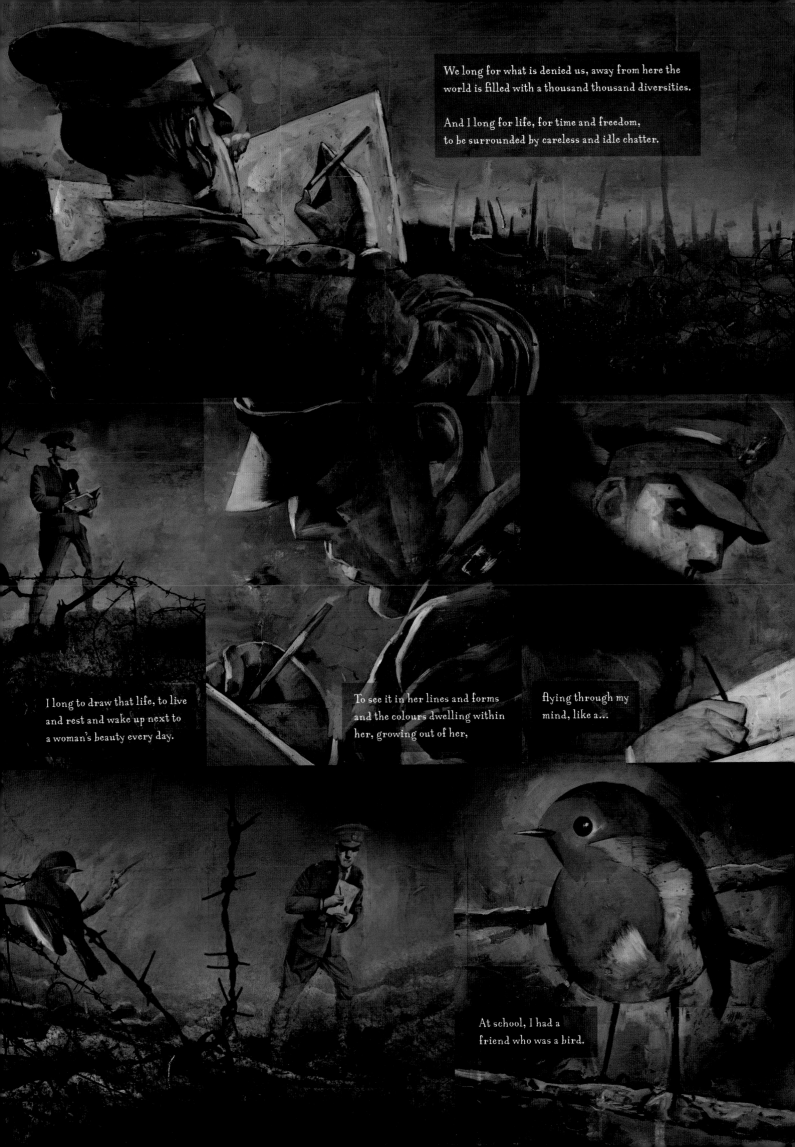

We long for what is denied us, away from here the world is filled with a thousand thousand diversities.

And I long for life, for time and freedom, to be surrounded by careless and idle chatter.

I long to draw that life, to live and rest and wake up next to a woman's beauty every day.

To see it in her lines and forms and the colours dwelling within her, growing out of her,

flying through my mind, like a...

At school, I had a friend who was a bird.

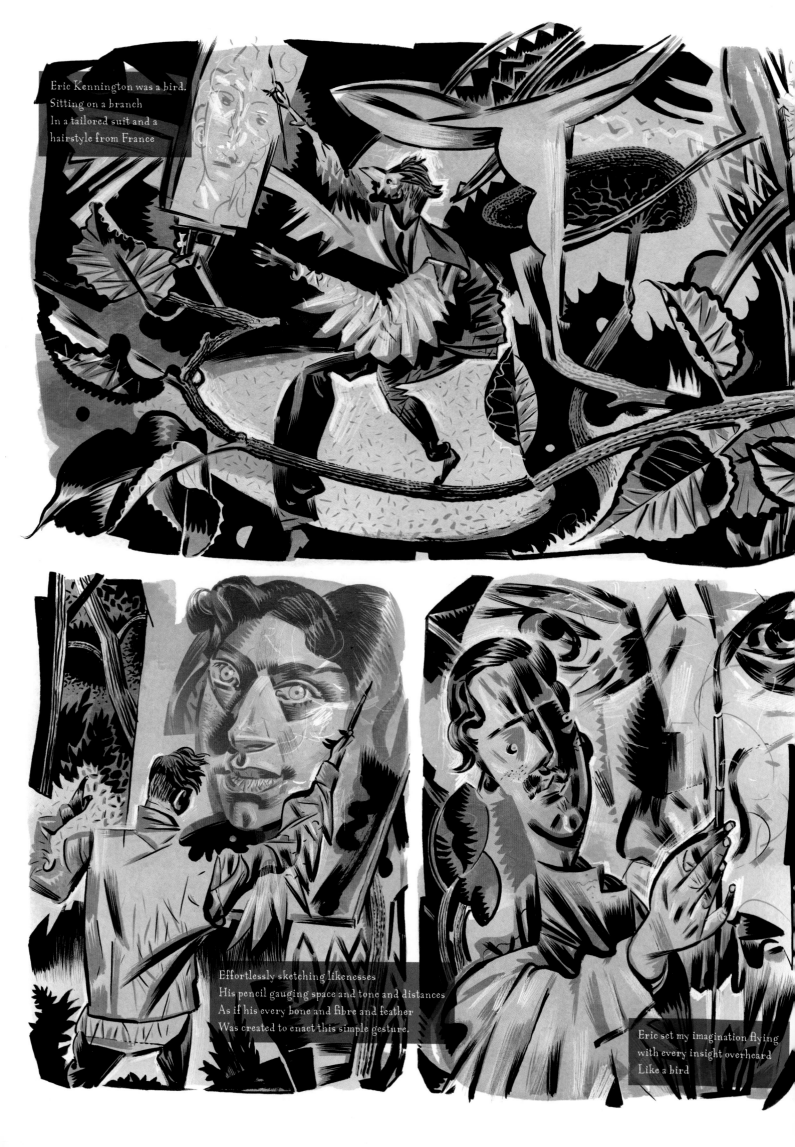

Eric Kennington was a bird.
Sitting on a branch
In a tailored suit and a
hairstyle from France

Effortlessly sketching likenesses
His pencil gauging space and tone and distances
As if his every bone and fibre and feather
Was created to enact this simple gesture.

Eric set my imagination flying
with every insight overheard
Like a bird

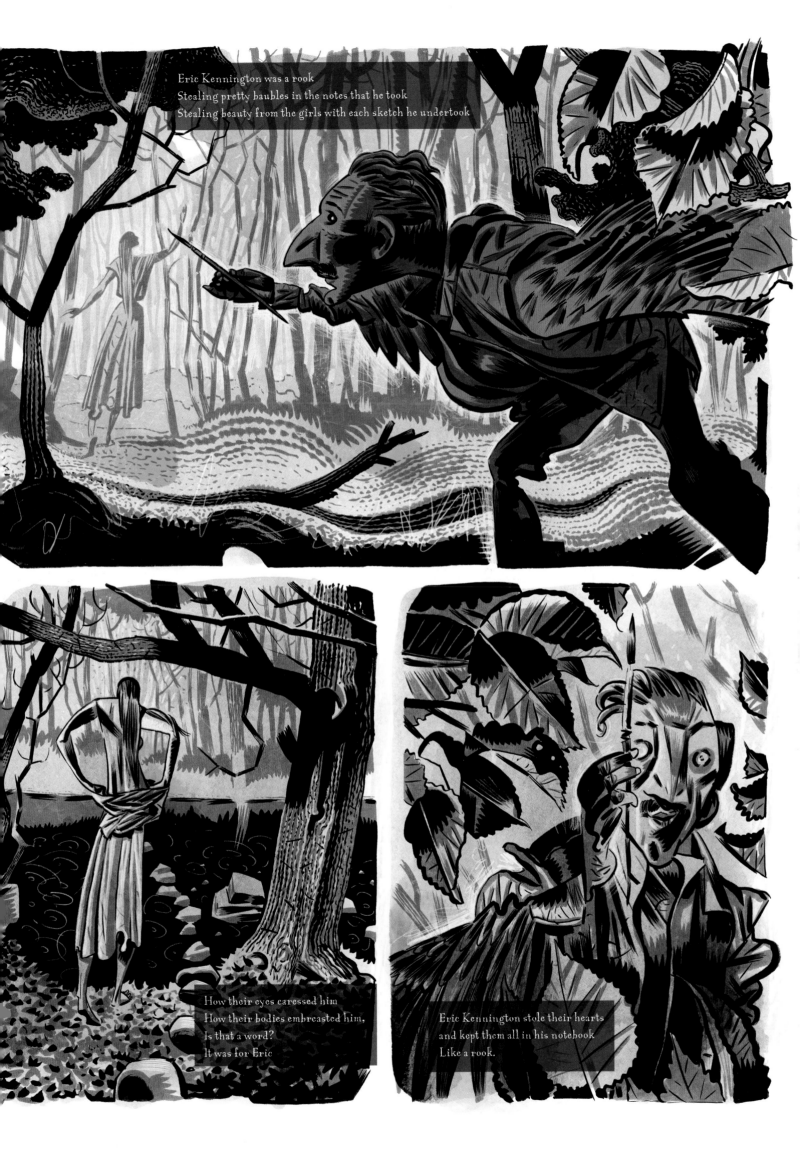

Eric Kennington was a rook
Stealing pretty baubles in the notes that he took
Stealing beauty from the girls with each sketch he undertook

How their eyes caressed him
How their bodies embreasted him,
Is that a word?
It was for Eric

Eric Kennington stole their hearts
and kept them all in his notebook
Like a rook.

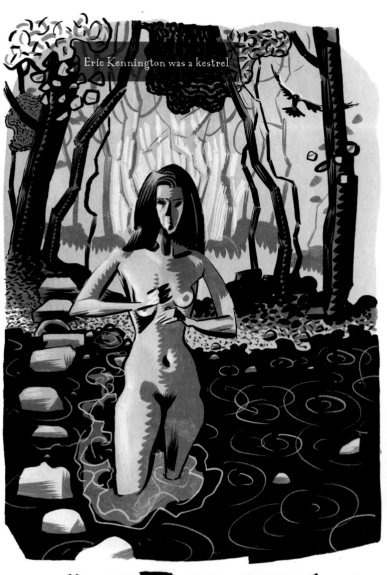

Eric Kennington was a kestrel

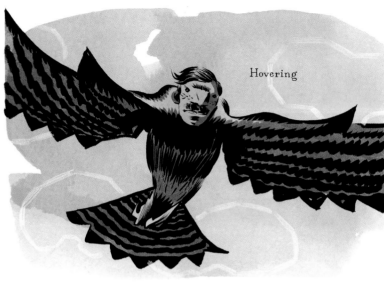

Hovering

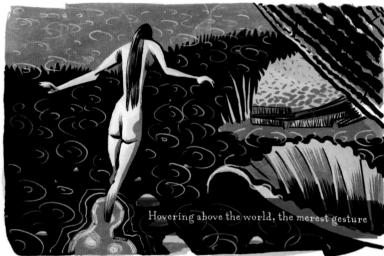

Hovering above the world, the merest gesture

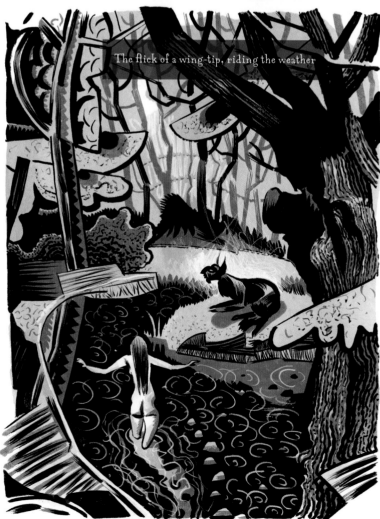

The flick of a wing-tip, riding the weather

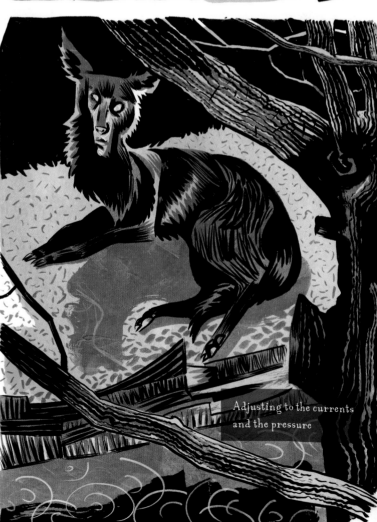

Adjusting to the currents
and the pressure

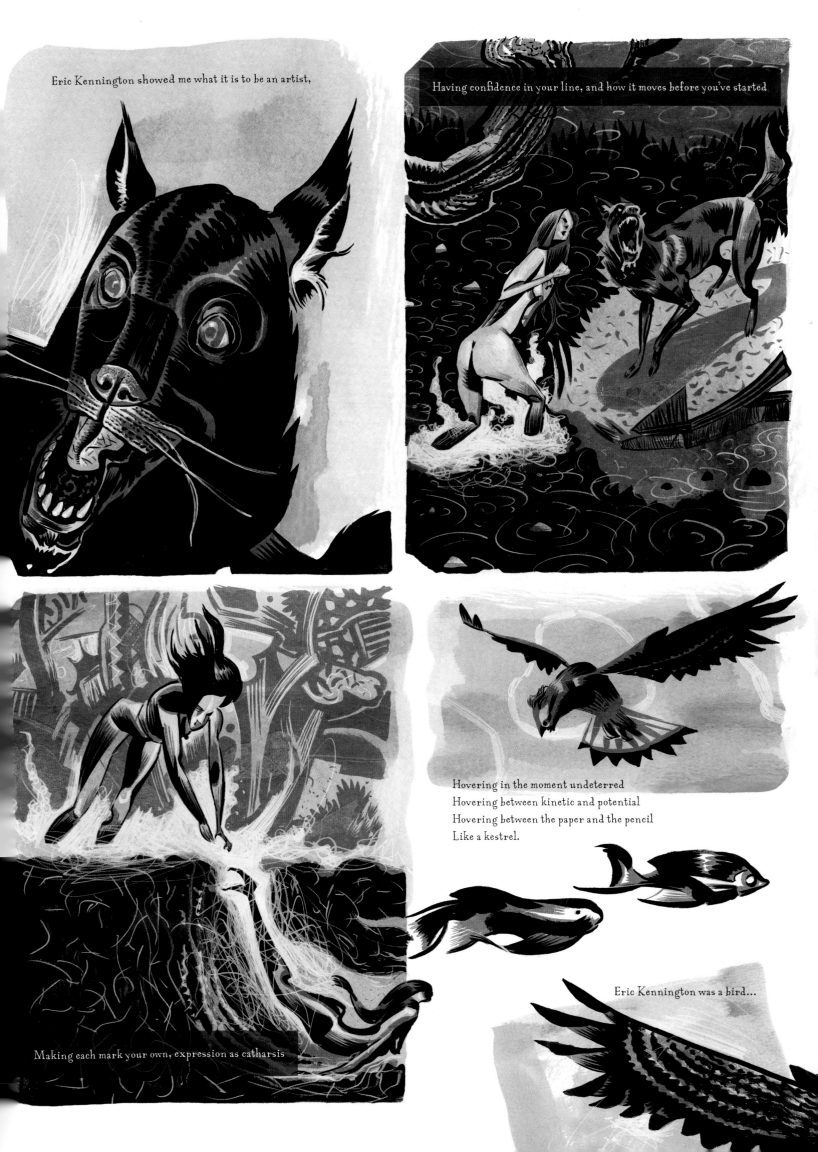

Eric Kennington showed me what it is to be an artist,

Having confidence in your line, and how it moves before you've started

Hovering in the moment undeterred
Hovering between kinetic and potential
Hovering between the paper and the pencil
Like a kestrel.

Making each mark your own, expression as catharsis

Eric Kennington was a bird...

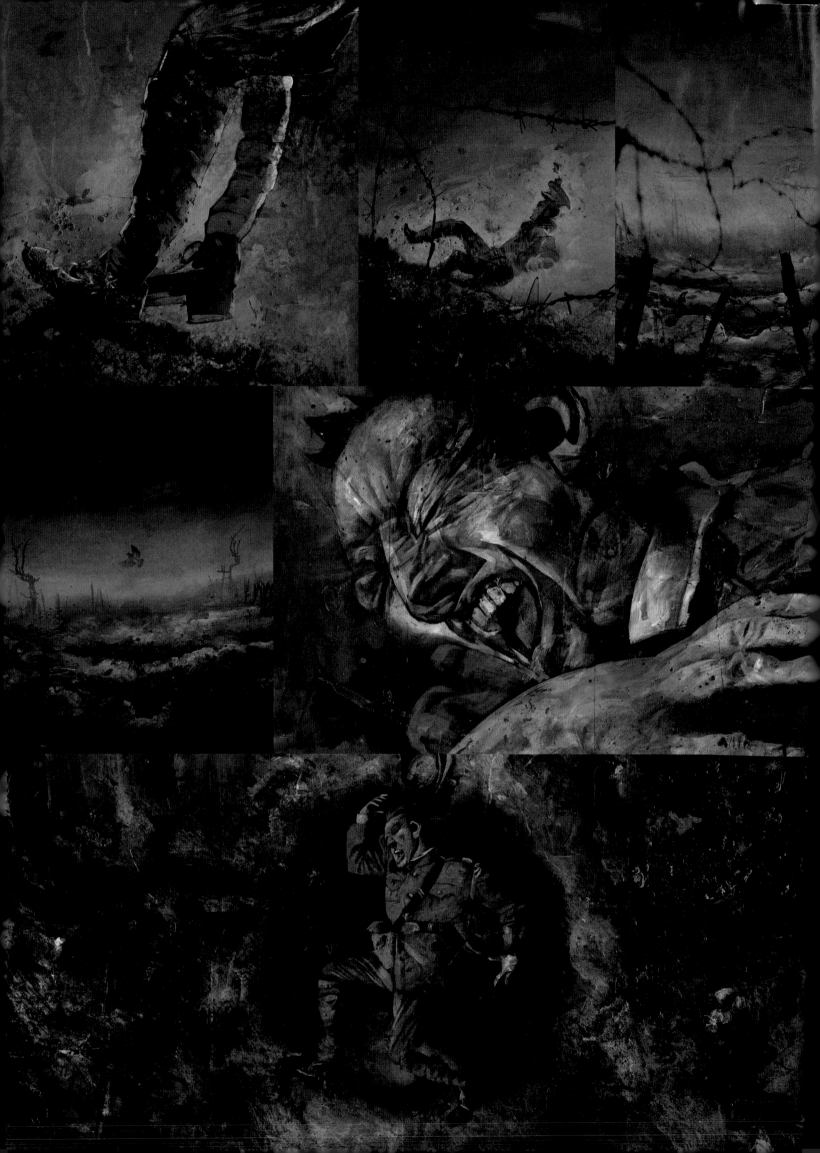

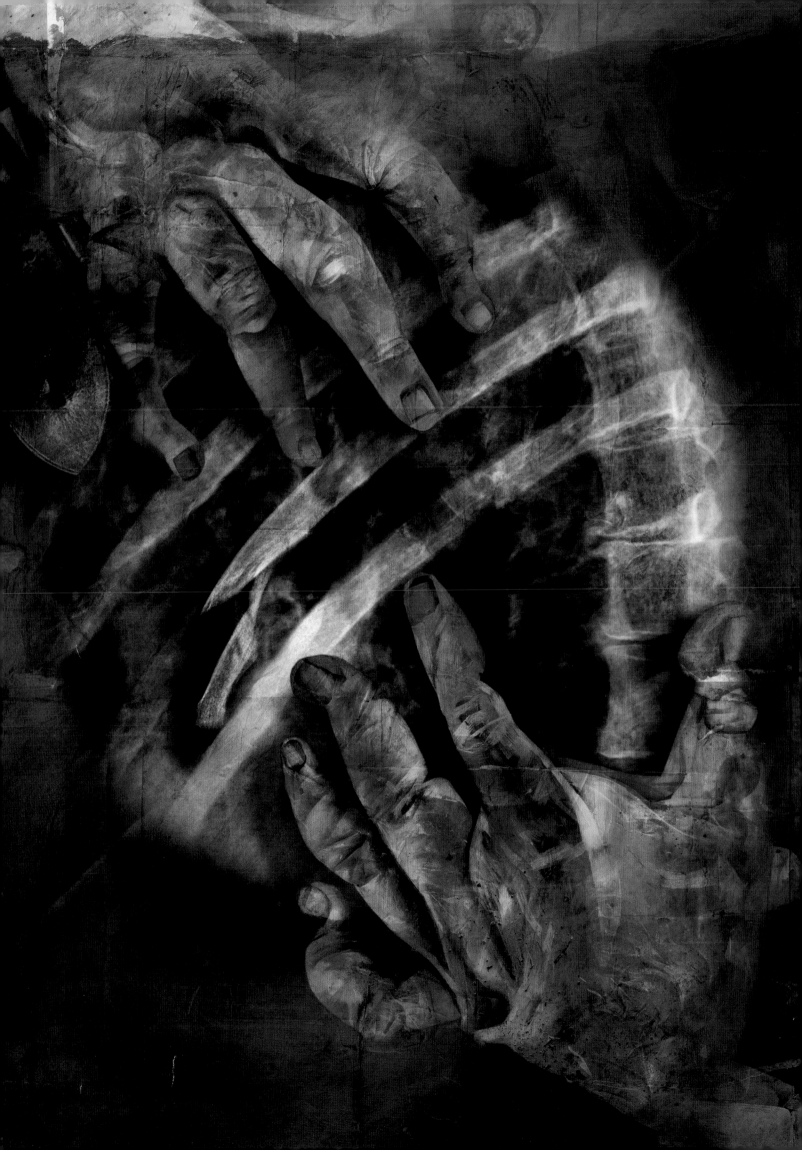

11

1917 - Swedish Hospital, London

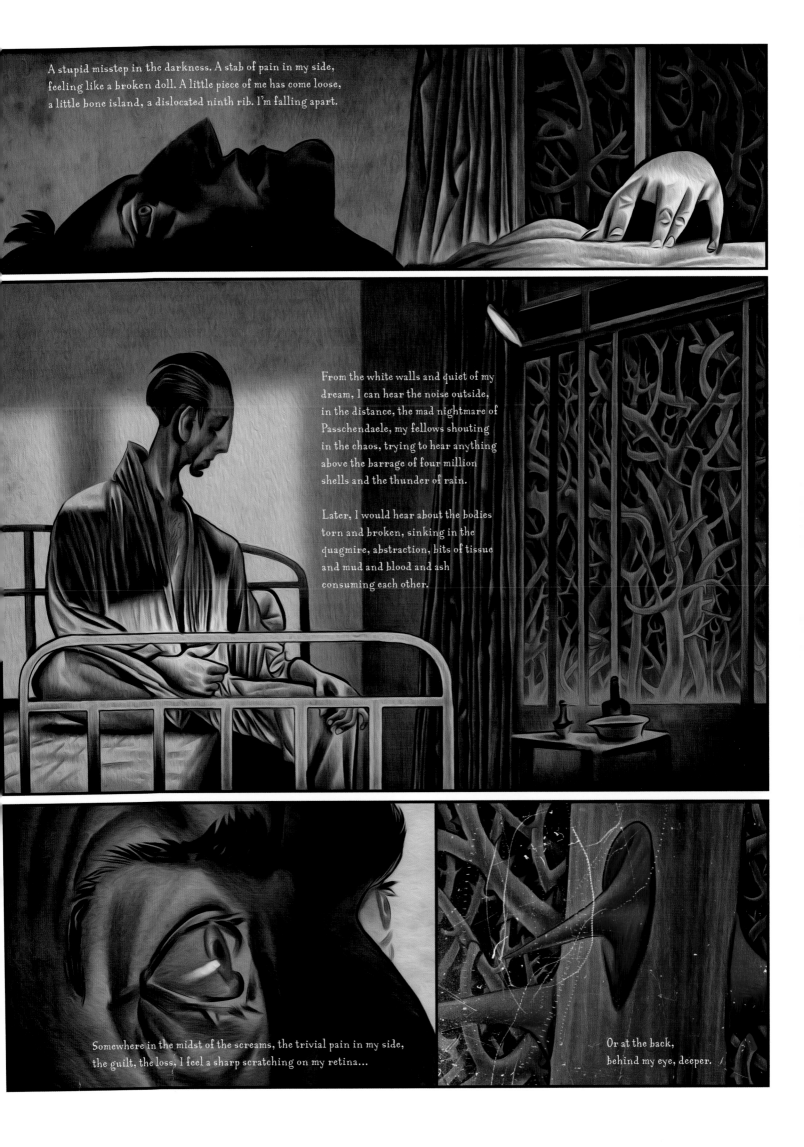

A stupid misstep in the darkness. A stab of pain in my side, feeling like a broken doll. A little piece of me has come loose, a little bone island, a dislocated ninth rib. I'm falling apart.

From the white walls and quiet of my dream, I can hear the noise outside, in the distance, the mad nightmare of Passchendaele, my fellows shouting in the chaos, trying to hear anything above the barrage of four million shells and the thunder of rain.

Later, I would hear about the bodies torn and broken, sinking in the quagmire, abstraction, bits of tissue and mud and blood and ash consuming each other.

Somewhere in the midst of the screams, the trivial pain in my side, the guilt, the loss, I feel a sharp scratching on my retina...

Or at the back, behind my eye, deeper.

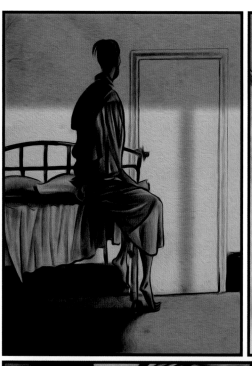

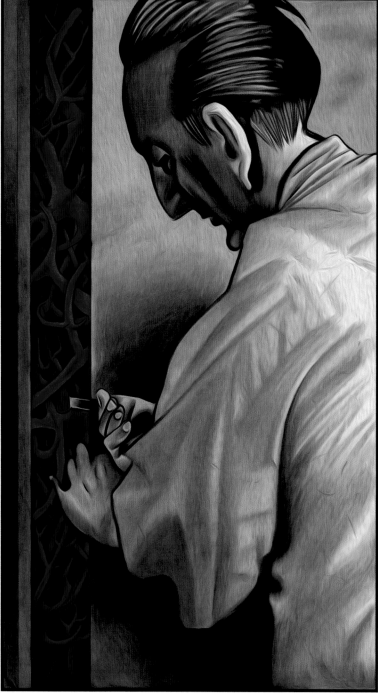
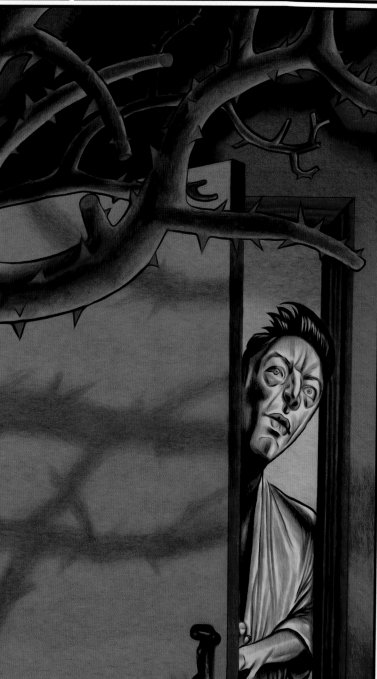

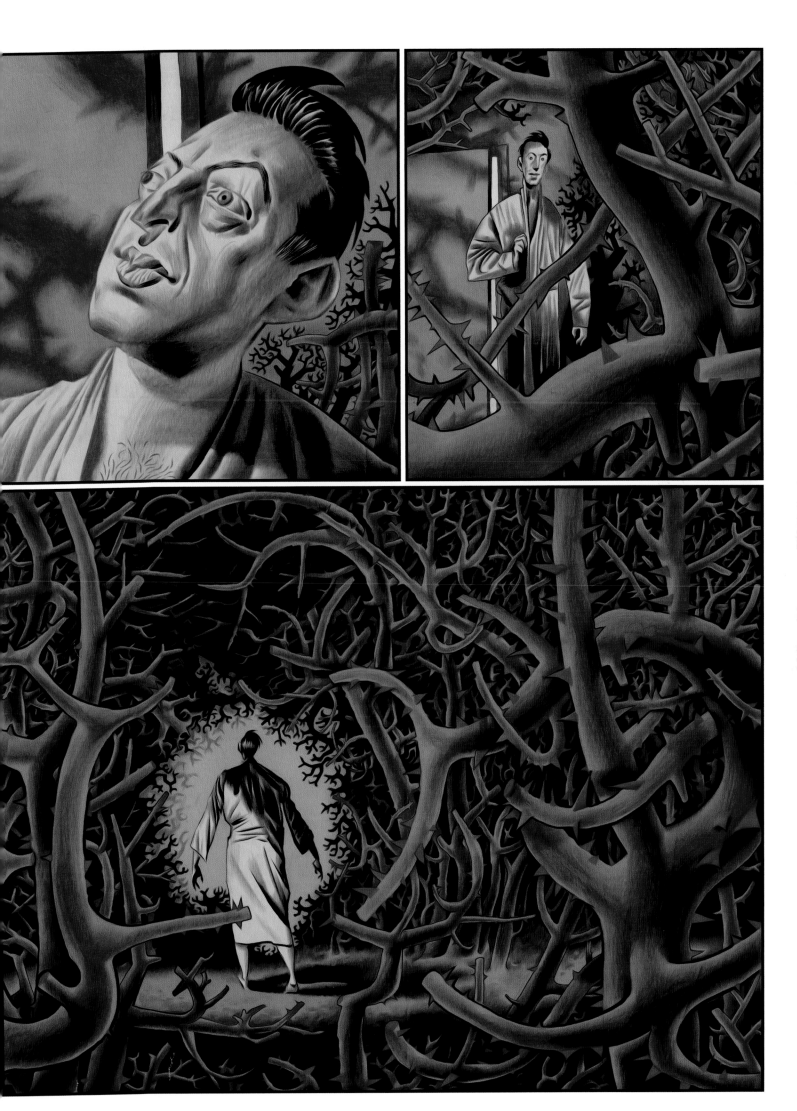

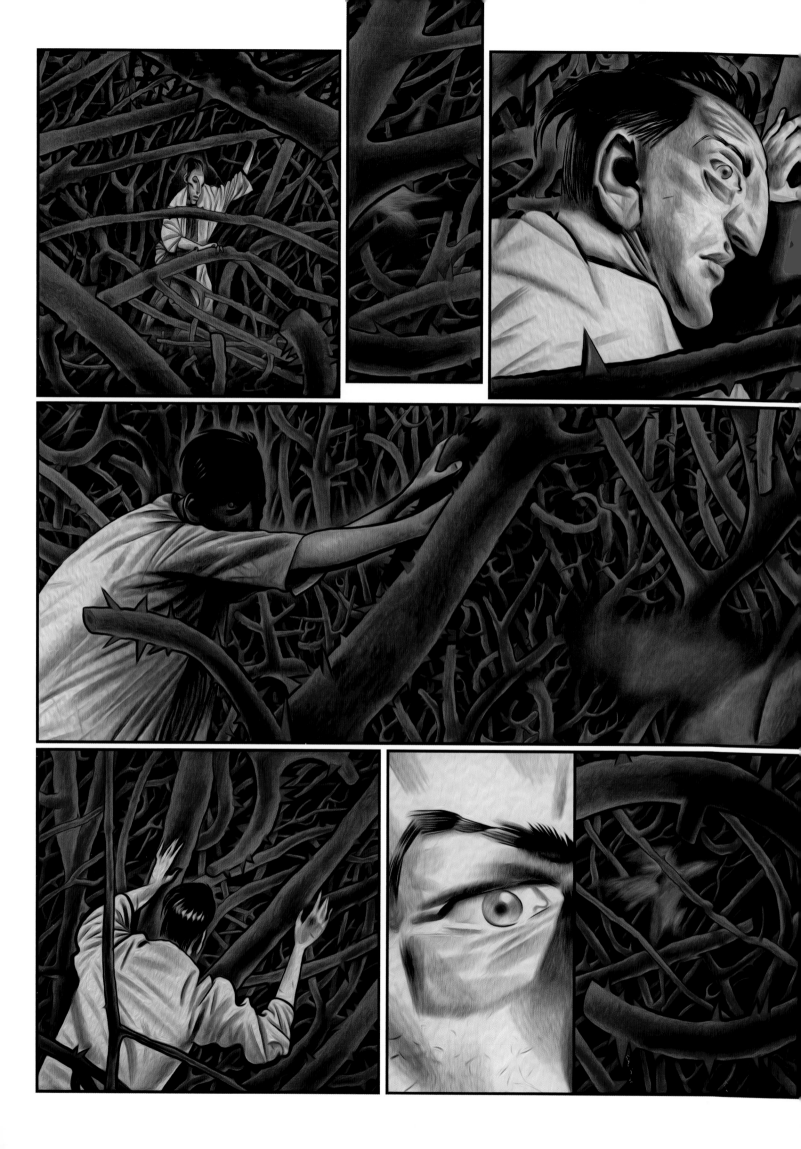

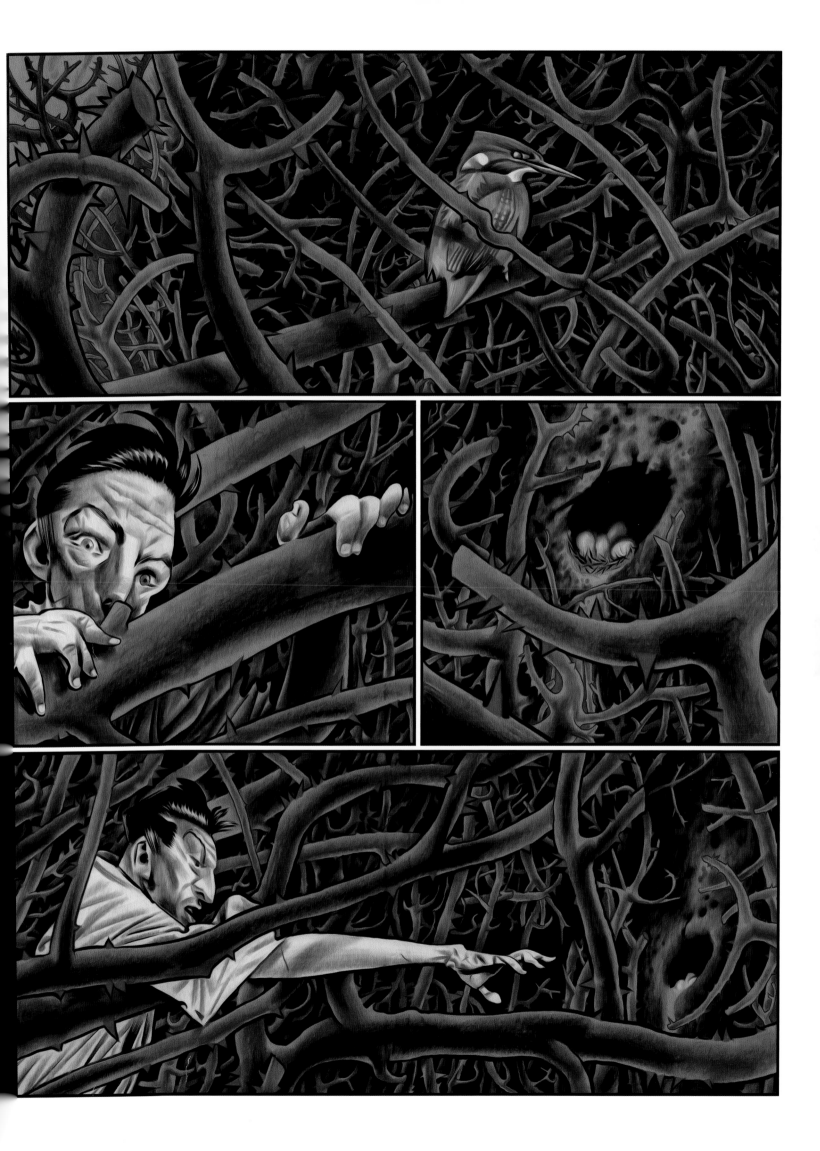

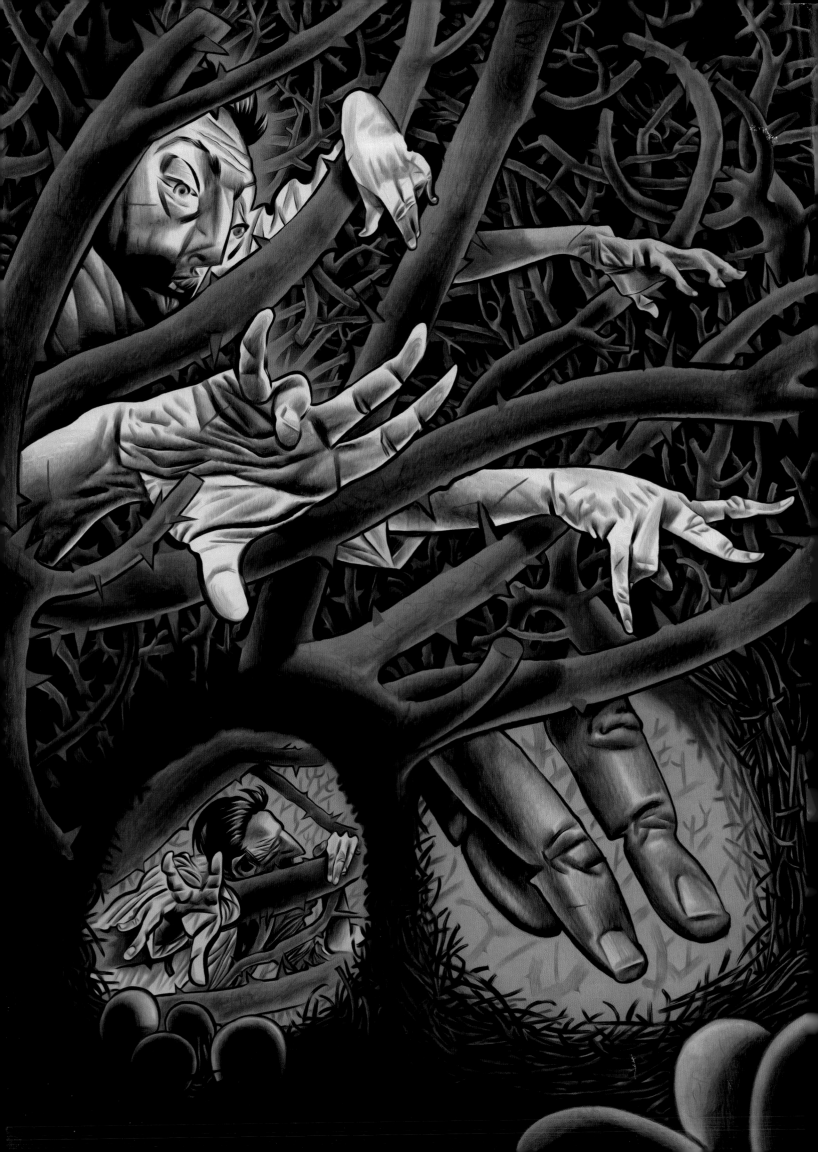

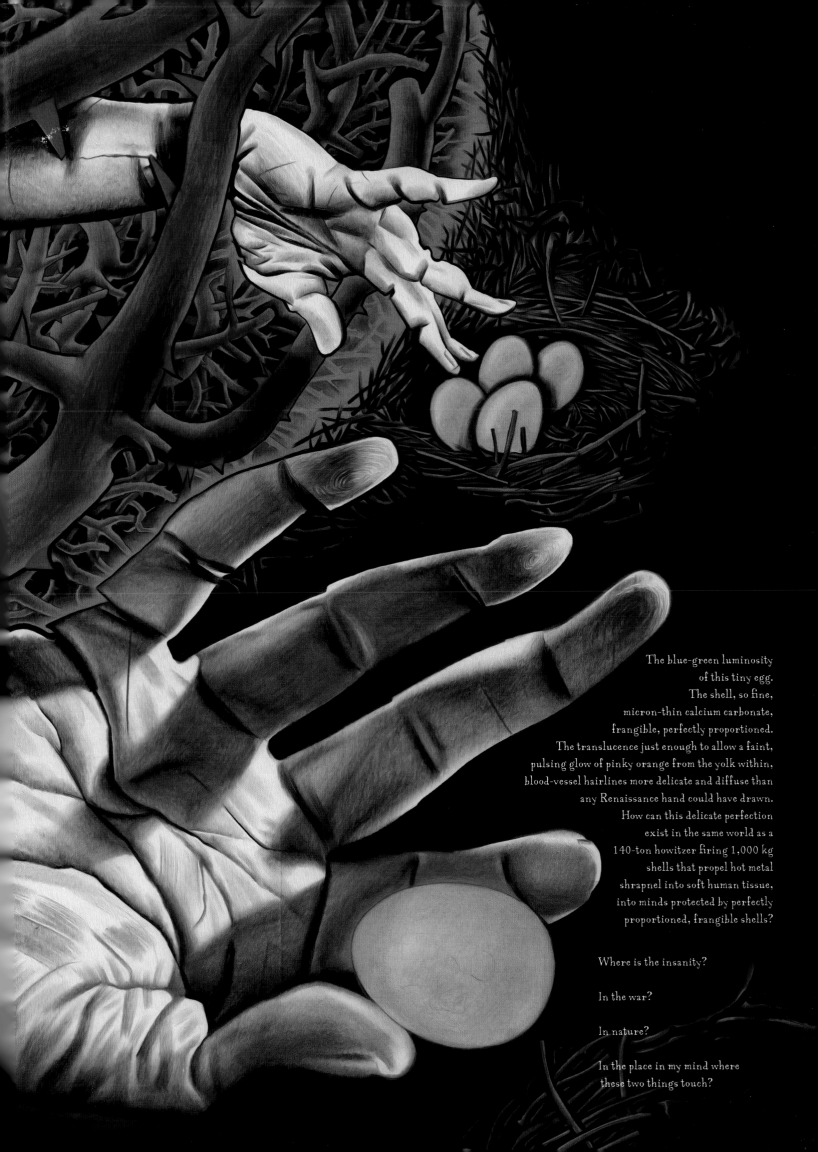

The blue-green luminosity
of this tiny egg.
The shell, so fine,
micron-thin calcium carbonate,
frangible, perfectly proportioned.
The translucence just enough to allow a faint,
pulsing glow of pinky orange from the yolk within,
blood-vessel hairlines more delicate and diffuse than
any Renaissance hand could have drawn.
How can this delicate perfection
exist in the same world as a
140-ton howitzer firing 1,000 kg
shells that propel hot metal
shrapnel into soft human tissue,
into minds protected by perfectly
proportioned, frangible shells?

Where is the insanity?

In the war?

In nature?

In the place in my mind where
these two things touch?

1918 - Ypres Salient

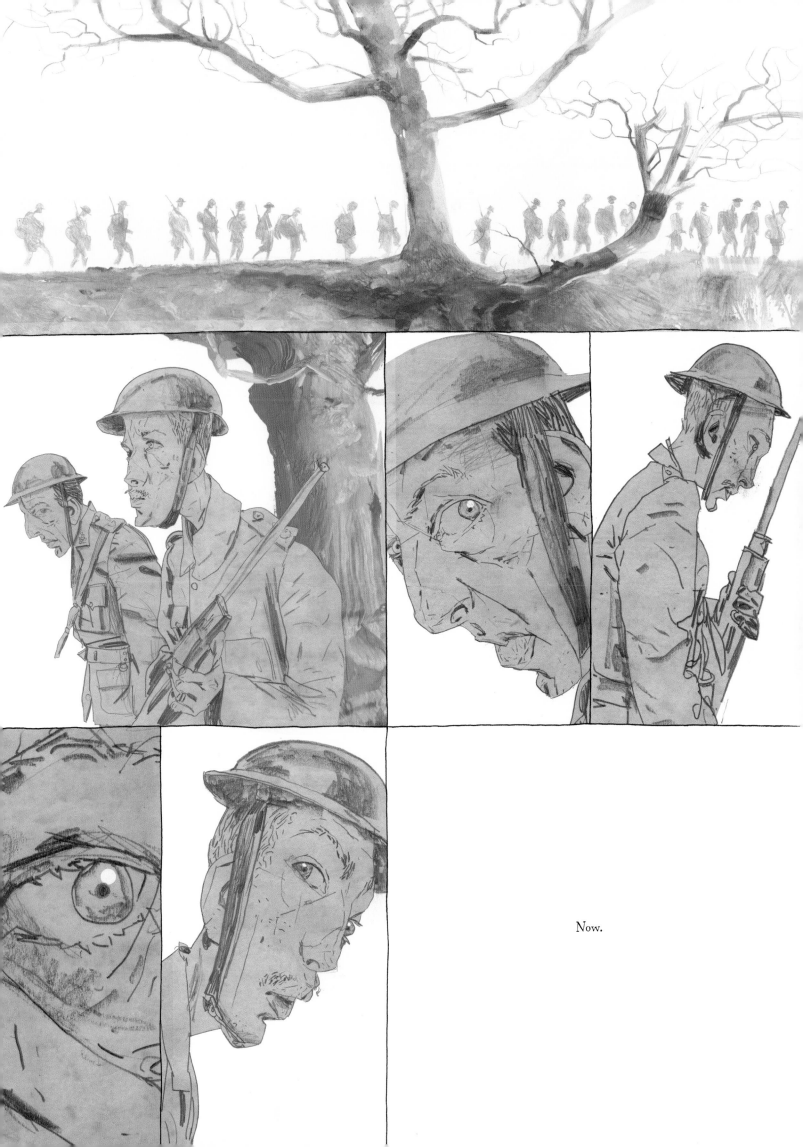

Now.

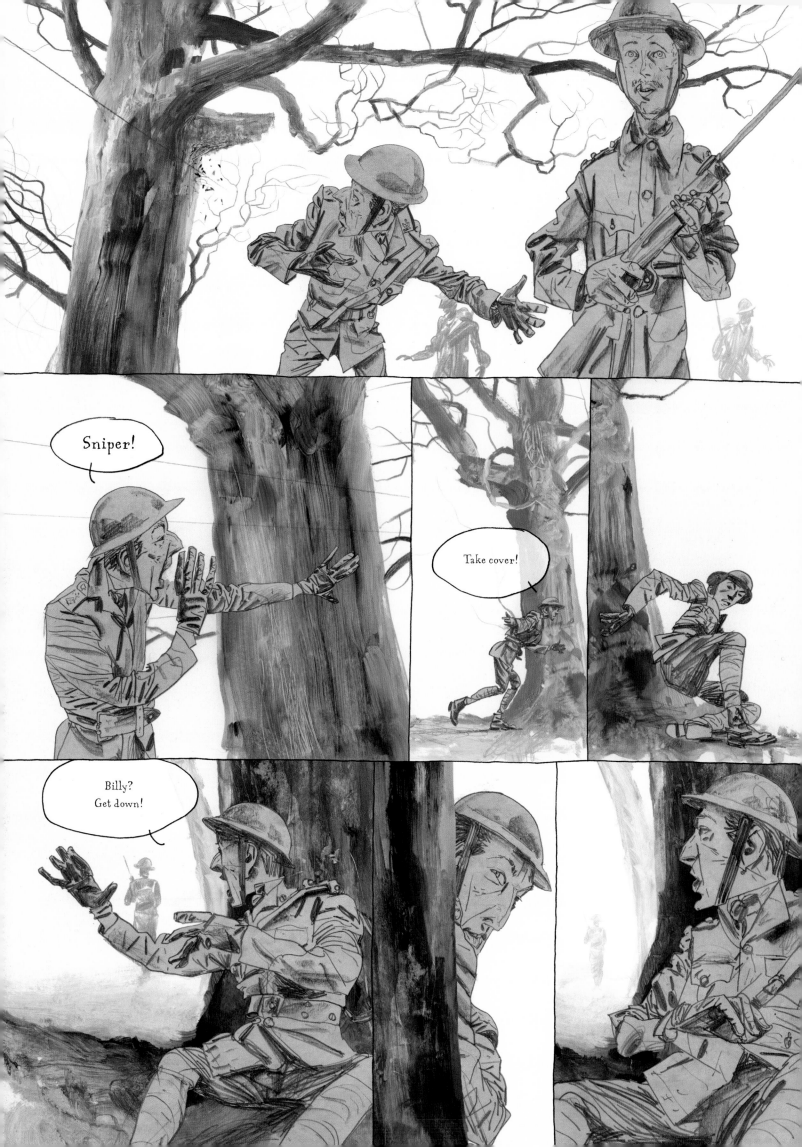

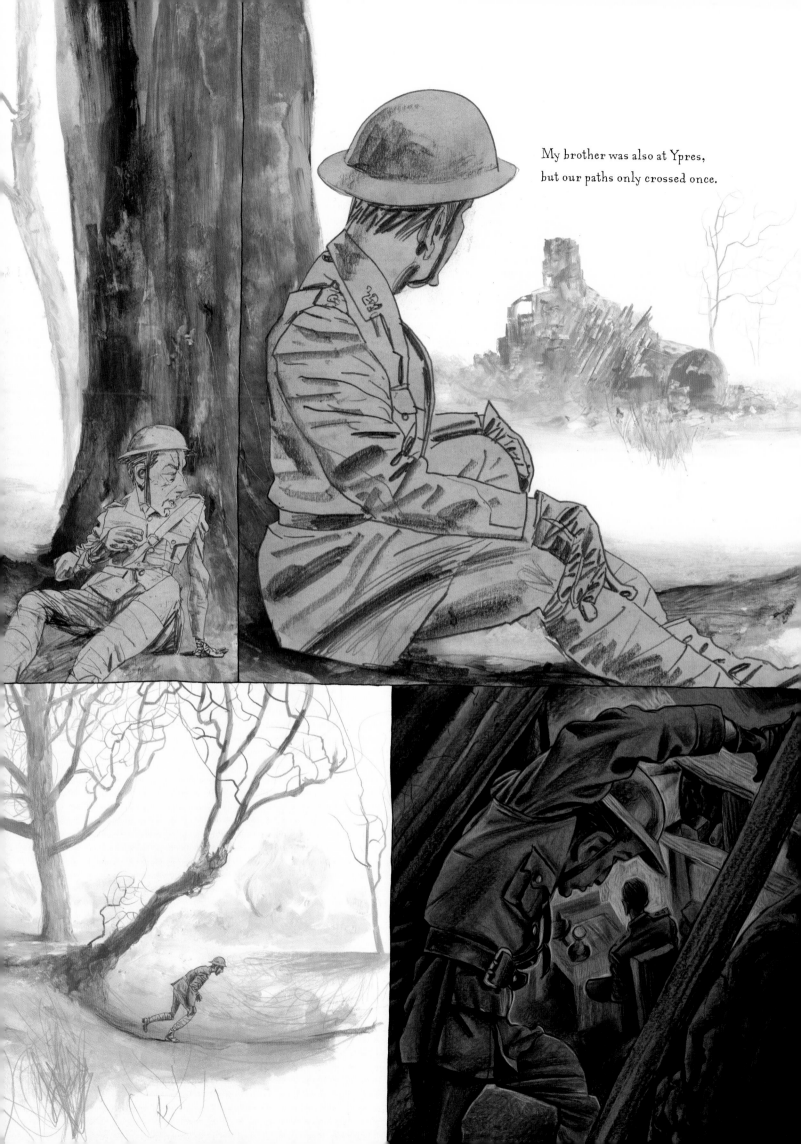

My brother was also at Ypres,
but our paths only crossed once.

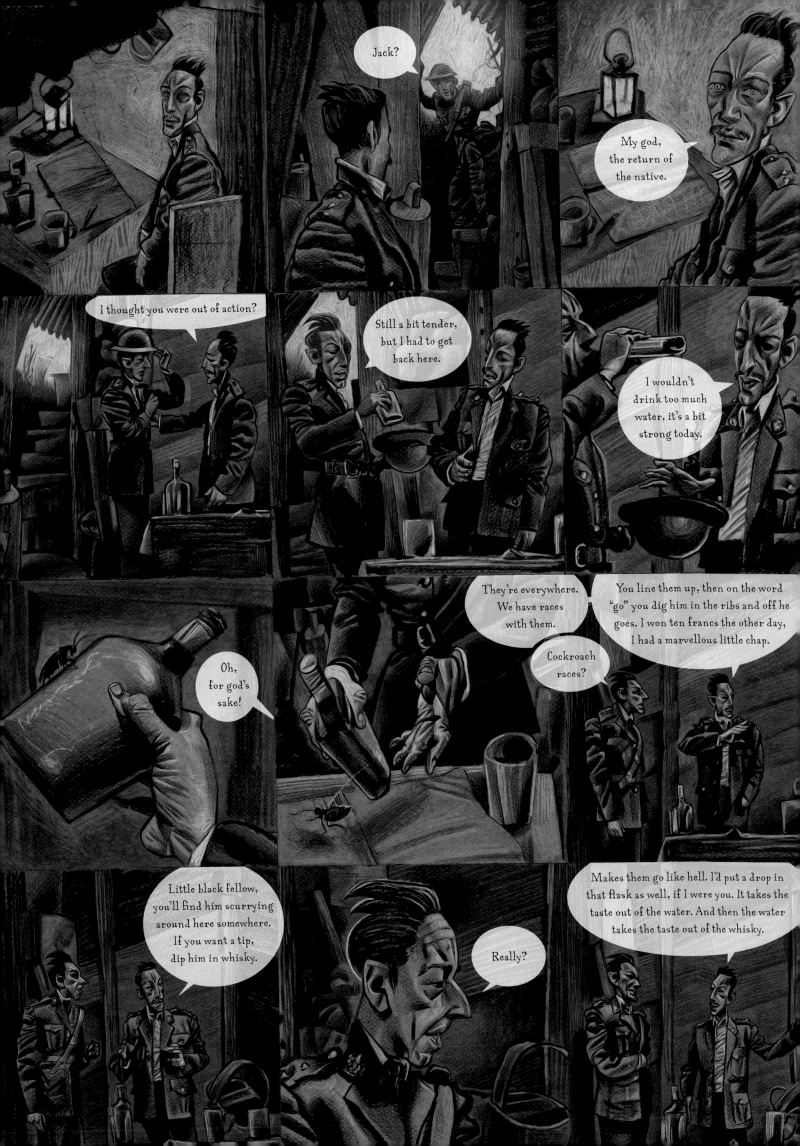

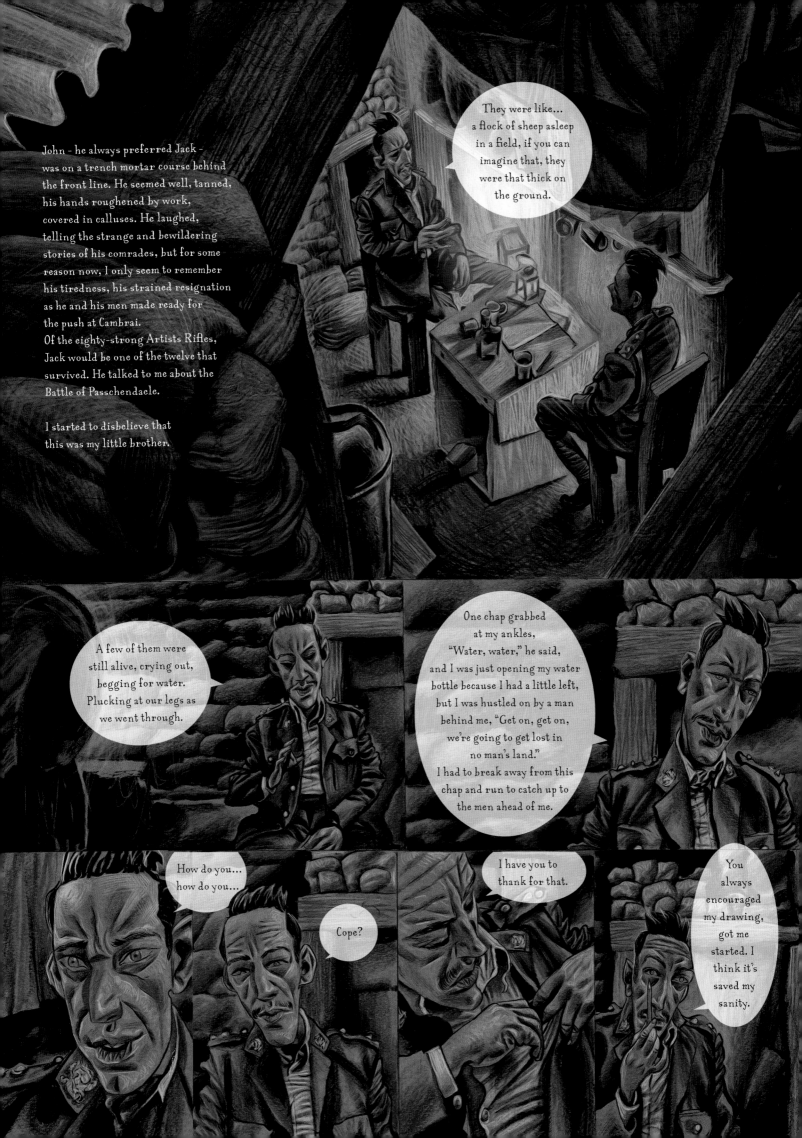

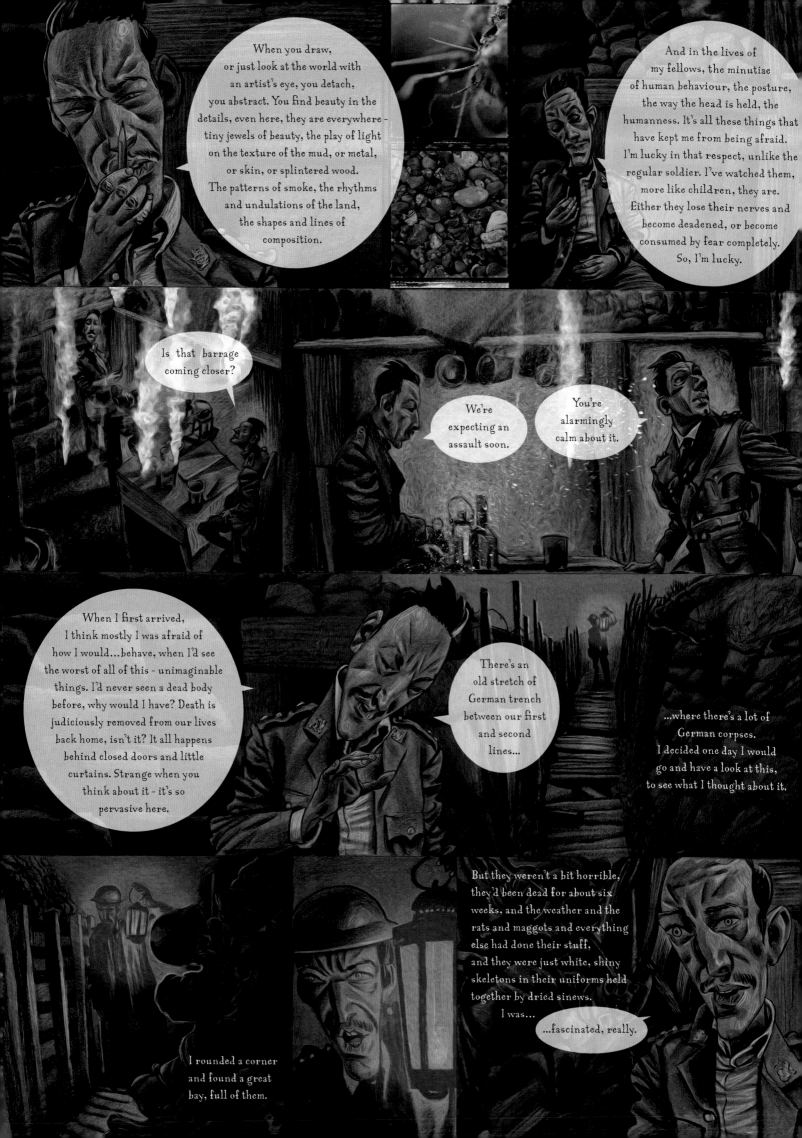

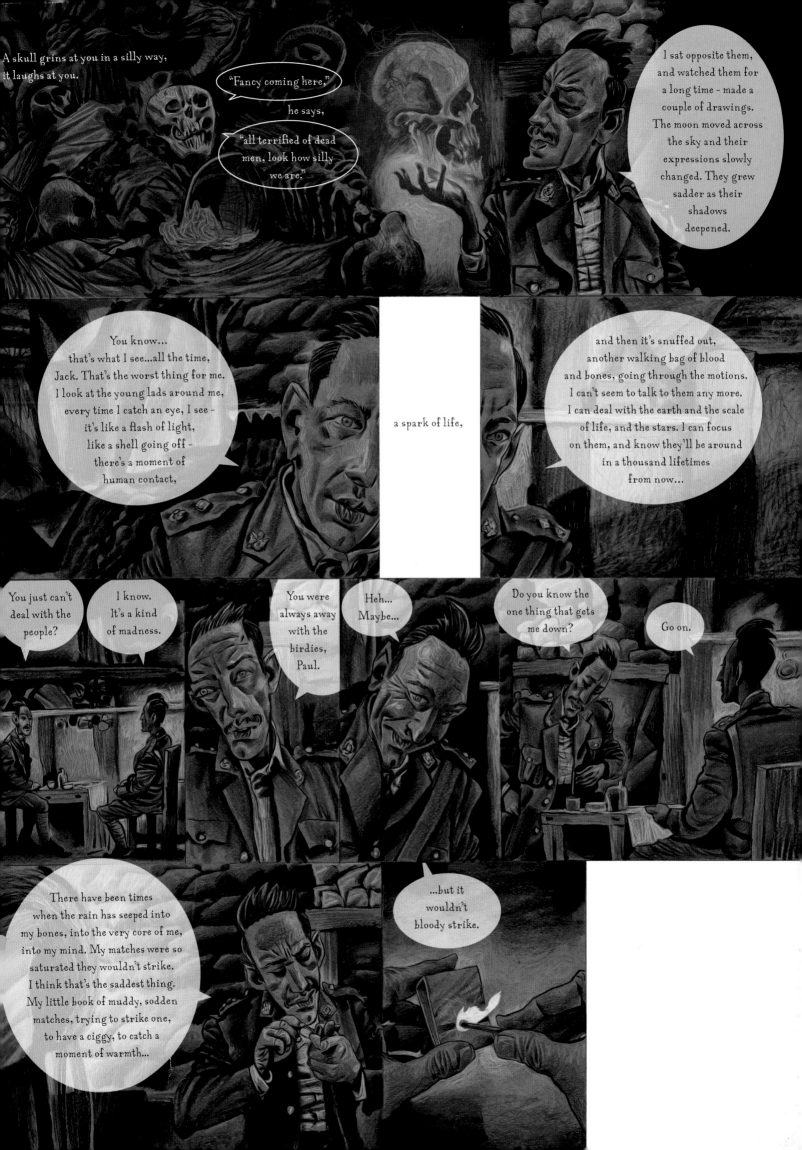

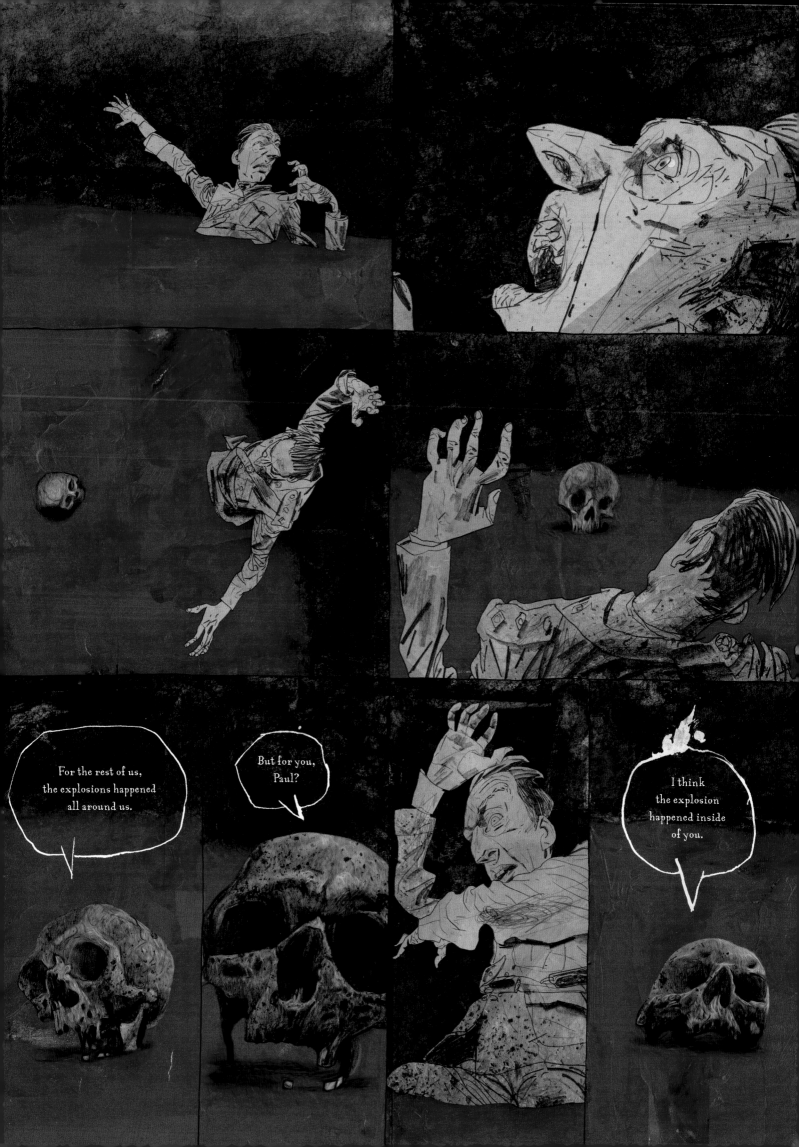

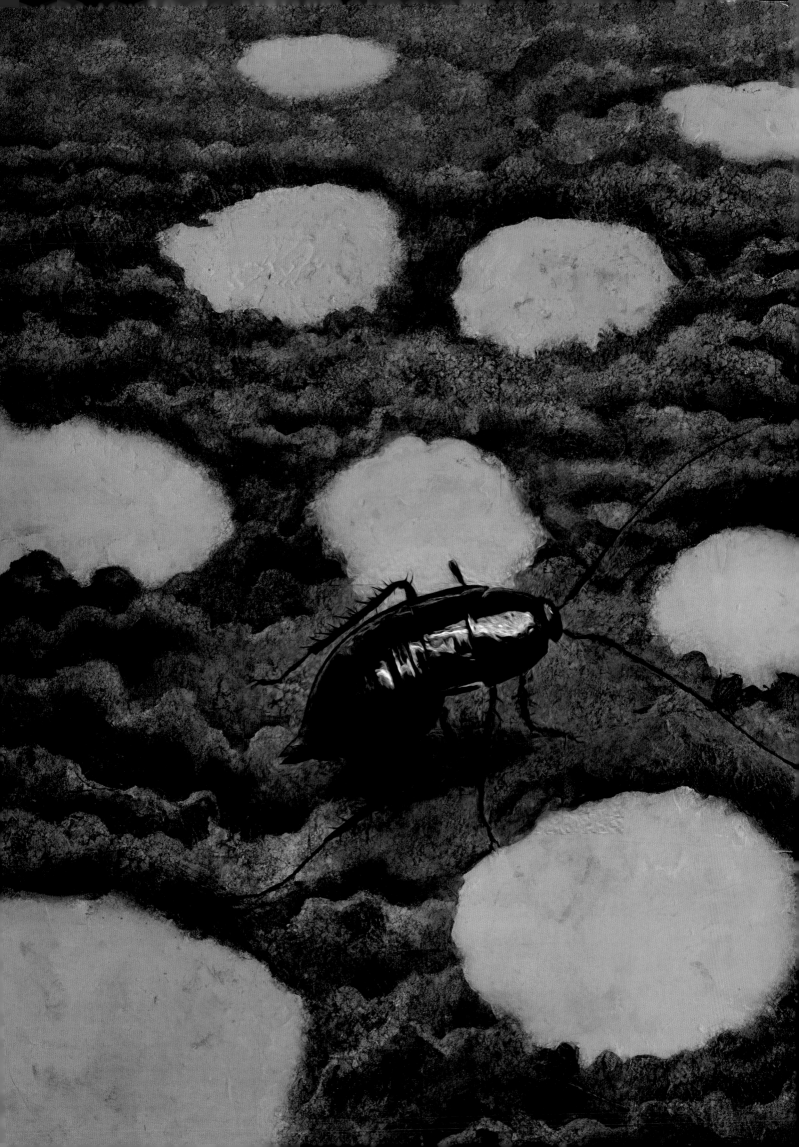

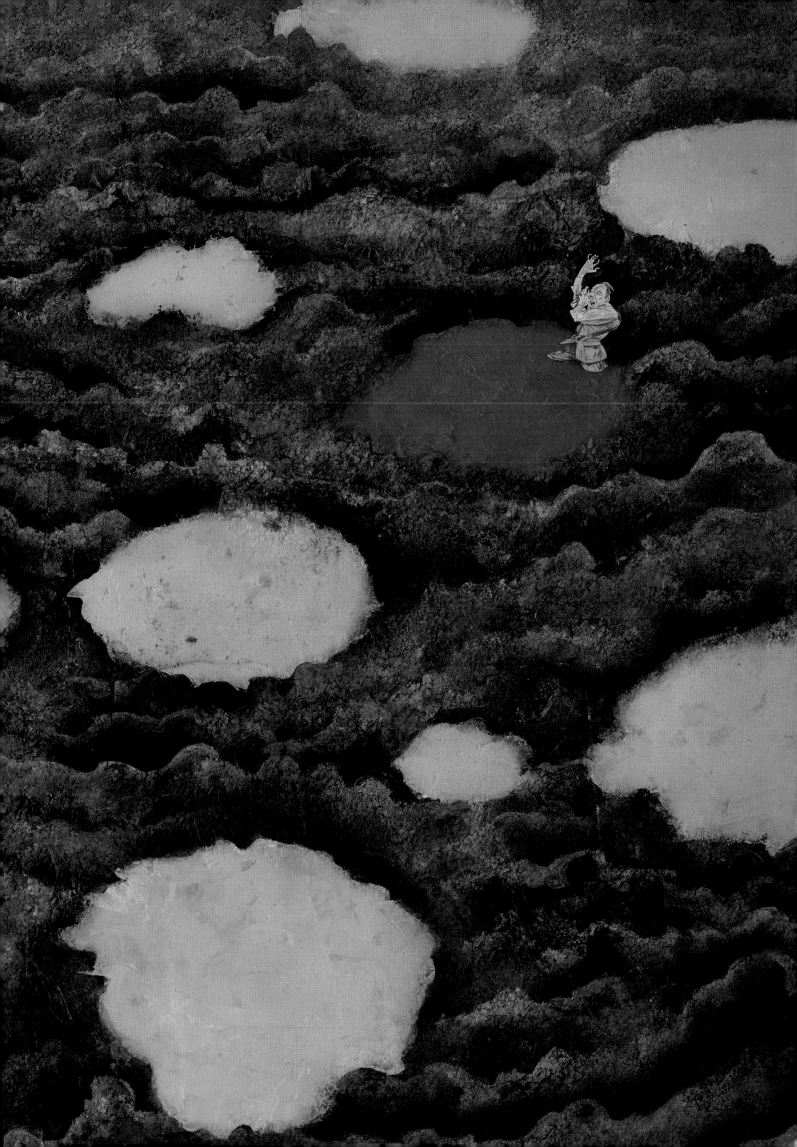

13

1919 - Dymchurch
1918 - Ypres Salient

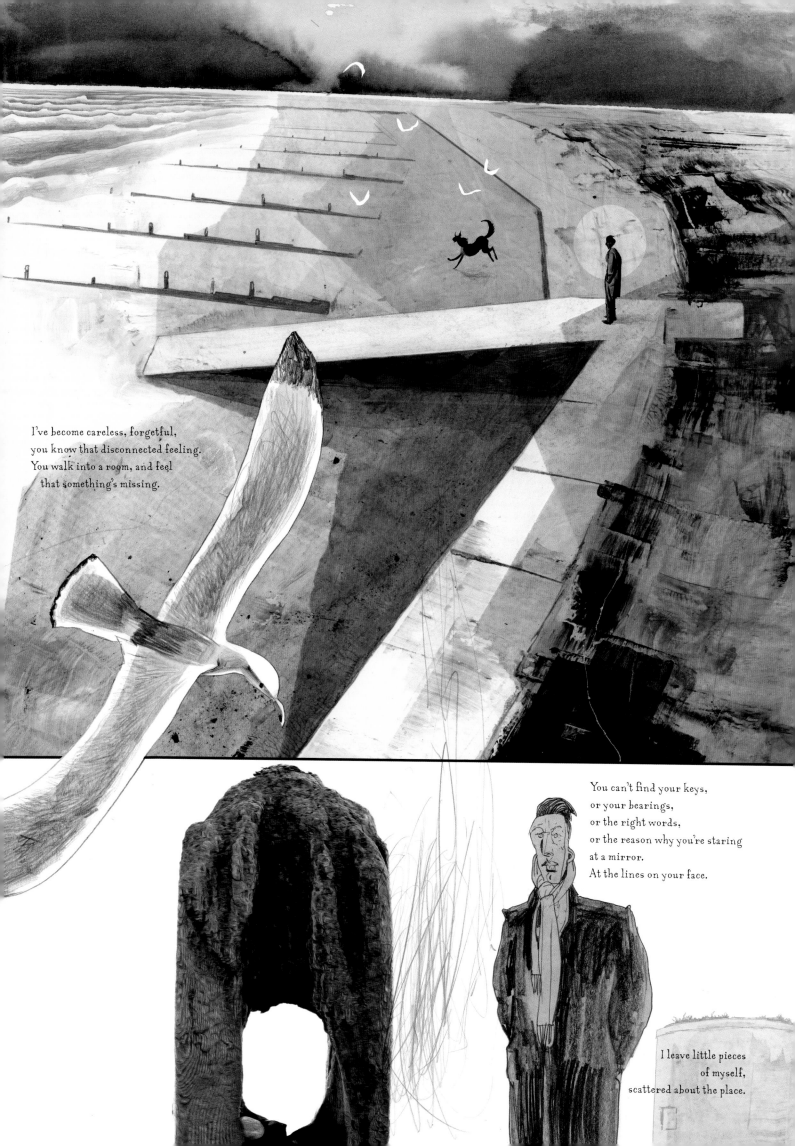

I've become careless, forgetful,
you know that disconnected feeling.
You walk into a room, and feel
that something's missing.

You can't find your keys,
or your bearings,
or the right words,
or the reason why you're staring
at a mirror.
At the lines on your face.

I leave little pieces
of myself,
scattered about the place.

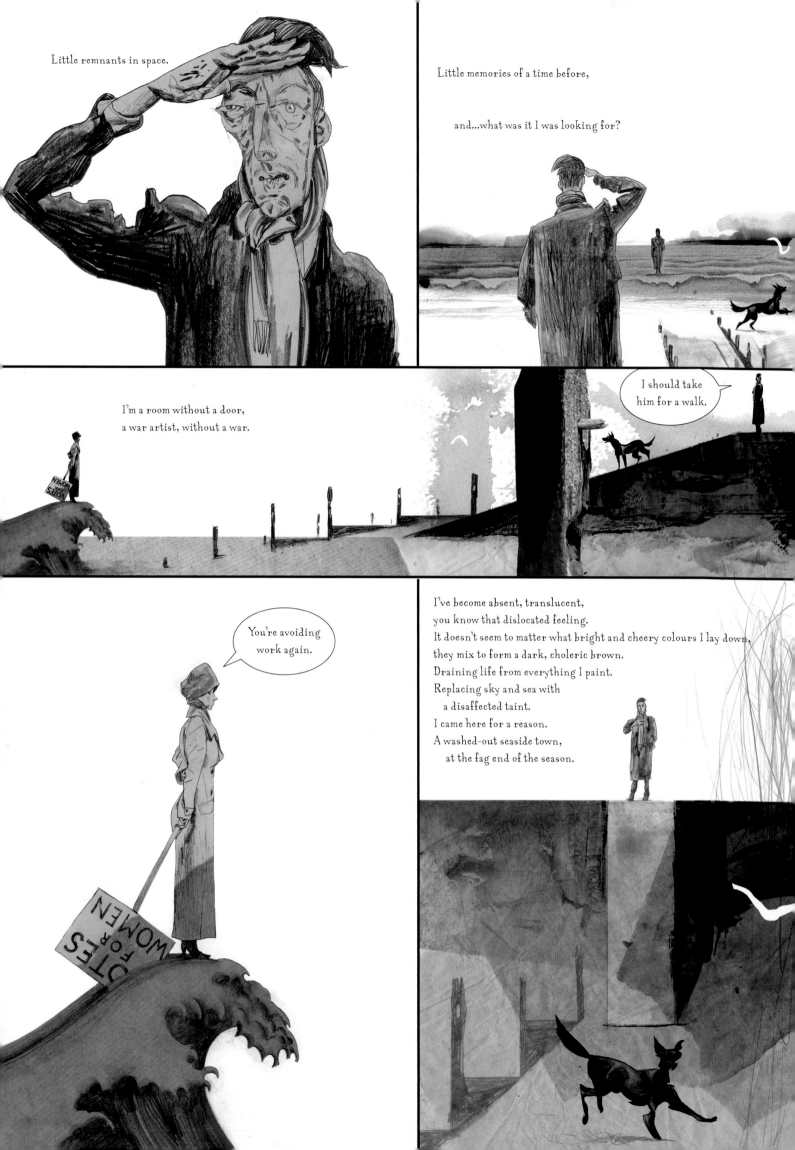

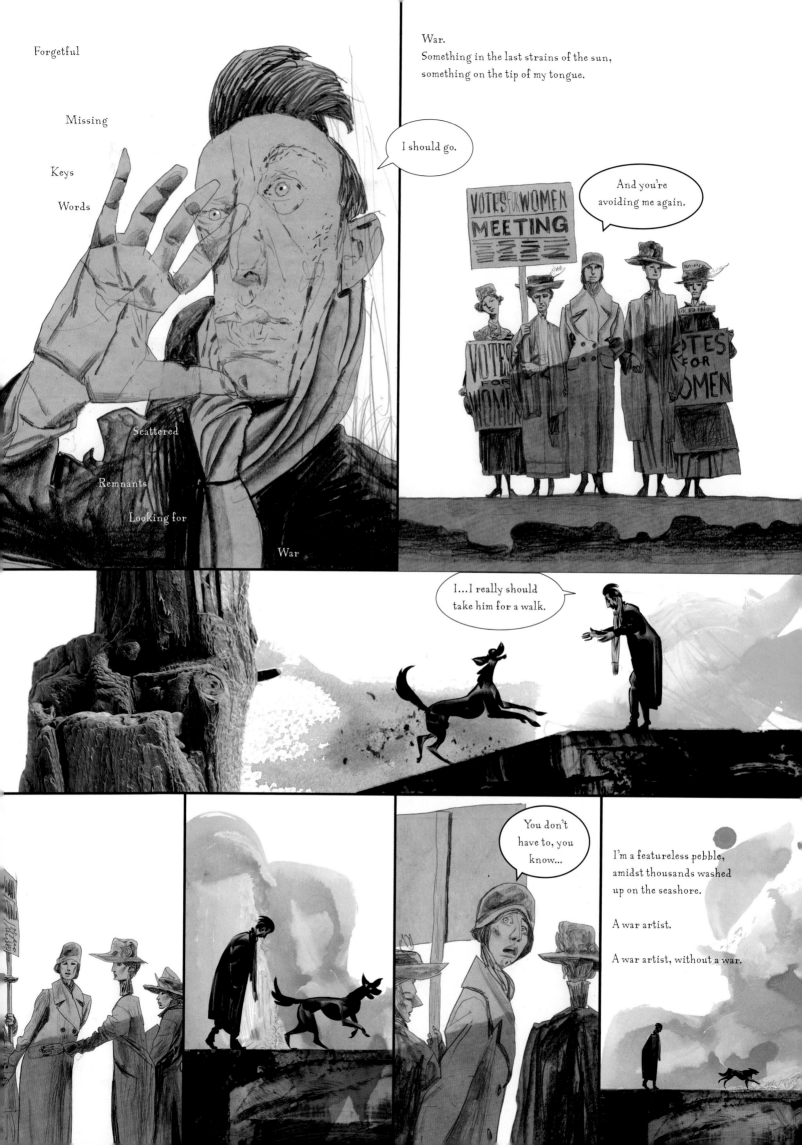

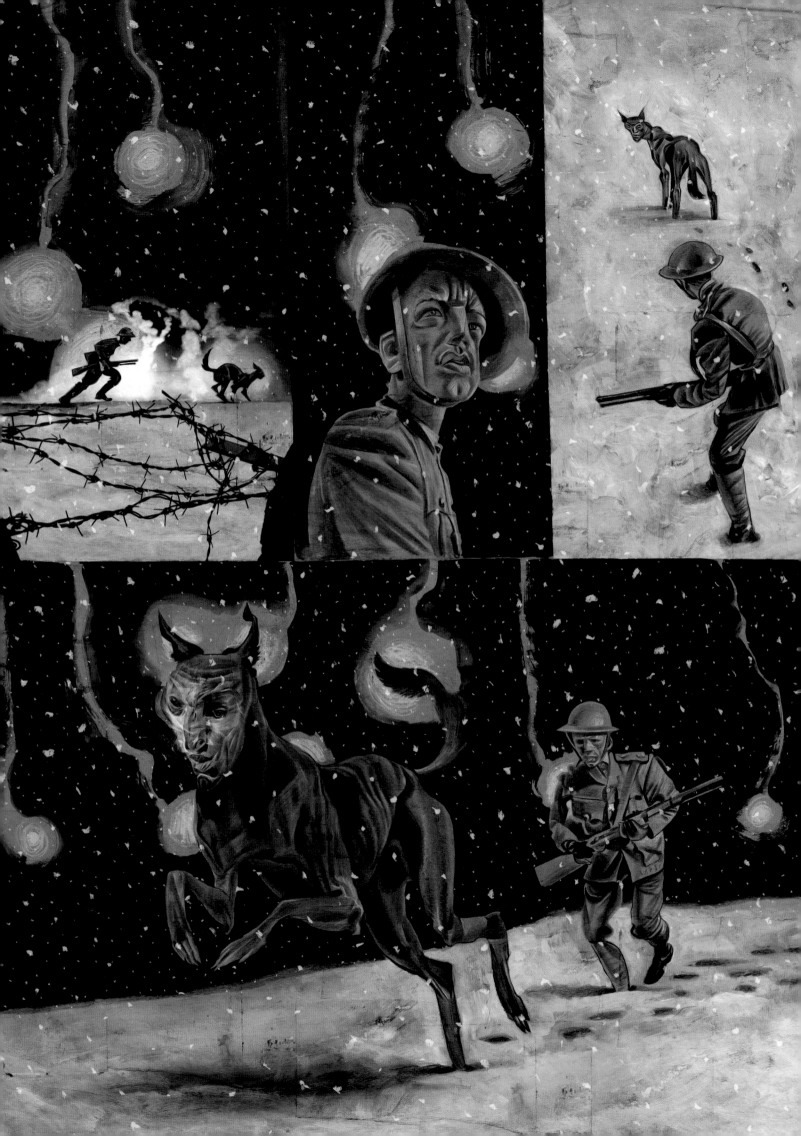

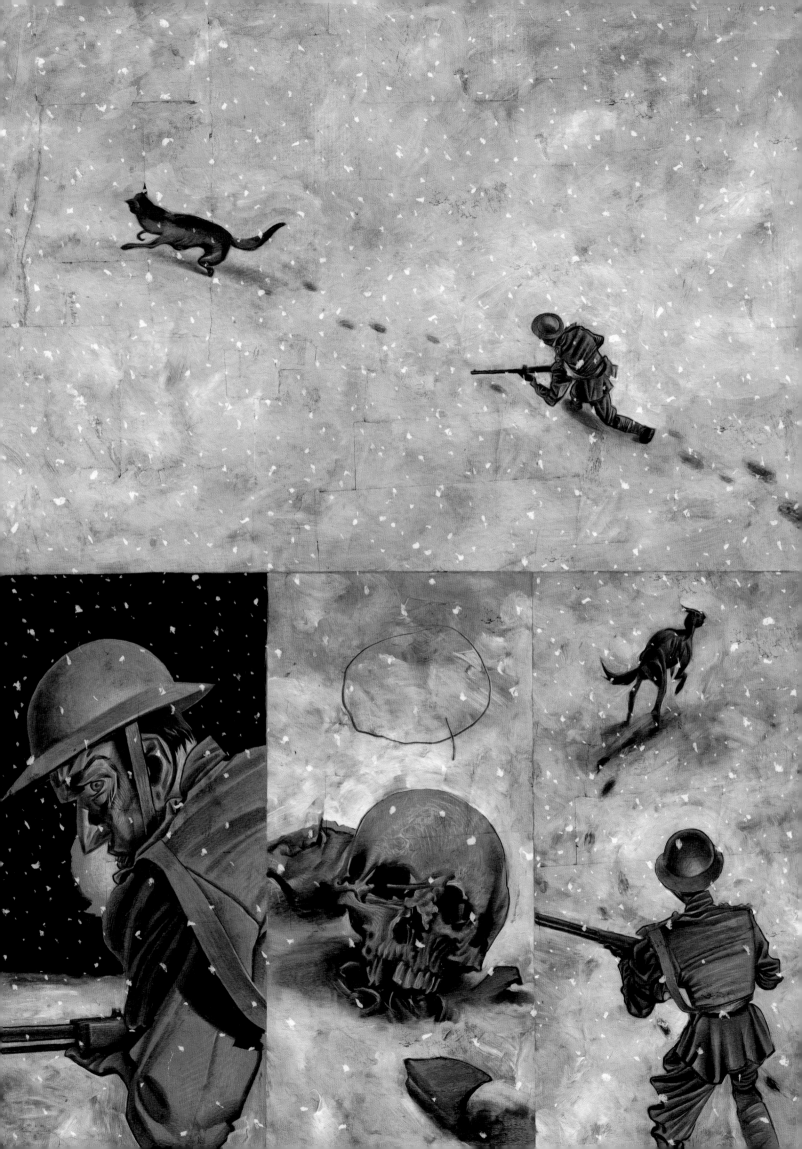

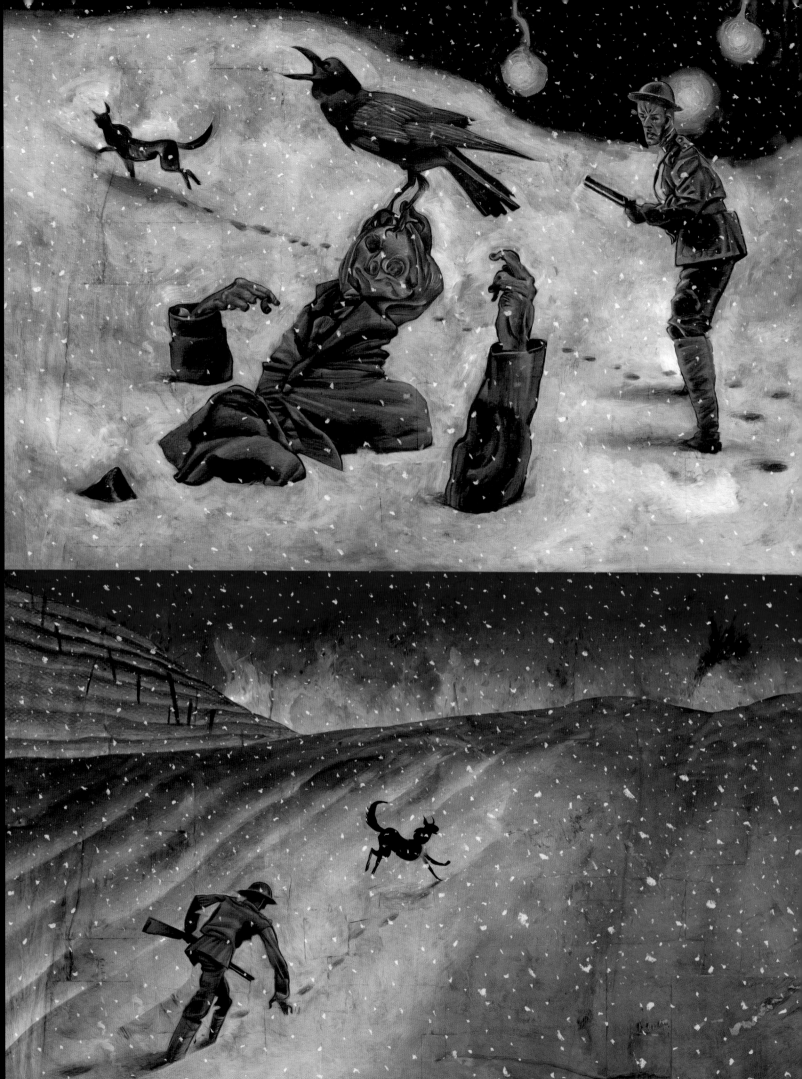

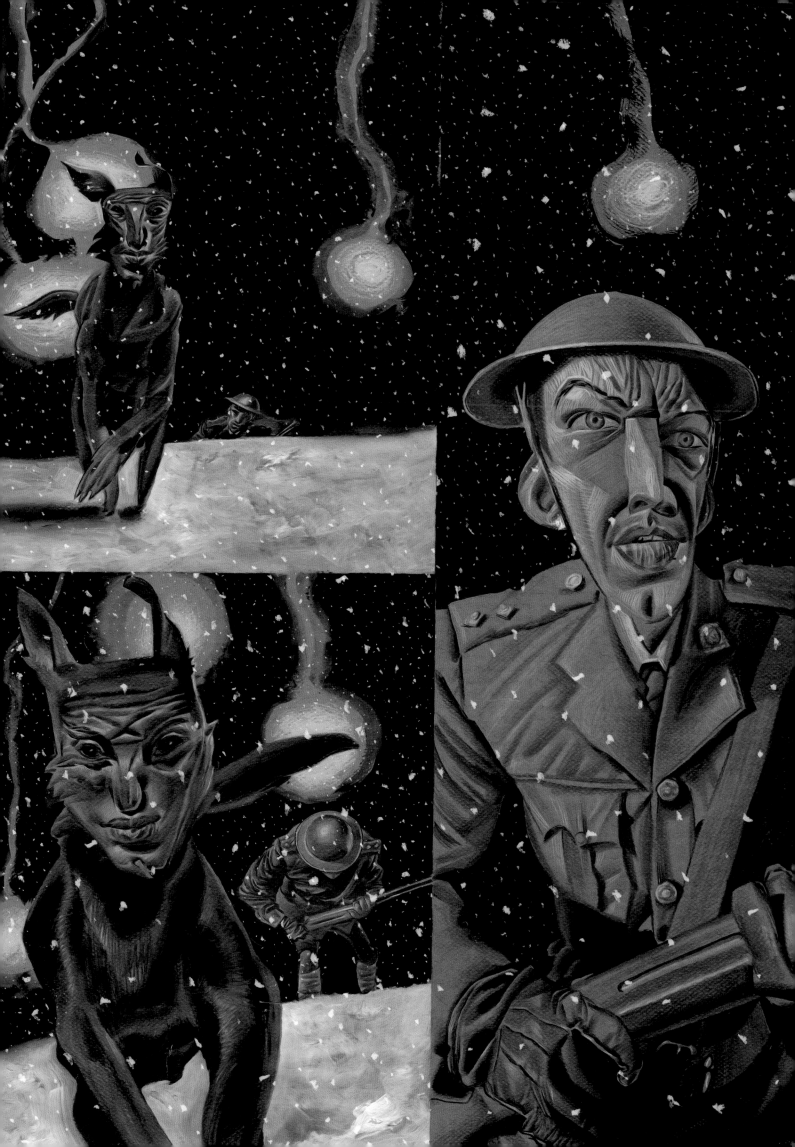

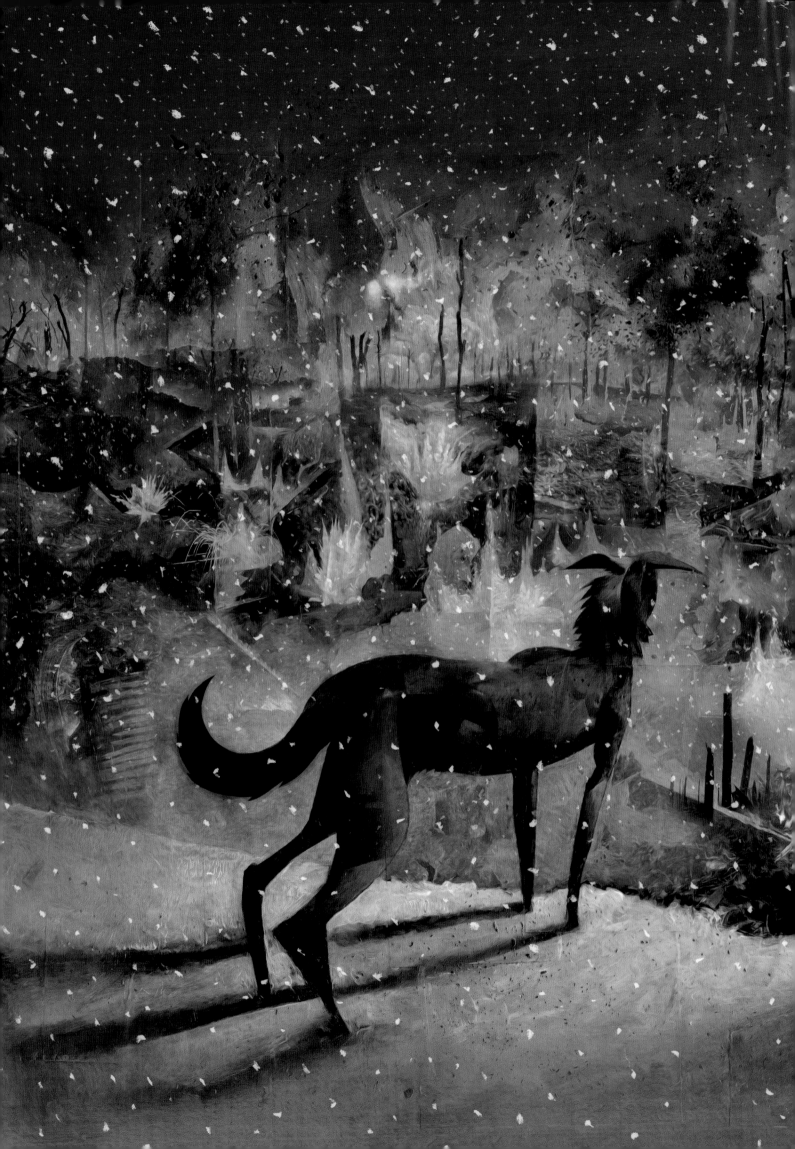

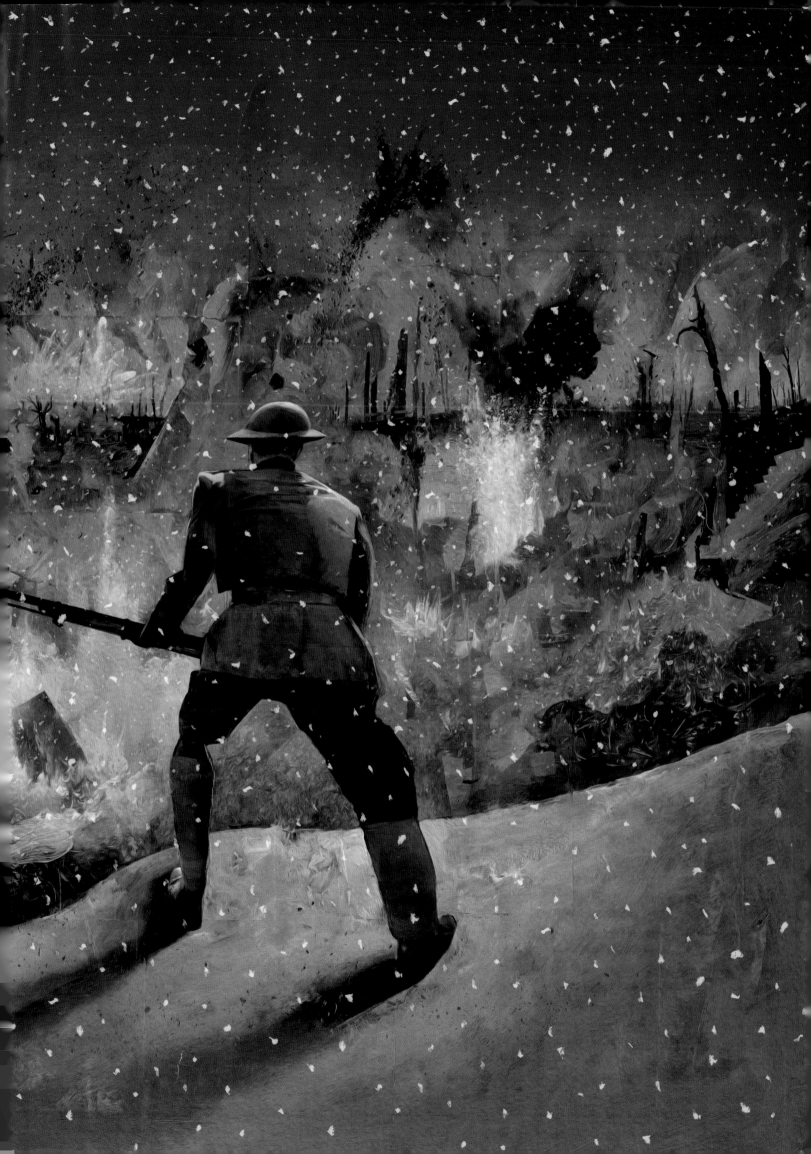

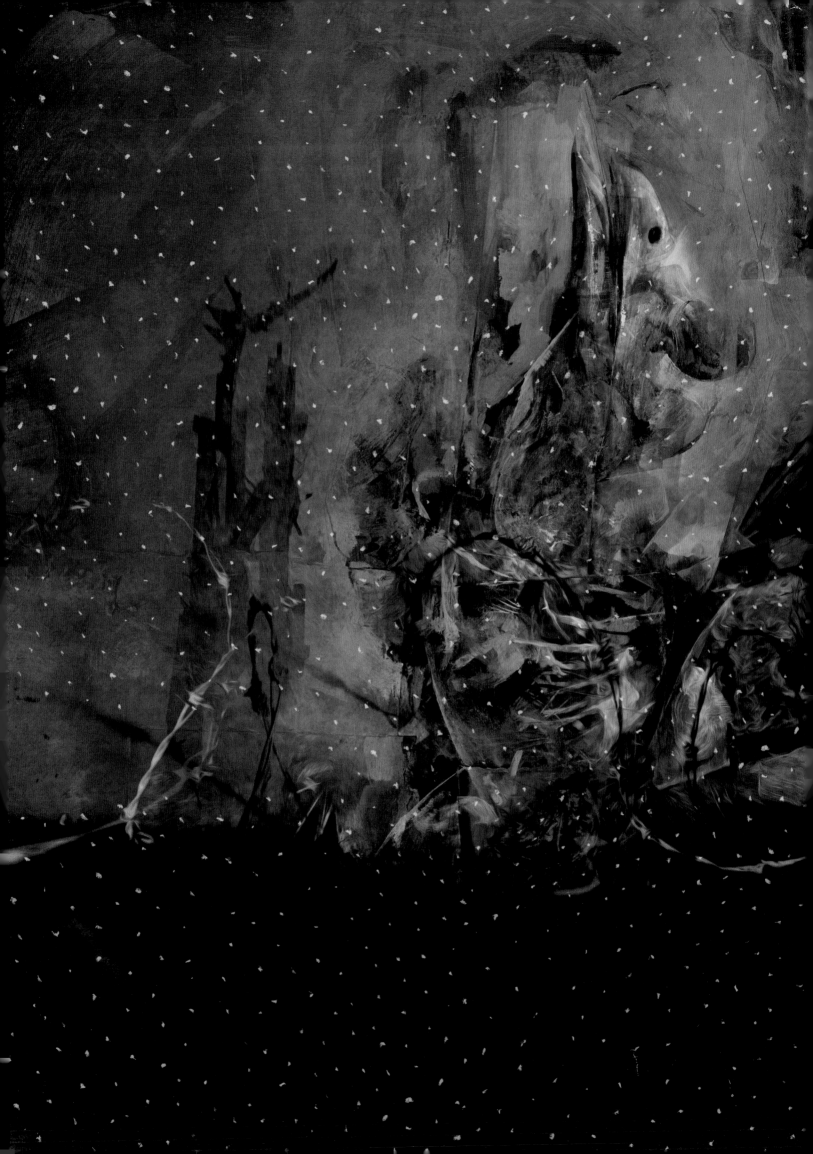

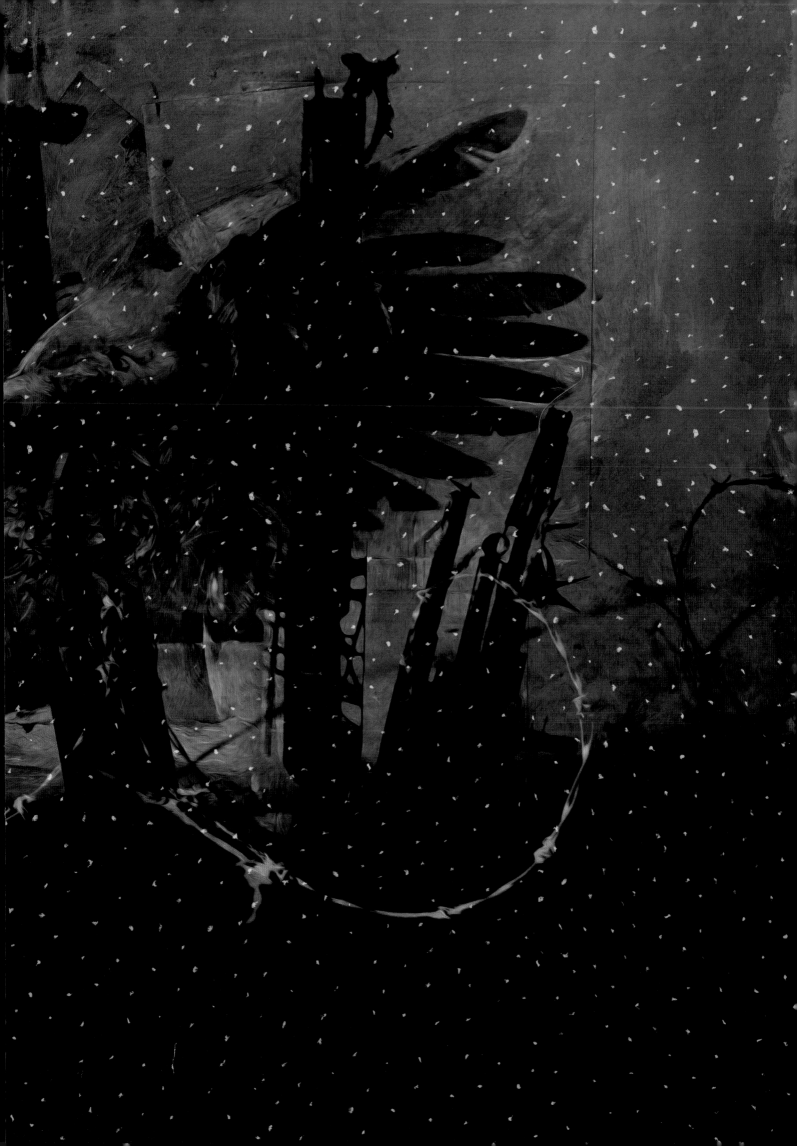

14

1921 - Rye Harbour
with Claud Lovat Fraser
1918 - Ypres Salient

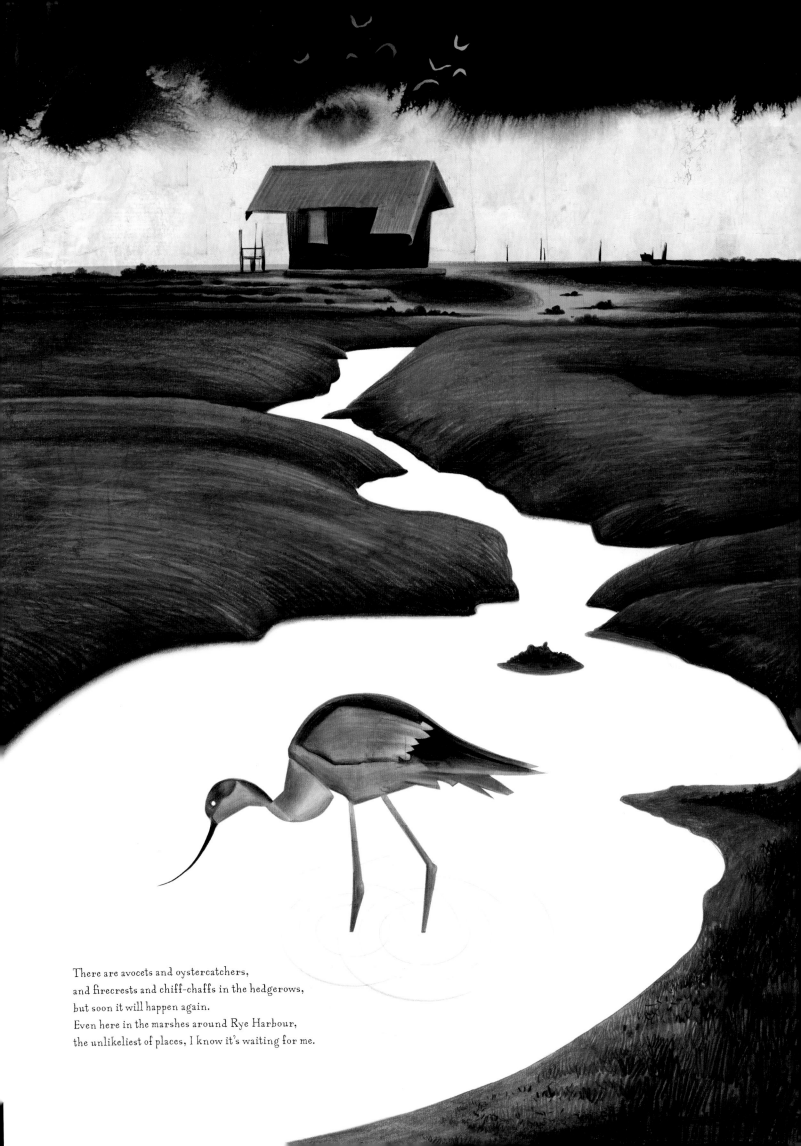

There are avocets and oystercatchers,
and firecrests and chiff-chaffs in the hedgerows,
but soon it will happen again.
Even here in the marshes around Rye Harbour,
the unlikeliest of places, I know it's waiting for me.

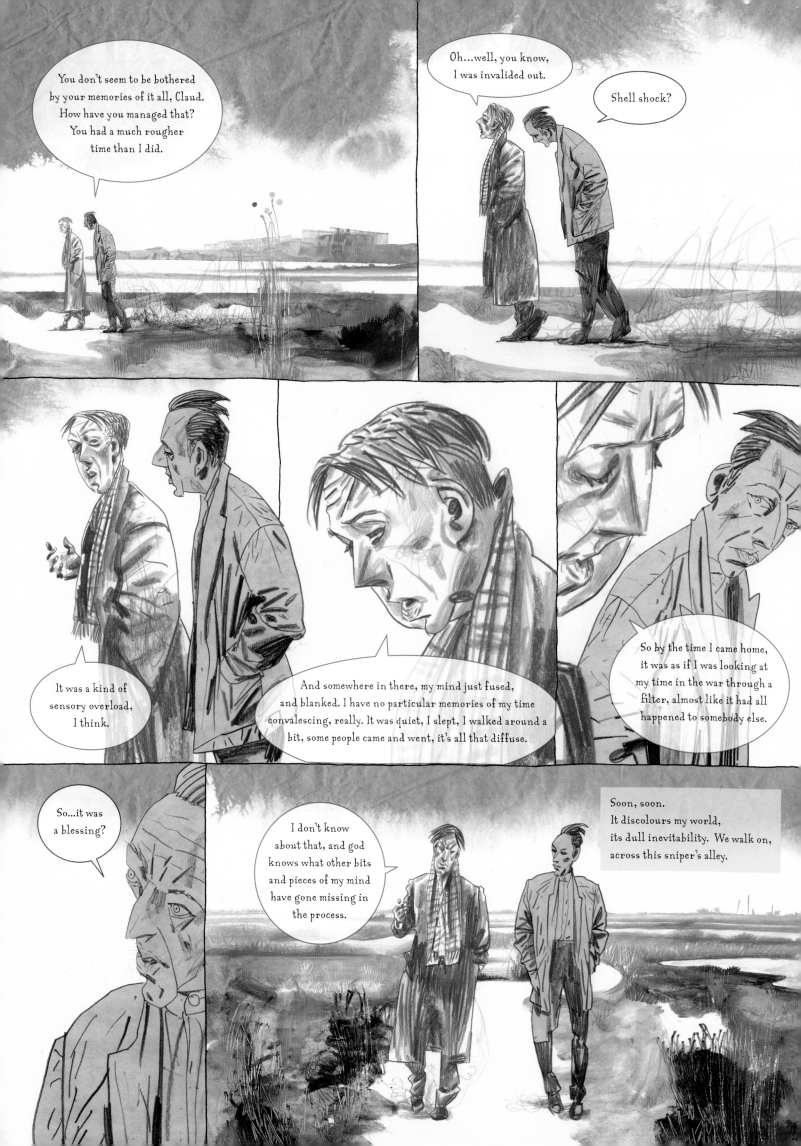

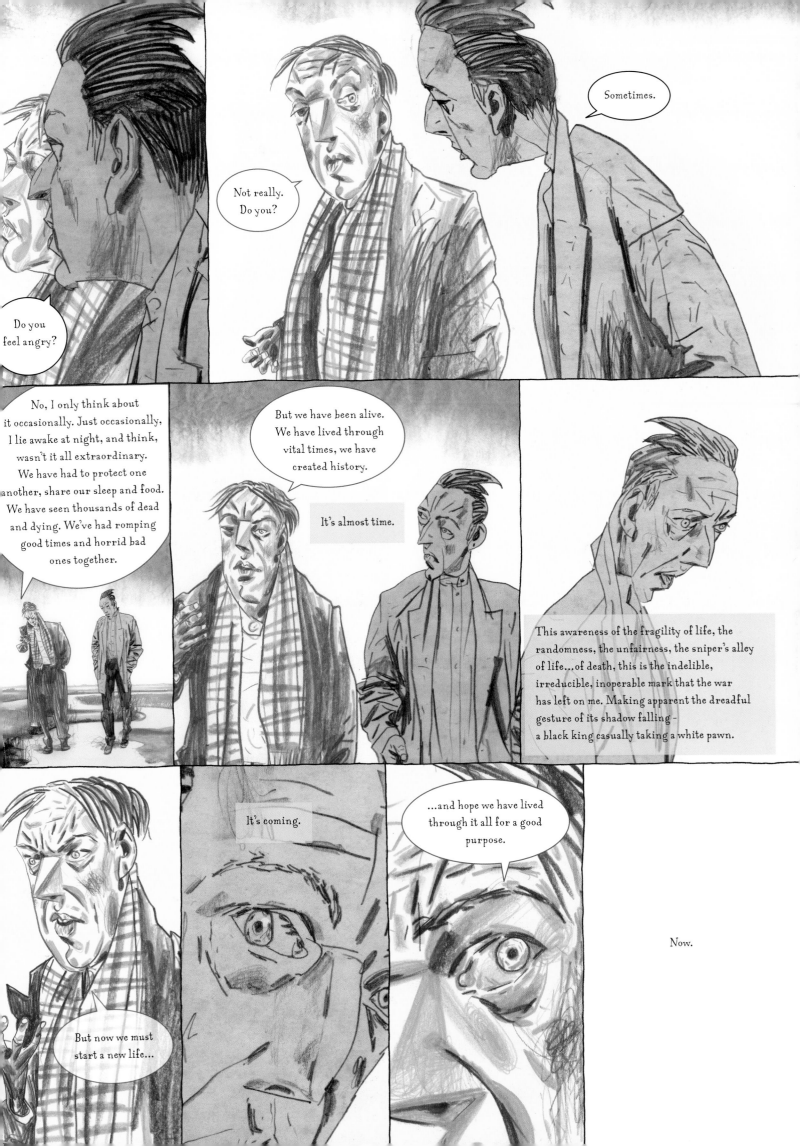

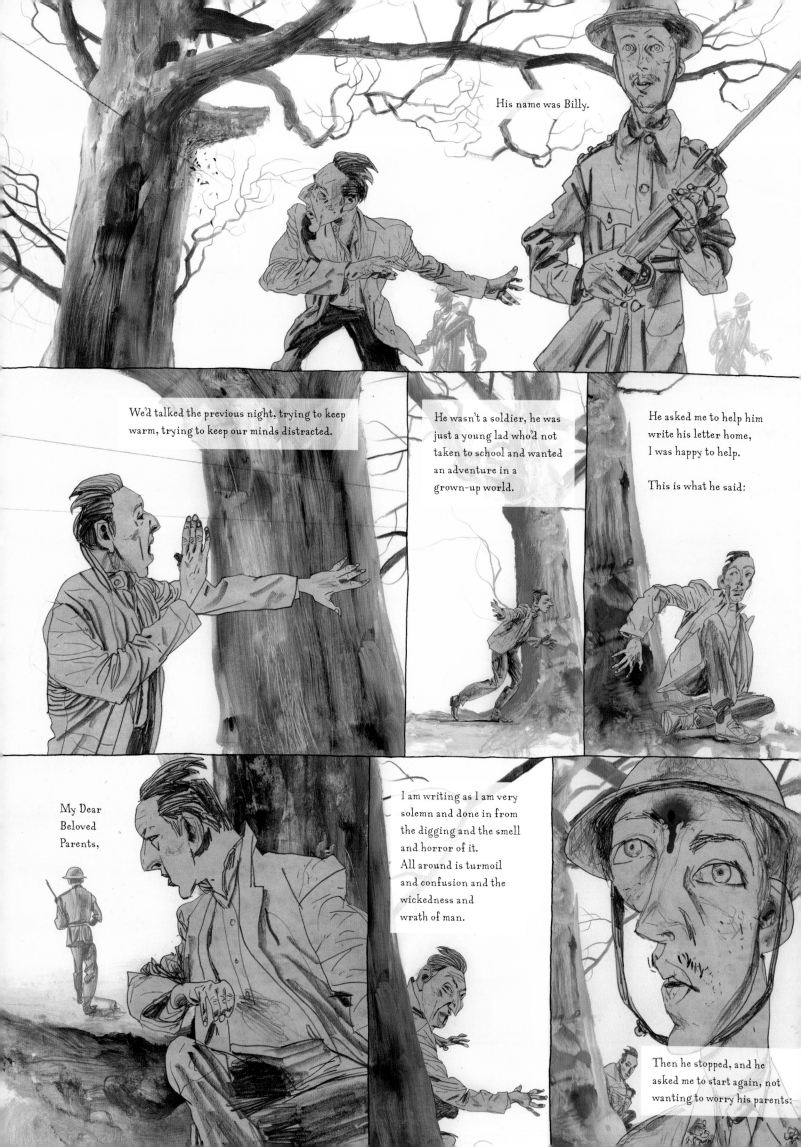

His name was Billy.

We'd talked the previous night, trying to keep warm, trying to keep our minds distracted.

He wasn't a soldier, he was just a young lad who'd not taken to school and wanted an adventure in a grown-up world.

He asked me to help him write his letter home, I was happy to help.

This is what he said:

My Dear Beloved Parents,

I am writing as I am very solemn and done in from the digging and the smell and horror of it. All around is turmoil and confusion and the wickedness and wrath of man.

Then he stopped, and he asked me to start again, not wanting to worry his parents:

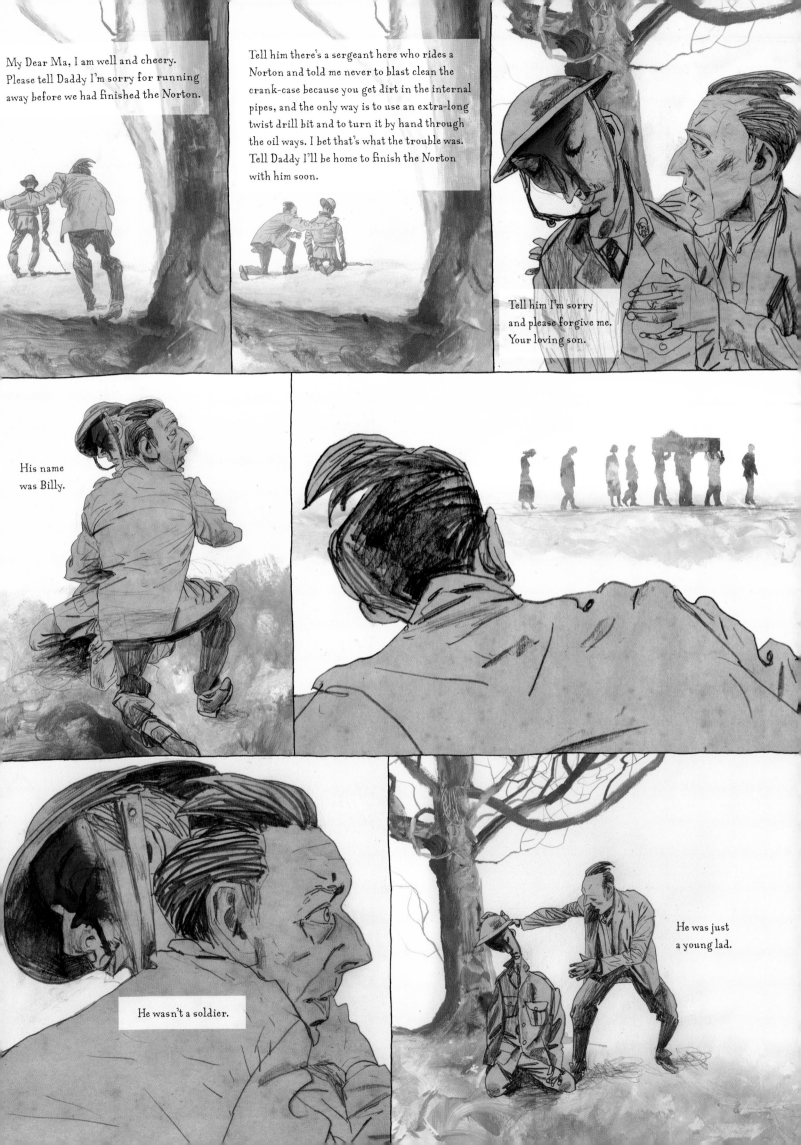

My Dear Ma, I am well and cheery. Please tell Daddy I'm sorry for running away before we had finished the Norton.

Tell him there's a sergeant here who rides a Norton and told me never to blast clean the crank-case because you get dirt in the internal pipes, and the only way is to use an extra-long twist drill bit and to turn it by hand through the oil ways. I bet that's what the trouble was. Tell Daddy I'll be home to finish the Norton with him soon.

Tell him I'm sorry and please forgive me. Your loving son.

His name was Billy.

He wasn't a soldier.

He was just a young lad.

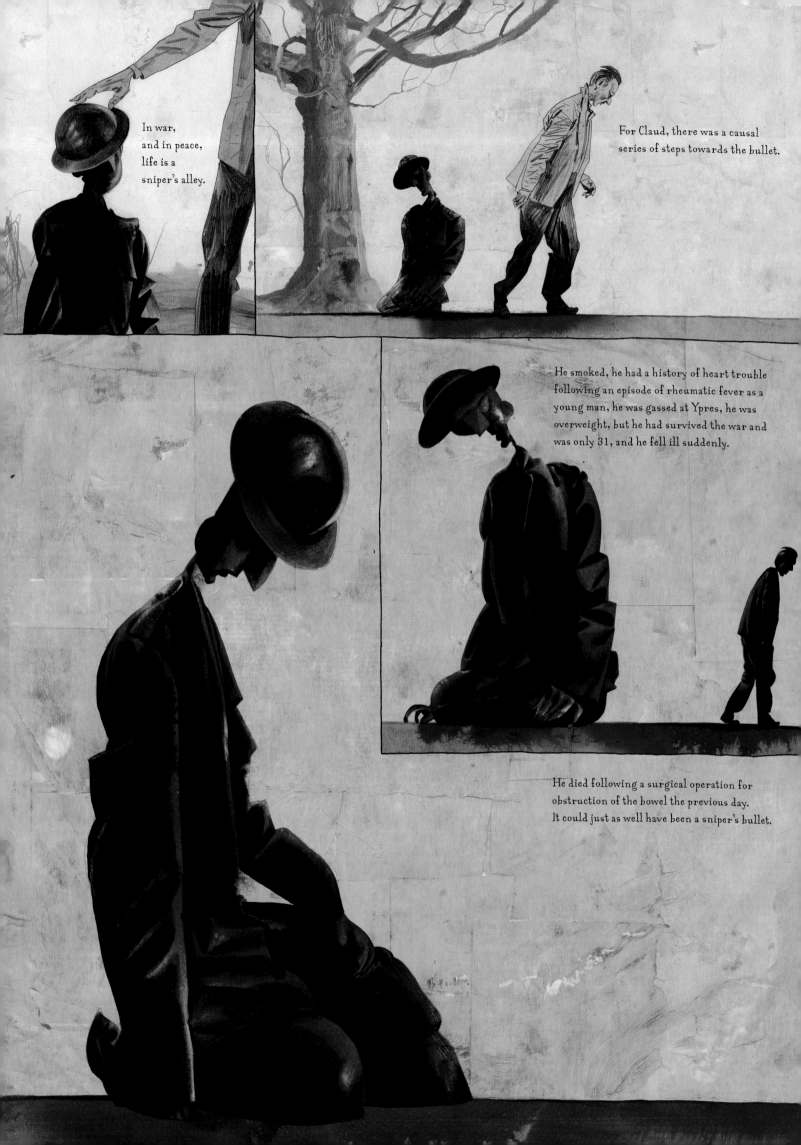

In war,
and in peace,
life is a
sniper's alley.

For Claud, there was a causal
series of steps towards the bullet.

He smoked, he had a history of heart trouble
following an episode of rheumatic fever as a
young man, he was gassed at Ypres, he was
overweight, but he had survived the war and
was only 31, and he fell ill suddenly.

He died following a surgical operation for
obstruction of the bowel the previous day.
It could just as well have been a sniper's bullet.

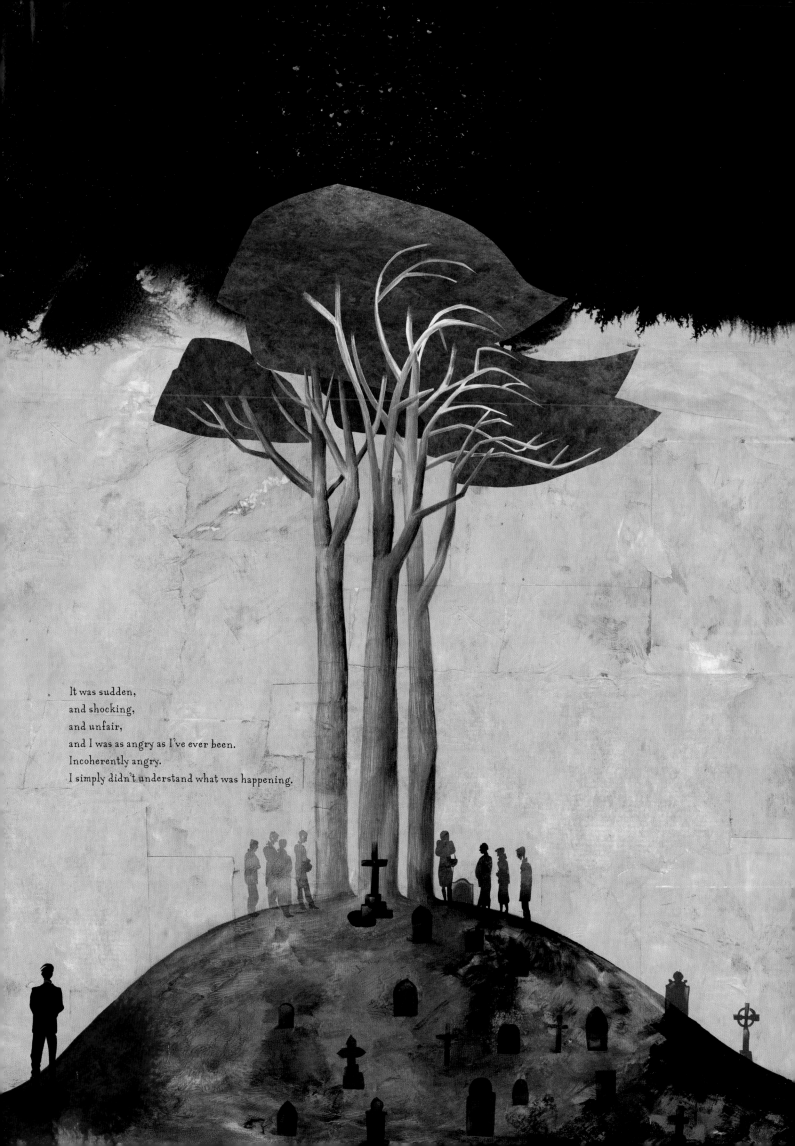

It was sudden,
and shocking,
and unfair,
and I was as angry as I've ever been.
Incoherently angry.
I simply didn't understand what was happening.

15

1921 - QUEEN SQUARE HOSPITAL FOR NERVOUS DISEASES, LONDON
WITH MARGARET NASH AND GORDON HOLMES

This was my last dream.
At least the last dream I remember.
After this they worked themselves out on canvas.
Fragments of doorways and marks in a landscape

The memory of finding my father on the floor
And assuming he was dead,
And the distance in my head
Between us falls away
As my dream takes me down a final desolate passageway.

My father had fallen.
He recovered, but in that moment he was Billy,
and Claud, and all of them, and I blacked out.
I had to escape.
I had to think.

If you strip away the accumulated fiction of the war -
the grand themes, the mud and the limbs and the jolly old rain,
the constructs and stories that constitute an official history - what is left?

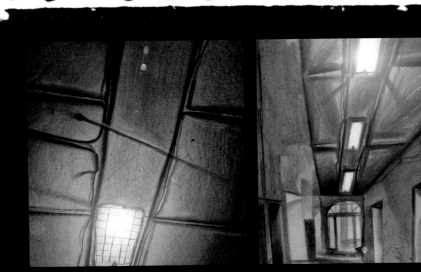 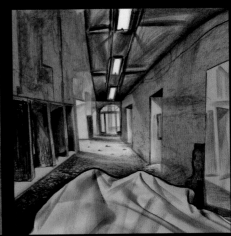

Peel away the layers

Strip away the nerves and the
synapses and senses

Cut away the skin and these
paper-thin defences

Underneath the
son is the father

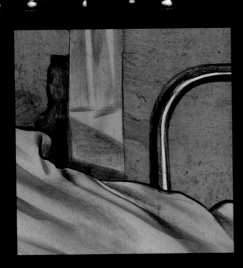 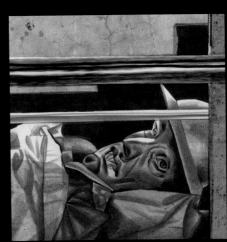

Peel away the layers

Push away the duty and the
khakis and pretences

Dig beneath the sandbags
and the barbed-wire fences
Underneath the soldier
with the stripes is the man

Fragile and naked
Profane and sacred

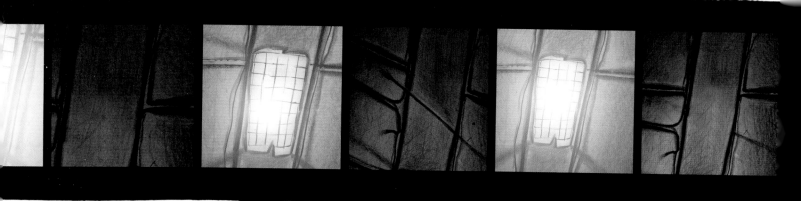

In war, one lives on the desperate edge of now.
War reveals that essential, present-tense creature at the centre of oneself,
and once it has been illuminated, even in the most failing of light,
you can't unsee it.

That is the only subject worthy of this oil and ink and blood.
To reach that essential pulsing life, one must excavate,
deep into the paper and the canvas.

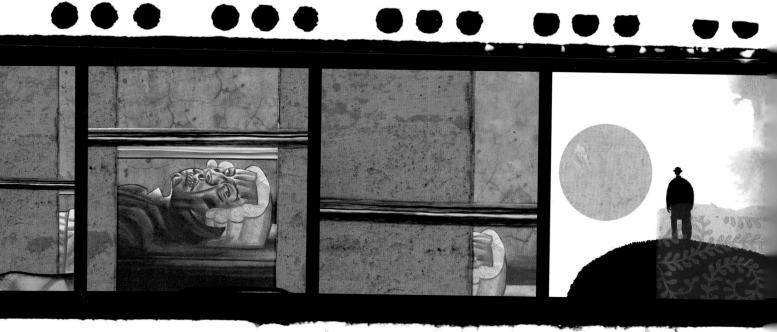

I'm defined by him
And in opposition to him.

I've tried to make judicious changes
Cut down the anger, add a little patience
I've tried to wash some colour through his pages

Swimming against his genes
His influence in my bloodstream.

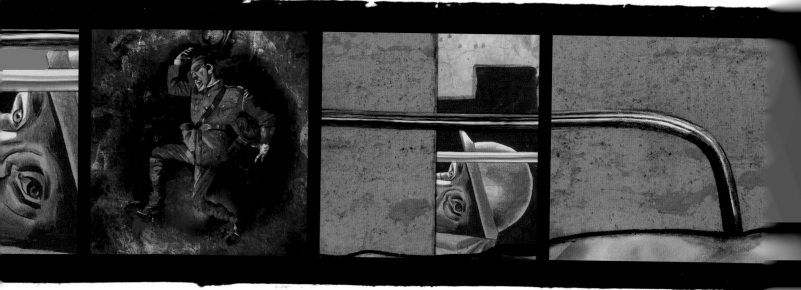

Looking at the life around him, wasted
With love and hatred

Battening down, just like the rest

With fears and doubts suppressed

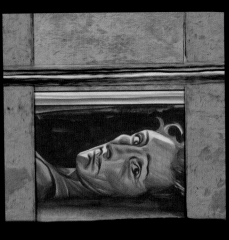
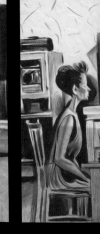

Excavate the layers

An autopsy of all those strange occurrences and memories

Digging in the labyrinthine dark and lonely places

Beneath the sanity and civility is my mother

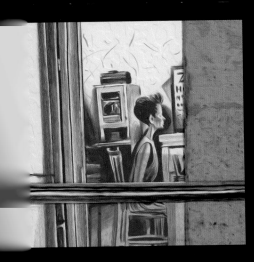
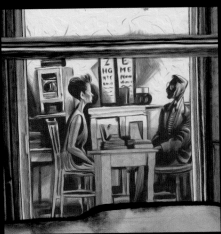
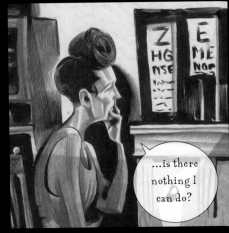

"Margaret?"
I call out but my voice echoes in my head and disappears.

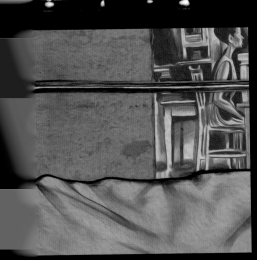

Strip away the layers of mortality

Peel away the symbols and the artifice and fancy

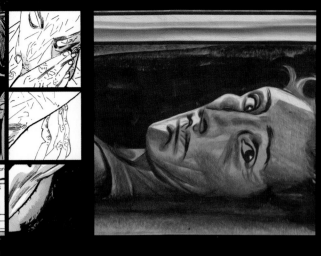
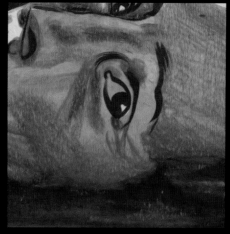
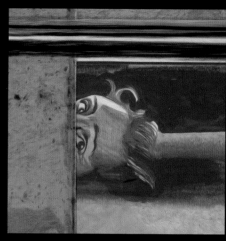

Trapped in a mind haunted by familiars
A mind that shouldn't be
running with scissors

In a house that is a hall of mirrors
How could such a spirit be so
consumed with illness?

The butterfly that turned into a chrysalis

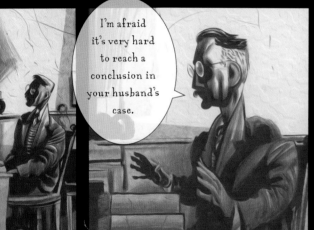
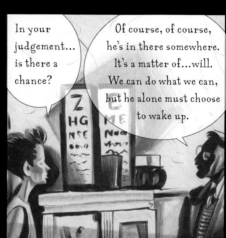
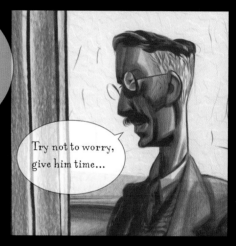

I'm afraid it's very hard to reach a conclusion in your husband's case.

In your judgement... is there a chance?

Of course, of course, he's in there somewhere. It's a matter of...will. We can do what we can, but he alone must choose to wake up.

Try not to worry, give him time...

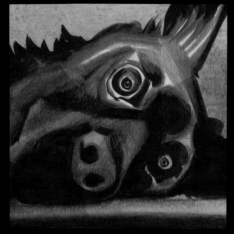
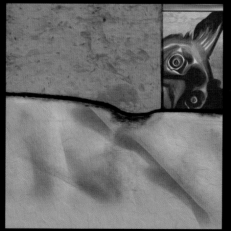
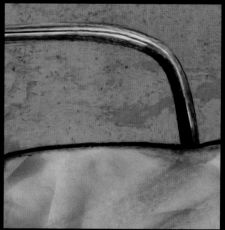

Underneath the forest of my dreams is reality

Am I sloughing off the black dog
or is he expelling me?

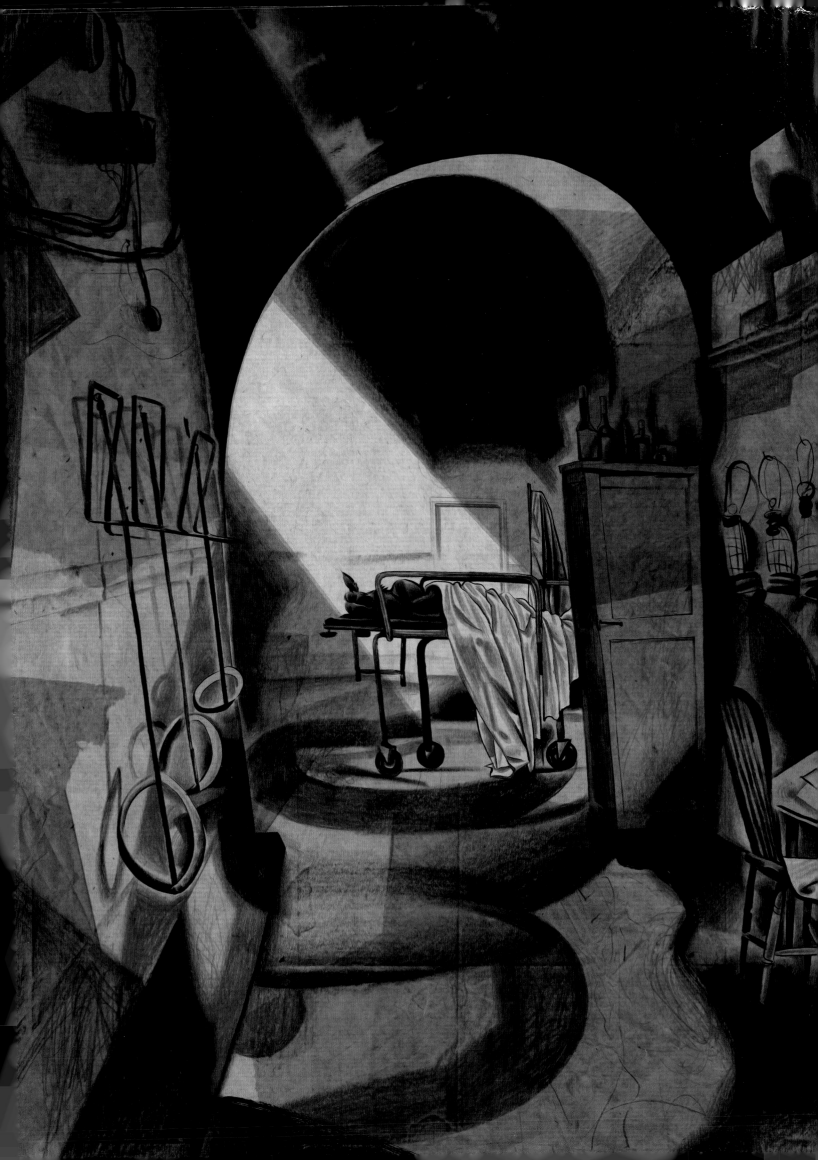

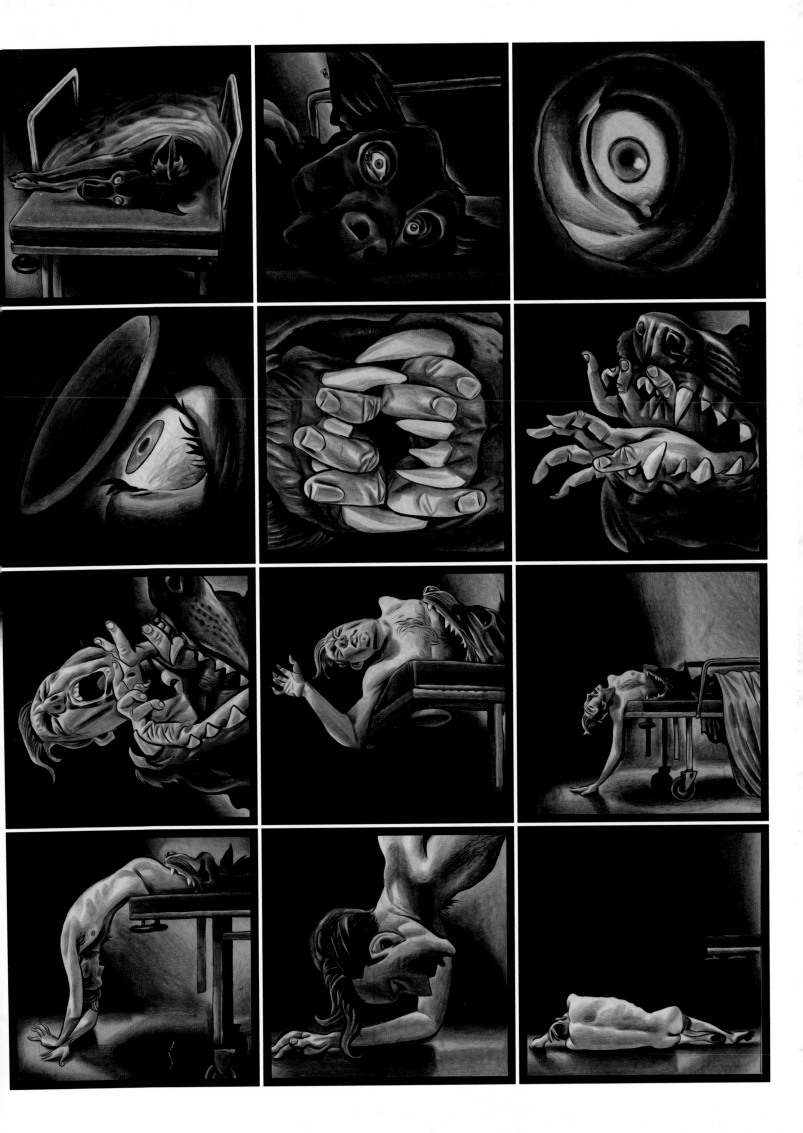

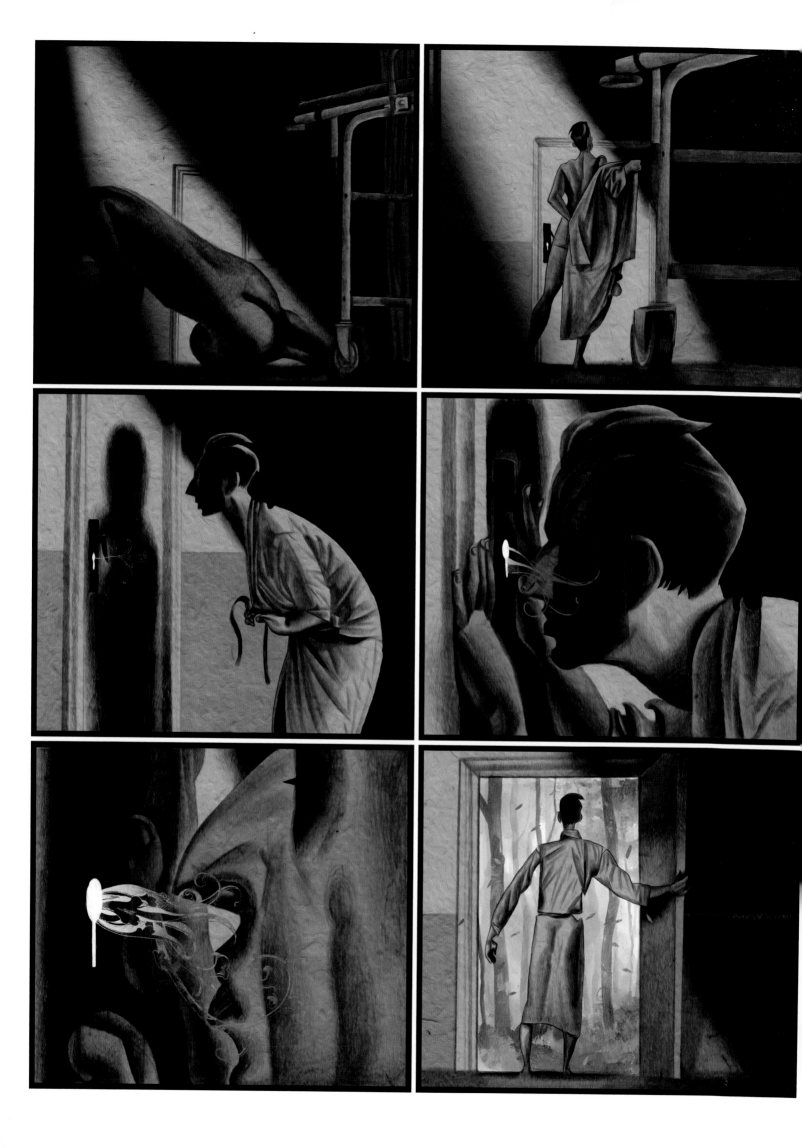

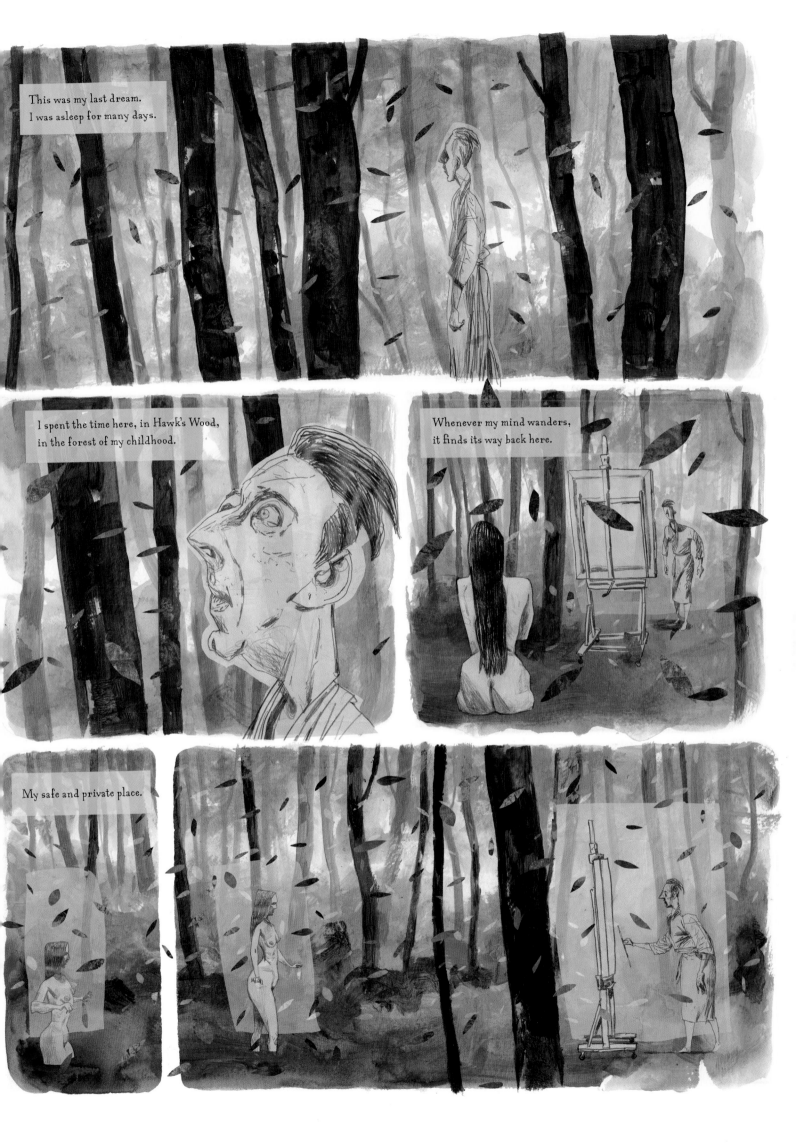

This was my last dream.
I was asleep for many days.

I spent the time here, in Hawk's Wood,
in the forest of my childhood.

Whenever my mind wanders,
it finds its way back here.

My safe and private place.

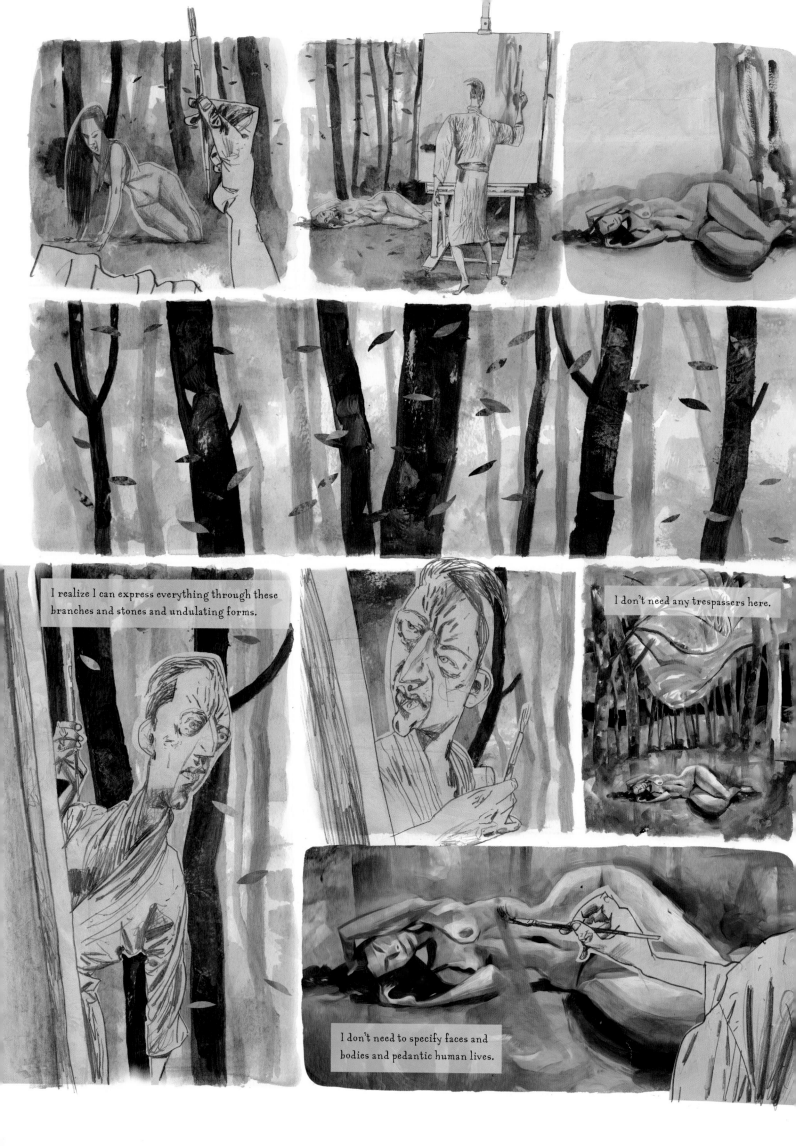

I realize I can express everything through these branches and stones and undulating forms.

I don't need any trespassers here.

I don't need to specify faces and bodies and pedantic human lives.

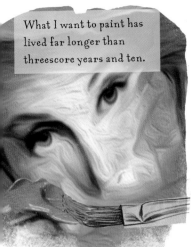

What I want to paint has lived far longer than threescore years and ten.

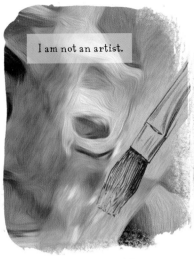

I am not an artist.

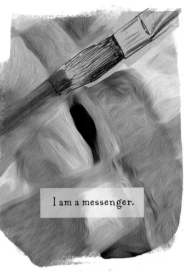

I am a messenger.

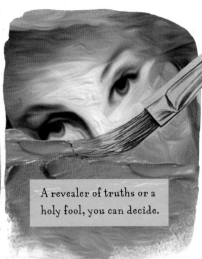

A revealer of truths or a holy fool, you can decide.

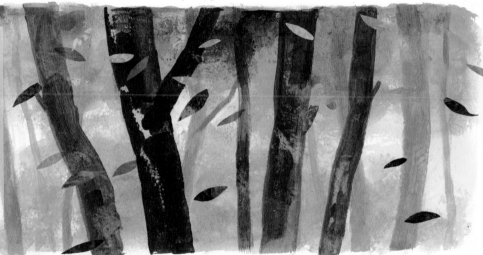

Every time I return to my private landscape, I understand more deeply that our sense of the natural world as a constant, benign equilibrium is far too simplistic. Nature is a dynamic, constantly changing, fluxing, complex chaos, and we are only leaves blown about by those forces – a minor component, an infestation, a virus. And when I'm not here, when I'm out there in the conscious world, I realize that so long as there are two people remaining on this world, there will be war. So what can I do?

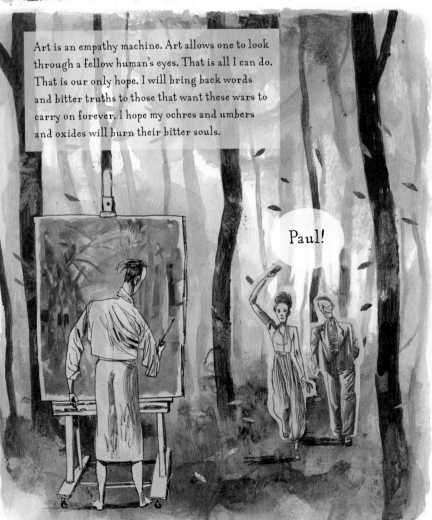

Art is an empathy machine. Art allows one to look through a fellow human's eyes. That is all I can do. That is our only hope. I will bring back words and bitter truths to those that want these wars to carry on forever. I hope my ochres and umbers and oxides will burn their bitter souls.

Paul!

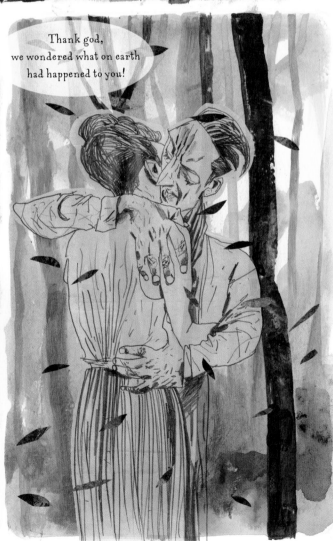

Thank god, we wondered what on earth had happened to you!

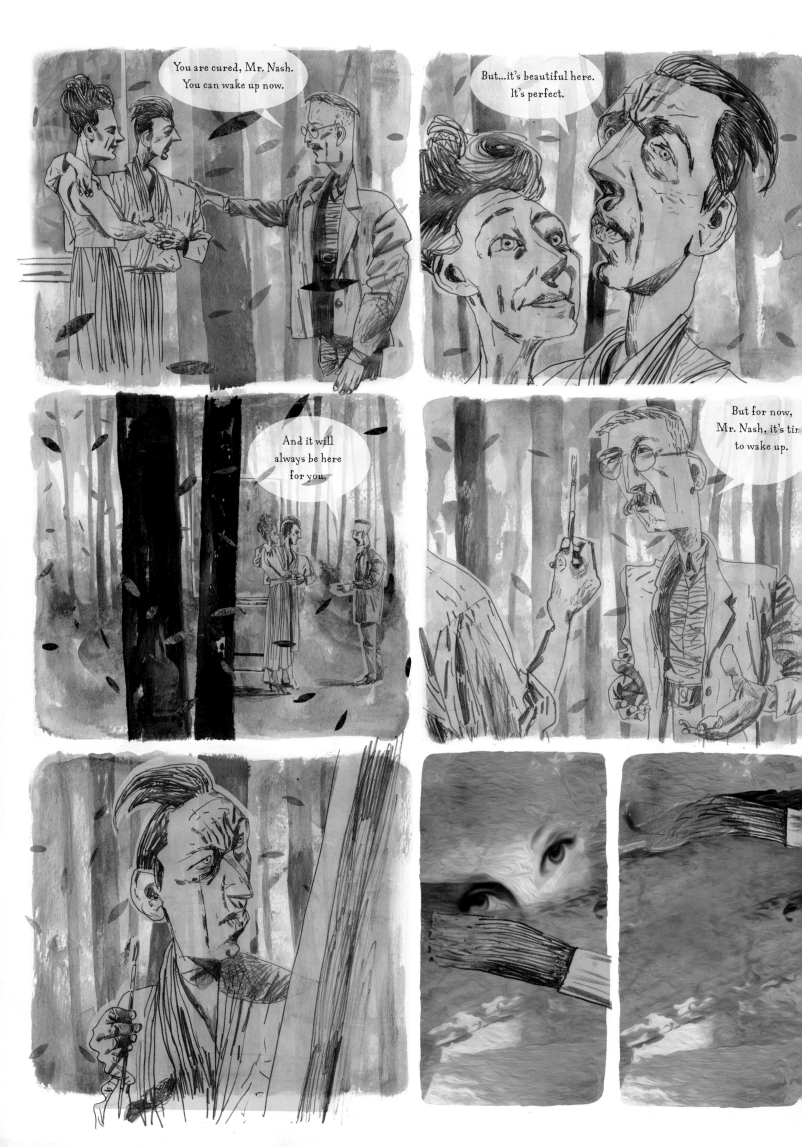

BIOGRAPHY

Dave McKean has illustrated many award-winning books and graphic novels, including **The Magic of Reality** (*Richard Dawkins*), **What's Welsh for Zen** (*John Cale*), **The Savage**, **Slog's Dad**, and **Mouse Bird Snake Wolf** (*David Almond*), **The Homecoming** (*Ray Bradbury*), **Varjak Paw** and **Phoenix** (*SF Said*), **The Fat Duck Cookbook** and **Historic Heston** (*Heston Blumenthal*), **Voodoo Lounge** (*The Rolling Stones*), **Arkham Asylum** (*Grant Morrison*), and **Violent Cases**, **Signal to Noise**, **Coraline**, **The Graveyard Book**, and **Mr. Punch** (*Neil Gaiman*).

Dave also contributed all the cover illustrations and design for Gaiman's popular **Sandman** series of graphic novels.

Dave has written and illustrated **Cages**, which won the Harvey, Ignatz, International Alph-Art, and La Pantera Awards.

His collection of short comix, **Pictures That Tick**, won the Victoria and Albert Museum Illustrated Book of the Year Award, and many of McKean's fifty-nine books are in the V&A collection.

He has created hundreds of CD, book, and comic book covers, has created advertising campaigns for *Kodak, Sony, Nike, BMW Mini,* and *Firetrap*, and has produced conceptual design work for two of the **Harry Potter** films, *Elton John* and *Bernie Taupin's* **Lestat** musical, and *Lars von Trier's* **House of Zoon**.

Dave has written or cowritten, edited, designed, and directed several short films and three feature films, **MirrorMask** (*the Jim Henson Company/Sony Pictures*), **The Gospel of Us** (with *Michael Sheen*), and **Luna** (Best British Feature award at the 2014 Raindance Festival).

He created and performed a musical/narrative/film work called **9 Lives** which premiered at the *Sydney Opera House*, and has since collaborated on the multimedia works **Wolf's Child** (*Wildworks*) and **An Ape's Progress** (Manchester Jazz/Literature Festival commission with *Iain Ballamy* and *Matthew Sweeney*).

He has exhibited in Europe, America, and Japan, and is represented in private and public collections.

He is currently acting as Director of Story for *Heston Blumenthal's* three-star **Fat Duck** restaurant in Bray, finishing a collection of silent-movie-inspired paintings to be collected in a book called **Nitrate**, and working on **Caligaro**, a new graphic novel, and several other film and book projects.

He lives near Rye, Dymchurch, and Iden in the south-east of England, where Paul Nash would live and paint after the First World War.

ACKNOWLEDGEMENTS

Thanks to:

Clare Haythornthwaite, Liam McKean, Yolanda McKean, Flame Torbay Costume Hire, Andrew Robertshaw, Tom Gordon, Adam Curtis, Ashley Slater, Matthew Sharp, Julie Tait, Aileen McEvoy, Chris Dessent, Sud Basu, Jenny Waldman, Richard Slocombe, Alan Wakefield.

Many books, documentaries, and films have provided insight, inspiration, quotes, and ideas for this project:

Outline. The autobiography of Paul Nash
Interior Landscapes: A Life of Paul Nash by *James King*
Impossible Things by *Paul Nash*
Brothers in Arms: John and Paul Nash by *Paul Gough*
Poet and Painter.
 Correspondence between Gordon Bottomley and Paul Nash
Paul Nash: The Elements by *David Fraser Jenkins*
Paul Nash: Fertile Image. Edited by *Margaret Nash*
Places by *Paul Nash*
Paul Nash. Contemporary British Artists series
World War I in Photographs by *Adrian Gilbert*
The Great War. Edited by *Mark Holborn*
Under the Devil's Eye by *Alan Wakefield* and *Simon Moody*
A Crisis of Brilliance by *David Boyd Haycock*

The Great War (BBC 1964)
The First World War: An Historical Insight.
 Based on the book by *Hew Strachan*
Journey's End (1930 Dir. *James Whale*)
King & Country (1964 Dir. *Joseph Losey*)
Torneranno i prati (Greenery Will Bloom Again)
 (2014 Dir. *Ermanno Olmi*)
Passchendaele (2008 Dir. *Paul Gross*)
Uomini contro (1970 Dir. *Francesco Rosi*)
The Big Parade (1925 Dirs. *King Vidor* and *George W. Hill*)
Wooden Crosses (1932 Dir. *Raymond Bernard*)
Westfront 1918 (1930 Dir. *G. W. Pabst*)
All Quiet on the Western Front (1930 Dir. *Lewis Milestone*)
Stoßtrupp 1917 (Shock Troop)
 (1934 Dir. *Ludwig Schmid-Wildy* and *Hans Zöberlein*)
The Battle of the Somme (1916 Prod. *William F. Jury*)